DIGITAL PAINTING

FOR THE COMPLETE BEGINNER

Includes techniques using Corel® Painter™ and Adobe Photoshop®

CARLYN BECCIA

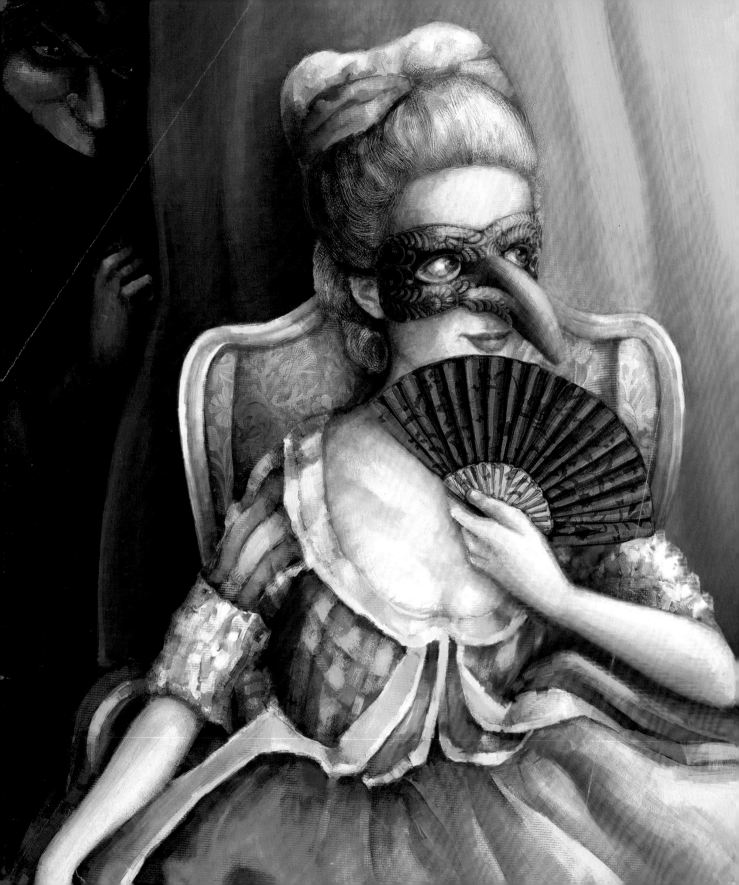

DIGITAL PAINTING

FOR THE COMPLETE BEGINNER

Includes techniques using Corel® Painter™ and Adobe Photoshop®

CARLYN BECCIA

Watson-Guptill Publications / New York

Published in the United States by Watson-Guptill
Publications, an imprint of the Crown Publishing
Group, a division of Random House, Inc.,
New York.

www.crownpublishing.com
www.watsonguptill.com

Published in Great Britain by
The Ilex Press Limited,
Lewes, East Sussex, BN7 2NS

WATSON-GUPTILL is a registered trademark and
the WG and Horse designs are trademarks of
Random House, Inc.

Library of Congress Cataloging-in-Publication Data
Library of Congress Control Number: 2011928847

ISBN: 978-0-8230-9936-8

This book was conceived, designed, and produced by
The ILEX Press, 210 High Street, Lewes, BN7 2NS, UK

For Ilex Press:
Publisher: Alastair Campbell
Creative Director: James Hollywell
Managing Editor: Nick Jones
Senior Editor: Ellie Wilson
Commissioning Editor: Emma Shackleton
Art Director: Julie Weir
Designers: Chris and Jane Lanaway

Printed in China

10 9 8 7 6 5 4 3 2 1

First American Edition

Though this be madness, yet there is method in 't.

CONTENTS

PART 1
DIGITAL PAINTING ESSENTIALS

PART 2
TUTORIALS

DIGITAL ART

WELCOME TO THE DIGITAL ART MOVEMENT

My love for digital painting began when I fell in love with roller skates and Kirk Cameron. My dad worked for Hewlett Packard so we had something most people would never see in a family room—a personal computer. It sat on his desk humming away with its bloated monitor taking up about as much space as a set of luggage. It only had Dos commands—you had to manually type in basic instructions in scary, glowing green—and it was the same creamy color as our diesel station wagon, but I remember I could wrap my small hand around the mouse and do rudimentary line drawings. Then my dad got a dot matrix printer and I was in nirvana. I made endless dotted ponies and stick riders heading off into a speckled sunset. I was hooked.

When I was in my first year of art school, my art instructor complained that we had not gone through an art movement in more than a decade. I immediately raised my hand and asked, "Isn't computer art a movement?" My outburst only earned me the scorn of the whole class. At the time, Photoshop existed, but it didn't have layers yet. Pressure sensitive tablets were rare and extremely expensive. Most digital art looked like something Pacman ingested. It was computerized, cold, and not "real" art.

Thankfully, all that has changed and will continue to change. Digital art has become so ubiquitous that it is rare for anyone in a commercial art field not to incorporate it into their workflow. And with Giclée printing, digital art can be as tangible as any painted work. Welcome to the digital art movement.

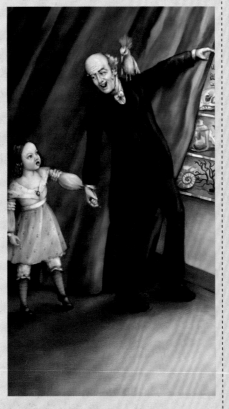

Mr. Buckland's All Beast Feast
Created using Painter's real media brushes.

WHO THIS BOOK IS FOR

As everyone knows, art is very subjective, so my teaching method will be influenced by what I like and dislike. I am personally not moved by overly blended, super smooth digital art that looks, well . . . digital.

I love art where you can see the hand in the painting and want to reach out and touch the paint. My favorite artists are Cézanne, Sargent, Leyendecker, and, most of all, Michelangelo. These artists were all very expressive painters. Their brushwork feels alive to me.

They do not merely create textural eye candy nor do they only model a form with their paint. Their paint leads your eye around their forms. Although I will never be able to paint like these masters, the tutorials in this book are inspired by them and written to encourage you to combine the digital medium with the old masters' techniques.

But wait, you say . . . I don't want my digital painting to look like an oil painting. Digital art is an entirely different medium and should never try to disguise what it is.

Yes and no. I love digital painting because I get to have both worlds. I get the expressive hand-drawn feel of traditional art, but still have the freedom to experiment and push its boundaries. This book teaches you how to translate traditional painting techniques into the digital medium so that you can push your own boundaries.

HOW TO USE THIS BOOK

When I began this book, I was concerned that beginner and intermediate digital artists would want to learn how to use either Adobe Photoshop or Corel Painter. And that including the two programs might be confusing.

I asked my artist friends, and I was surprised with the responses. As one explained, "The reason technical books are so boring is that they teach how to use software, not how to paint digitally." That made a lot of sense. You could master any one of the digital painting programs on the market today and still be a lousy painter, but if you don't learn the basic software skills then you will never be able to create masterpieces.

If you are a complete beginner, Part 1, chapters 1–14 are essential for completing the tutorials. All of the tutorials in this book assume you have this foundation.

Each tutorial is numbered with a difficulty level of 1–3. Level 1 tutorials should be pretty easy while level 3 tutorials are more advanced.

Some of the brushes, patterns, and textured backgrounds used in the tutorials have been uploaded to the book's accompanying website, www.carlynpaints.com, so you can easily download these if you would like to use them in your own digital art. This site will also include extra resources, content, and tips, as well as links to video tutorials.

Although I have given you this shortcut, I strongly recommend that you learn how to create your own brushes, which is part of understanding how brushes work. Brushes are also a very personal part of creating digital art and how you customize that brush should feel right to you, and only you.

APPLICATIONS
The application icon indicates when Painter or Photoshop or both are used for the step-by-steps in the chapter.

REFERENCE IMAGES
Examples of traditional art highlight key themes and techniques.

ART TUTORIALS
Tutorial chapters begin with a finished image that is broken down into individual steps explaining the techniques used.

STEPS
Each part of the digital painting process is broken down into smaller easy-to-follow steps.

SCREEN SHOTS
Tutorials include screen shots of the tools and settings for easy reference.

FIG CAPTIONS
Figure captions highlight important techniques or tools.

QUICK TIPS
Helpful tips relating to the chapter theme show how you can apply the techniques to your own art.

PAINTER OR PHOTOSHOP?

WHY USE BOTH?

Application
PAINTER/PHOTOSHOP

Imagine for a moment that you are a billionaire rap star about to purchase a car. Since money is no object in this dream sequence, you choose something sporty like a shiny red Porsche. Then you get inside your Porsche and you realize that you don't know how to drive a stick shift. Your new toy has the potential to go 120 miles per hour if only you could figure out how to work that stick thing in the middle. Using Corel Painter is kind of like driving a Porsche. It has so much power, but at first, that power can be overwhelming.

Now imagine that you strip a few gears and you master driving your Porsche. Then the unthinkable happens . . . you have a baby. You immediately think—how the heck am I going to fit a car seat in a Porsche?

So you go out and buy something more practical, but still glitzy. Let's say it's a pimped-out Cadillac with tinted windows and a license plate that reads, "D-guru" (Digital Guru). Now, that Cadillac can go just as fast as your Porsche, but you certainly are not going to use it to go drag racing with your gangsta' buddies. You have a baby for god's sake. You just need to get from point A to point B, safely, and in style.

Adobe Photoshop is a lot like that sensible Cadillac. It has its share of bells and whistles, but those tools were designed for photographers and designers, not for illustrators.

It actually is three times the size of Corel Painter, but only a small portion of the program is dedicated to painting, while almost all of Painter is dedicated to painting. (Thus the names PHOTOshop and PAINTER). Yes, Photoshop has many crazy cool painting tools and the art that some artists create with it is truly amazing, but it still will never be able to mimic hand-created traditional mediums as easily as Painter can (if that is your goal). Just as you could pimp out that Cadillac with a Porsche engine, you can get the same results with Photoshop, but it is going to take a lot more tinkering.

So which do you use—the pimped-out Cadillac or the Porshe? Well, you really don't have to decide. You are stinking, filthy rich with a bevy of groupies tramping after your tour bus. You can use both. You take the Porsche out when you want to cruise down the highway and the Cadillac when you are off to visit grandma. I use both programs in my workflow and I would not be able to sacrifice either. I use Photoshop for all my collage work, color correcting, fixing composition problems, and preparing for press. I use Painter for all my brushwork.

Now back to reality. Sorry, you are not really a millionaire rap star any more. You have bills to pay, grumpy clients, and maybe even a two-year-old that won't let you sleep. For most people, money always has to be considered. So, if you cannot afford both then hopefully this book will help you decide which program is right for you. In the end, software programs are just tools. It's the artist that makes the difference between a good and a great painting.

MAC OR PC?

To emulate the drama and violence of the Circus Maximus, you would not need lions or Roman gladiators. All you would have to do is put a Mac and PC user in the same arena and let them at it. People get very fiery on which is better. I use both, but prefer my Mac. Most of the screenshots in this book were done on my Mac, but all of the keyboard shortcuts are written with a "/" between them to indicate the Mac to PC equivalent.

Shortcuts you need to remember

Mac		PC
Command	=	CTRL
Shift	=	Shift
Option	=	Alt
Delete	=	Backspace

Most pressure sensitive tablets have "hot keys" that you can customize to your needs. For example, I quickly increase and decrease my brush as I paint by stroking the sensor strip up and down on my Cintiq.

PHOTOSHOP AND PAINTER SHORTCUTS

The following are my can't-live-without shortcuts.
(All of these shortcuts are identical in Photoshop and Painter unless marked *)

Shortcuts

Action	Mac	PC
Create a new file	Command + N	CTRL + N
Open a file	Command + O	CTRL + O
Save a file	Command + S	CTRL + S
Undo	Command + Z	CTRL + Z
Undo more than the last step*	Command + Alt + Z	CTRL+ Alt + Z
Fit your art to the screen	Command + 0	CTRL + 0
Select all	Command + A	CTRL + A
Copy	Command + C	CTRL + C
Cut	Command + X	CTRL + X
Paste	Command + V	CTRL + V
Create a new layer	Command + Shift + N	CTRL + Shift + N

* Use Command/CTRL + Z in Painter

Brush Tool Shortcuts

While you have your brush tool selected, these shortcuts will save you time

Action	Mac	PC
Toggle between brush and color sample tool	Hold down Option	Hold down Alt
Decrease brush size	[[
Increase brush size]]
Reset your colors to black and white* (you will use this when painting masks)	D	D

* Only works in Photoshop

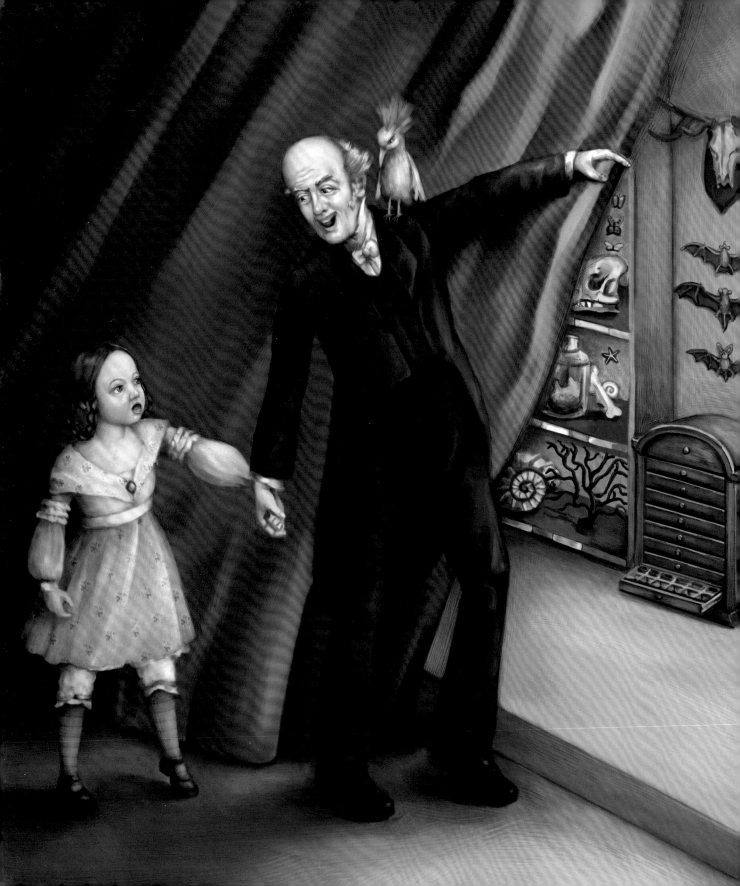

DIGITAL PAINTING
ESSENTIALS

01

01
DIGITAL BASICS

Before putting digital ink to digital paper, a good starting point is the basic terminology that is used in digital painting. What is important is not the acronyms or fancy terms, but an understanding of how they apply to your own work.

Queen of Diamonds
I created this image combining vector art and Painter's Real Oil Brush. The costume is drawn in vectors while the face, hands, and unicorn is an example of pixel-based art.

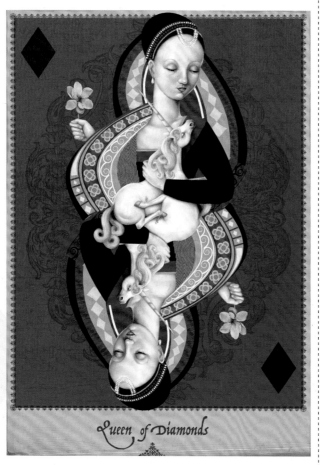

QUICK TIP

Don't confuse the file resolution with the screen resolution. Your screen resolution is the number of distinct pixels that can be displayed by your screen.

PIXELS

A pixel is the smallest single component of a digital image. If you zoom in on an image really closely, you will see the tiny, square pixels that make up your image. Programs like Photoshop and Painter are primarily pixel-based programs or raster programs.

VECTORS

Vectors are lines, curves, objects, and fills that are calculated mathematically. Every time you create a shape layer in Photoshop or Painter, that is a vector. As vectors are defined mathematically, they are resolution independent. This means that you can scale a vector up or down without losing any image quality.

RESOLUTION

The number of pixels in an image is called its resolution. Image resolution is measured in pixels per inch for offset printing and dots per inch for inkjet printing. The more dots you have, the higher the resolution. All of the tutorials in this book assume that you are working at 300 DPI. You can choose a higher resolution, but it will make a larger file and most printers request images at 300 DPI.

SAVING FILES IN PHOTOSHOP

I really hate to nag, but I am going to anyway . . . you should save frequently. Even the most reliable computers can surprise you with a sudden crash. I save about every ten minutes.

1. Select *Command/CTRL + S*.
2. Name your file something that makes sense and save it to the correct location on your drive (Fig. 1A).
3. Choose a file format from the drop-down menu (Fig. 1B). (See sidebar.)
4. Make sure *Embed Color Profile* is checked (Fig. 1C). For more on color management see p. 30.

SAVING FILES IN PAINTER

Saving files in Painter is nearly identical except the screens look different.

1. Select *Command/CTRL + S*.
2. Name your file something that makes sense and save it to the correct location on your drive (Fig. 2A).
3. Choose a file format from the drop-down menu (Fig. 2B). (See sidebar.)
4. Make sure *Embed Color Profile* is checked (Fig. 2C). For more on color management see p. 30.

COLOR MODES

Color Modes are the range of colors used to define files. In Photoshop, any color mode can be changed by selecting *Image > Mode.* In Painter, you will only use the RGB color mode. (Color modes are discussed in more detail in Chapter 6: Taming the Color Beast.)

RGB: Stands for Red, Green, and Blue. This is the color mode used by your monitor, TV screen, and digital cameras. It has the largest color space so it is the mode that you should use for all your paintings until you are ready to send your file to a commercial printer. In RGB mode, every color is assigned an intensity value from 0 to 255. (Zero is equal to black, 255 is equal to white.)

CMYK: Stands for Cyan, Magenta, Yellow, and K for Black. This is the color process used in books, magazines, commercial brochures, and most materials with large print runs. In commercial or offset printing, cyan, magenta, yellow, and black are print__ other using tiny half-tone__ loop and look at a magaz__ tiny dots. In CMYK __ assigned a percentage val__ __ne process inks to tell the printer how much of that ink is to be used.

Grayscale: Used for black and white images in a gray tonal range without any color information. Grayscale images are measured as percentages of black ink coverage (0% is equal to white, 100% to black).

Bitmap: Used for pure black and white images without any gray. Files must be grayscale images before they become bitmaps. I often use bitmaps to create spot varnishes over art. A spot varnish creates a shiny area over your art to contrast against the matte areas. Most printers will ask that you specify where you want the varnish to go by sending a bitmap file.

USEFUL TIPS!

MEMORY ALLOCATION

RAM, or Random-Access Memory, is the amount of data your computer's memory can hold. You can increase RAM in Painter and Photoshop.

To increase RAM in Photoshop:

1. On a Mac, select *Photoshop > Preferences > Performance*. On a PC, select *Edit > Preferences > Performance*.

2. In the *memory usage* dialog box, drag the arrow to the right-hand side to increase the percentage of memory allocated to Photoshop or type in a desired number.

3. Under the scratch disk dialog box, make sure that any additional drives you have are set as scratch disks.

To increase RAM in Painter:

1. On a Mac, select *Painter > Preferences > Memory & Scratch*. On a PC, select *Edit > Preferences > Memory & Scratch*.

2. Type in a larger number under the *memory usage* box.

3. Under the scratch disk drop-down menu, select the drive that has the largest amount of available space.

IMPORTANT: If possible, do not set your scratch disk to the same drive your OS uses as a startup drive.

Keep in mind that allocating more memory to one program will mean less memory for programs running in the background.

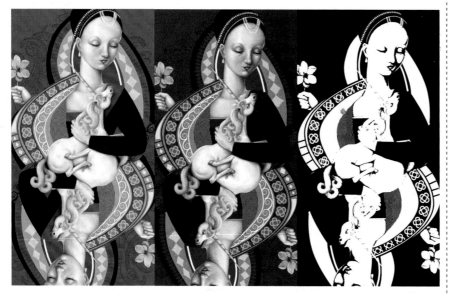

CMYK Grayscale Bitmap

 ## CREATING A NEW FILE IN PHOTOSHOP

Every piece of art must start somewhere, and, for most projects, it is a white piece of paper. To create a new file in Photoshop:

1. Select *Command/CTRL + N*.

2. Name your file in the Name field (Fig. 3A).

3. Change the dimensions and resolution (Fig. 3C) or choose one of the drop-down presets (Fig. 3B). I always work at a resolution of 300 dpi.

4. Make sure your color mode is set to *RGB* (Fig. 3D).

CREATING A NEW FILE IN PAINTER

To create a new file in Painter:

1. Select *Command/CTRL + N*.

2. Change the dimensions and resolution. I always work at a resolution of 300 dpi.

Note: Every new Painter file is by default set to RGB.

OPENING FILES IN PAINTER

Painter works only in RGB mode so CMYK and grayscale files that you open or import will immediately be converted to RGB. To open files:

1. Select *Command/CTRL + O*.

2. Navigate to the file that you wish to open and double click on it.

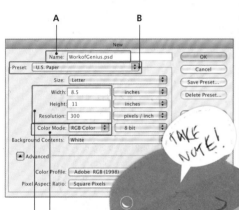

FIG. 4

OPENING FILES IN PHOTOSHOP

The two easiest ways to open files in Photoshop are:

A. Select *Command/CTRL + O* and navigate to the file that you wish to open.

B. Open Adobe Bridge. Choose the folder location of your file from the left-hand panel. Right-click on the file's thumbnail, select *Open With* and then Photoshop (Fig. 5).

QUICK TIP ADOBE BRIDGE

1 You can open multiple files by *Shift + clicking* on thumbnails.

2 If you find yourself navigating to the same folders in Bridge, you can create a "favorites folder" that will appear on the left-hand side for quick access. To create a favorites folder: Select *File > Add to Favorites*.

3 You can use Bridge to open files in Painter too. Just right-click on the thumbnail and choose *Open With*. Then navigate to the Painter application from the drop-down menu.

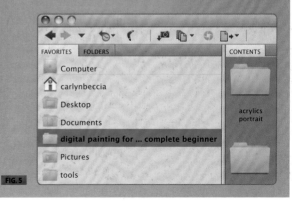

FIG. 5

02
PHOTOSHOP TOOLBOX

Photoshop has a very user-[...] you will probably find yourself using the same si[...] to seven menus. I find it helpful to close the menus that I don't use. All menus can also be docked and undocked by clicking on the tabbed top portion with their title and dragging it to a new location.

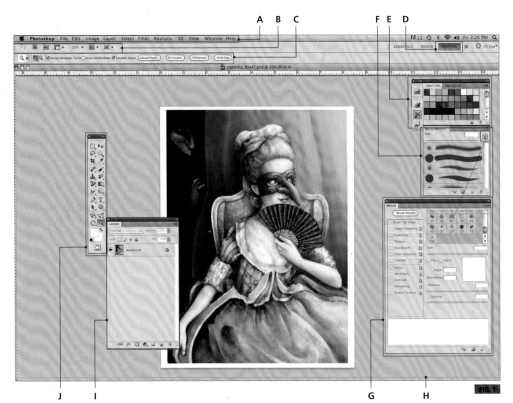

FIG. 1

D. Painting Workspace
If you are planning to mostly do painting in Photoshop, then switch to the Painting Workspace.

E. Swatch Panel
This is where you can quickly pick colors. Swatch panels can be customized by selecting the small right arrow to open up the *Preset Manager*.

F. Brush Presets
Contains a scrolling menu that allows you to choose your brush. Click on the small folder icon on the right-hand side and it will bring up the *Brush Presets* menu where you can further tweak your brush. (See p. 54 for more on Photoshop brushes.)

G. Brush Panel
Allows you to further customize any brush.

H. Document Window
Outlined in green here.

I. Layers Palette
Discussed more on p. 20–22.

J. Tools Menu
Discussed more on p. 17.

A. Menu Bar
The top-level bar that contains all the drop-down menus under each category. For example, selecting *Filter* in the Menu bar will drop down a list of possible filter options.

B. Application Bar
Controls how you will view your files such as the magnification, guides, and how your files stack next to each other. (Note: In Windows this is located to the right of the Menu bar instead of below it.)

C. Control Panel
Displays the options for each tool. The Control Panel will change depending on the tool you have selected. For example, selecting the *Zoom* tool gives you a set of options for zooming.

THE TOOLS MENU

Here is a brief description of the tools I most frequently use when painting [?]
on the small arrow beneath the icon, you can pull out more opt[?]
Also, when selecting any tool, the *Control Panel* (Fig. 10[?]
change, giving you a different set of options.

FIG. 2

1. **Move Tool**
 Moves a layer, selection or guide.

2. **Selection Tool**
 When you use this tool, you will see a dashed line around your selection. For more on selections, see p. 24.

3. **The Lasso Tool**
 Creates a freehand selection.

4. **Magic Wand**
 Used to make selections based on color.

5. **Crop Tool**

6. **Eyedropper Tool**
 Samples colors from your image. You can access this tool while you have your Brush selected by *Alt + clicking* while you paint.

7. **Spot Healing Brush Tool**
 Used for correcting small imperfections on photos.

8. **Brush Tool**
 For more on brushes, see p. 48.

9. **Stamp Tool**
 I use this tool to correct gaps or patterns that need to blend more seamlessly.

10. **History Brush Tool**
 I use this tool to paint back a filter performed on an earlier step.

11. **Eraser Tool**

12. **Gradient Tool**
 Used to create soft blends between colors for backgrounds.

12a. **Paint Bucket Tool**
 I use this tool to fill my background layer or fill selections.

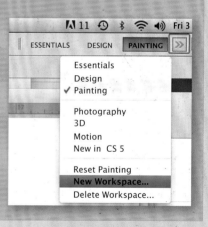

[?]es too much.

14a. **Dodge Tool**
 Lighten pixels.

14b. **Burn Tool**
 Darkens pixels.

14c. **Sponge Tool**
 Desaturates or saturates.

15. **Pen Tool**
 I most commonly use the pen tool to create more detailed selections but you are going to have to be familiar with vector drawing to use this tool correctly.

16. **Type Tool**

17. **Path Selection Tool**

18. **Shape Tool**
 All of the shape tools under this tool can create vector shapes or paths.

19. **3D Tools**

20. **Hand Tool**
 Use this tool to move an image around the document window.

21. **Zoom Tool**
 Magnifies an image. Press *Alt + click* to zoom out.

22. **Foreground Color**

23. **Background Color**
 Press the X key to switch between foreground and background colors.

24. **Quick Mask Mode**

FIG. 3

QUICK TIP
SAVING WORKSPACES

Once you have the panels and tools you most commonly use set into a comfortable position, you can save your workspace. Click the double arrow to the right of the Painting Workspace button and, from the drop-down menu, choose *New Workspace*. Name it and now that workspace will appear as a button in the *Applications* bar.

QUICK TIP

If you ever forget what a tool icon symbolizes, you can hold your pen over it and it will momentarily bring up "Tool Tips," telling you the name of the tool.

03
PAINTER TOOLBOX

Again, try not to be overwhelmed if this is completely new. I am going to break down these menus in more detail later. At this point, just familiarize yourself with the interface. Just like in Photoshop, menus can also be docked and undocked by clicking on the tabbed top portion with their title and dragging it to a new location. I also close menus that I don't use as often, but keep open:

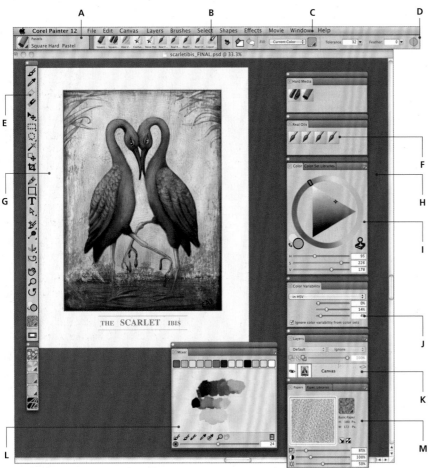

FIG. 1

D. Property Bar
Just like Photoshop's Control Panel, this palette displays the options for each tool and changes depending on the tool selected.

E. Toolbox
When a tool is selected, it is blue.

F. Custom Palettes
By holding down the *Shift* key while dragging a favorite Brush icon out of the *Brush Selector* (above) you can create custom toolboxes of favorite brushes for easy access.

G. Canvas
Your canvas is the area that you will paint.

H. Document Window
The document window contains the canvas area plus a gray background.

I. Colors Menu
Allows you to choose your colors based on RGB values or HSV values. (For more on choosing color see p. 42.)

J. Color Variability
Loads your brush with paint that varies different amounts of hue, saturation, or value. I use this option to create more painterly brushstrokes. Can also be changed to RGB values through the drop-down menu.

K. Layers Palette
Discussed more on p. 23.

L. Colors Mixer
Allows you to mix colors like traditional paint. (For more on mixing colors see p. 44.)

M. Paper Menu
I keep the *Papers* menu open because I like to vary the grain size, brightness, and contrast of my paper as I paint. (See p. 38 for more on papers.)

A. Brush Selector
Clicking on the arrow opens a menu of different brushes and their brush variants.

B. Recent Brushes
Quickly grab the last brushes used.

C. Menu Bar
Is the top level bar that contains all the drop-down menus.

THE TOOLS MENU

Here is a brief description of the tools I most frequently use when painting. Many of these tools work the same as Photoshop. As in Photoshop, by clicking on the small arrow beneath the icon, you can pull out more options for each of the tools. And, when selecting any tool, the Property Bar (Fig. 1A) will change, giving you a different set of options.

QUICK TIP
SAVING WORKSPACES

As in Photoshop, you can save workspaces in Painter. To save a workspace, select *Window > Workspace > New Workspace*. Name your workspace and now it will appear in the workspace drop-down menu under the Default option.

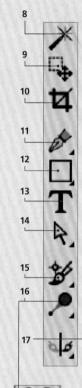

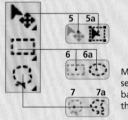

1. **Brush Tool**
 Use to paint.

2. **Dropper Tool**
 Samples colors from your image. You can access this tool while you have your brush selected by *Alt + clicking* while you paint.

3. **Paint Bucket Tool**
 Used to fill a selection or a layer with color or a pattern.

4. **Eraser**
 You can also just flip over your stylus and your Brush will switch to an Eraser.

Make selections based on these shapes

5. **Layer Adjuster**
 Used to select and move a layer. Similar to Photoshop's Move tool.

5a. **Transform Tool**
 Used to move, scale, rotate, distort or skew a layer.

6. **Rectangular Selection Tool**

6a. **Oval Selection Tool**

7. **Lasso Tool**
 Creates a freehand selection.

7a. **Polygonal Selection Tool**
 Allows you to draw your using fixed points.

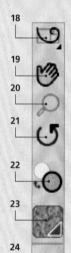

8. **Magic Wand**
 Used to make selections based on color

9. **Selection Adjuster**
 Scales and moves a selection without affecting the pixels that are contained within that selection. You can switch to the Layer Adjuster tool by pressing *Command/CTRL* while this tool is selected.

10. **Crop Tool**

11. **Pen Tool**
 Creates vector objects using curves and straight lines.

12. **Rectangle Shape Tool**
 Creates vector squares and rectangles.

13. **Text Tool**
 Creates text.

14. **Shape Selection Tool**
 Edits the vectors drawn with the Rectangle Shape tool or Pen tool.

15. **Cloner Tool**
 Used to clone patterns and painting. Always defaults to the last cloner brush used.

16. **Burn Tool**
 Darkens highlights, midtones, and shadows.

16a. **Dodge Tool**
 Lightens highlights, midtones, and shadows.

17. **Mirror Painting**
 Paints in symmetrical halves.

17a. **Kaleidoscope Mode**
 Paints in symmetrical kaleidoscope.

18. **Divine Proportion Tool**
 Guides to help create a composition based on classical measurements.

19. **Hand Tool / Grabber**
 Moves an image around the document window.

20. **Magnifier Tool**
 Zoom in on an image. *Alt + click* to zoom out.

21. **Rotate Page**
 Allows you to rotate your canvas in the same way you would reposition your paper while drawing.

22. **Color Selector**
 The top color shows your main color. The bottom color is your secondary color. You can switch these by clicking on the arrows in between them.

23. **Paper Selector**
 Allows you to choose a paper texture from the Paper Library.

24. **View Mode**
 Toggle between Full Screen and Windowed view.

04
LAYER BASICS

Ps Application
PHOTOSHOP

Using Layers is much like going shoe shopping because they give you the flexibility to "try on" different looks without making a commitment. Layers also allow you to stack images on top of each other in the same way that different colored sheets of cellophane could be stacked. You can move the stacking order simply by selecting the layer and dragging it, or combine different blending modes (Fig. 1.1 and p. 22) and opacities (Fig. 1.2). Here are the layer attributes I most often use when painting:

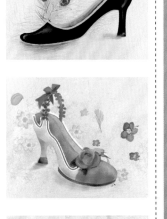

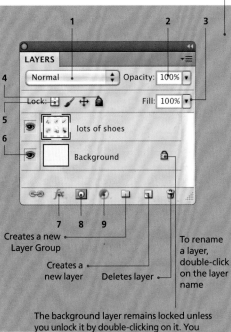

Creates a new
Layer Group

Creates a
new layer Deletes layer

7 8 9

To rename
a layer,
double-click
on the layer
name

The background layer remains locked unless you unlock it by double-clicking on it. You can still paint on this layer in its locked state but you cannot move this layer on top of other layers until it is unlocked.

FIG. 1

LAYERS

1. **Blending Modes:** Changes how layers interact with each other. I use these to alter color.

2. **Opacity:** Controls the transparency of the entire layer. I use this to make one part of an image show through beneath another image.

3. **Fill:** Controls the opacity of the layer but NOT the layer effects outside of its fill.

4. **Lock Layer:** Completely locks the layer so that you cannot edit it. I often use this for finished portions of an image that I don't want to accidently edit.

5. **Lock Transparency:** This allows you to paint on that layer, but not on the transparent areas. I use this when I want an object to have sharp edges.

6. **Show/Hide icon:** Clicking the eyeball icon will turn the layer's visibility on and off. I use this to "try on" different looks.

7. **Layer Effects:** These are the special effects areas of the layers ⟨...⟩ese for co⟨...⟩hes.

8. **Lay⟨...⟩** ⟨...⟩ you to ⟨...⟩ge while pro⟨...⟩ to is⟨...⟩ to ma⟨...⟩

9. **Adjustment Layer:** Allows nondestructive color changes to any layer beneath it. It is "nondestructive" because you can later delete the Adjustment Layer and the layers beneath it will return to their previous state.

LAYER MAGIC: EDITING TRANSPARENCY

LAYER MASKS

Layer Masks are an easy way to make parts of your image disappear, but unlike an eraser, you have the flexibility to paint parts back in. To work with layer masks:

1. In the *Layers* menu, click the *Layer Mask* icon (Fig. 2). Note: you cannot apply a layer mask to a background layer.

2. To erase part of your image, hit the D key to set your foreground color as black and paint on your image with your Brush or Pencil tool.

3. To paint back parts of your image, hit the X key to set white as your foreground color and paint on your image with your Brush or Pencil tool.

4. To erase or paint back your image using varying levels of transparency use gray.

FIG. 2
With all layer masks, painting with black hides the layer while painting with white shows the layer.

TRANSPARENCY

Every time you add a new layer, that layer is transparent until you paint something on it.

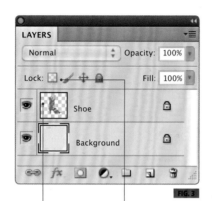

Transparency is indicated by a gray-and-white checkered pattern.

If you select the Lock Transparency icon then you can paint on this layer but not where it is transparent.

OPACITY VS. FILL

The difference between the layer opacity and fill can be confusing without an example. In the image to the left, I have applied a layer effect (Fig. 1.7) of a one-point outside stroke. If I lower the fill then my shoe is partially transparent, but the stroke around it is not because the stroke is outside the filled portion of the image.

LOCK TRANSPARENT

I painted a bluish pattern on the background layer. The shoe image sits on top of the background in the shoe layer.

When the *Lock Transparent* icon is turned off, I can paint on the transparent areas and the image areas of the shoe layer.

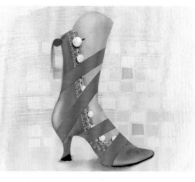

When the *Lock Transparent* icon is turned on, I cannot paint on the transparent areas of the shoe layer. This is helpful when you want a sharp edge to an object or simply don't want to paint outside an object.

GETTING COMFY WITH BLEND MODES

When you change a layer's *Blend Mode*, it combines with the layer beneath it to produce a different color. Try to think of these blend modes in painting terms: blend modes change an image's hue, saturation, or value (what Photoshop calls lightness). There are ? in Photoshop, but I only use the following:

Normal

When a layer is set to *Normal* it will not change how it interacts with the layer beneath it, unless the opacity is lowered. Lowering the Normal layer's opacity allows the layer beneath to show through. The default for every new layer is Normal.

Screen

Screen does the opposite of *Multiply*. It takes the lightest colors in a layer and multiplies them by the lightest color in the layer beneath it. If the colors are pure black, they are left unchanged. I use this mode to lighten values.

Hard Light

Either multiplies or screens colors blended between two layers if they are greater than or less than 50% gray. The effect is usually a little too strong, so I always lower the opacity of a *Hard Light* layer. *Hard Light* is one of my favorite blend modes because it is like taking your colors and shooting them through with light. (Think of it as having Monet over your shoulder.) It pushes your values either darker or lighter getting them out of that blah middle zone.

Multiply

Multiply takes the darkest colors in a layer and multiplies them by the darkest colors in the layer beneath it. If the colors are pure white, they are left unchanged. I use this mode to darken values.

Overlay

Multiplies and screens the colors blended between two layers if they are greater than or less than 50% gray. I frequently use *Overlay* set to 50% gray to increase contrast.

Soft Light

Soft Light applies a light tint. I sometimes use *Soft Light* to create atmospheric perspective in backgrounds.

Color

Color takes the hues and saturation from the layer and blends it with the layer beneath it while ignoring value. I use this mode for colorizing paintings. You can also use this mode if you are using a Grisaille method of painting and apply a color layer over your dark to light values. (For more on Grisaille, see p. 46.)

PAINTER'S LAYERS MENU

Painter's layer menu is very similar to Photoshop.

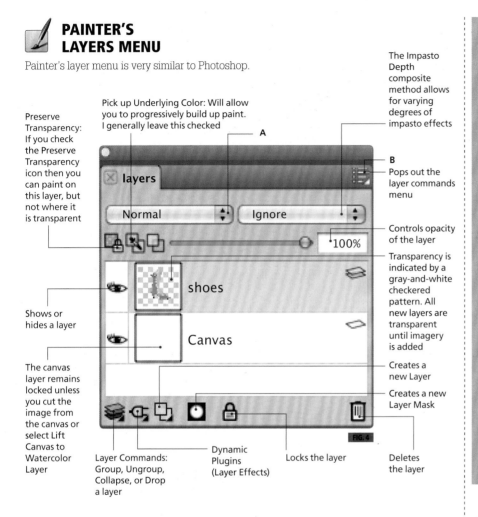

Pick up Underlying Color: Will allow you to progressively build up paint. I generally leave this checked

Preserve Transparency: If you check the Preserve Transparency icon then you can paint on this layer, but not where it is transparent

The Impasto Depth composite method allows for varying degrees of impasto effects

A

B — Pops out the layer commands menu

Controls opacity of the layer

Transparency is indicated by a gray-and-white checkered pattern. All new layers are transparent until imagery is added

Shows or hides a layer

Creates a new Layer

Creates a new Layer Mask

The canvas layer remains locked unless you cut the image from the canvas or select Lift Canvas to Watercolor Layer

Layer Commands: Group, Ungroup, Collapse, or Drop a layer

Dynamic Plugins (Layer Effects)

Locks the layer

Deletes the layer

FIG. 4

THE LAYER COMMANDS MENU

Selecting the right arrow in the *Layers* menu (Fig. 4B) reveals a drop-down menu where you can perform several common layer functions. For example:

To Merge two layers together: *Shift + click* on the layers that you want to merge together and then select *Collapse Layers*.

To Flatten all your layers down to one layer: Select *Drop All*.

To Drop one layer down to the canvas layer: Select the layer you want to move to the canvas layer and then select *Drop*.

To Group layers: *Shift + click* on the layers that you want to group and then select *Group Layers*.

To Delete a layer: Click on the layer that you want to remove and select *Delete Layer*.

To add a Layer Mask: Click on the layer that you want to add a mask to and then select *Create Layer Mask*.

COMPOSITE METHODS

Instead of blend modes, Painter calls the way a layer interacts with the layer beneath it "Composite Methods" (Fig. 4A). Painter's composite methods are compatible with Photoshop's blend modes with the exception of:

- Gel
- Colorize
- Reverse-Out
- Shadow Map
- Magic Combine
- Pseudo Color
- Gel Cover

If you use these composite methods and open the document in Photoshop, the closest blend mode will be substituted. (For example: Gel becomes Multiply which is nearly identical.)

QUICK TIP

Your canvas layer by default will always remain locked. Sometimes, you will need to lift this layer to a new layer. The quickest way to do this is to select *Command/CTRL + A* to select all and then using the *Layer Adjuster* tool, click anywhere inside your document. This will automatically put your canvas on the top layer.

05
MAGICAL MASKS & SELECTIONS

UNDERSTANDING SELECTIONS

During the painting process, I often have to make changes by isolating one area from another. Usually it is to adjust the saturation or color of the background. Sometimes I need to rearrange objects to fix composition problems. This is where selections and masks become invaluable.

Ps Application
PHOTOSHOP

LASSOING PIXELS

Photoshop has several selection tools, but I prefer the *Lasso* tool (Fig. 1B) and the *Quick Selection* tool (Fig. 1C). The Lasso tool "draws" the boundaries of your selection while the Quick Selection tool "paints" it in, and as it works like a brush it can be made

larger and smaller. Your selection is indicated by a dotted line (called "marching ants") and becomes editable. Once a selection is made, you can move, scale, rotate, distort, or paint in the content area, without affecting the content that is outside of your selection.

ADJUSTING YOUR SELECTIONS

Once you choose the lasso or shape selection tool, you will see options to modify those tools in the control panel.

A. New Selection
B. Add to Selection
C. Subtract from Selection
D. Intersect with Selection

E. A larger number blurs the edges of a selection for a softer edge
F. Always keep checked for smoother transitions

I prefer to use the keyboard shortcuts to adjust a selection. With the *Lasso* tool still selected you can:

1. Subtract from your selection:
 hold down the *Alt* key
2. Add to your selection:
 hold down the *Shift* key
3. Intersect your selection:
 hold down the *Shift + Alt* keys

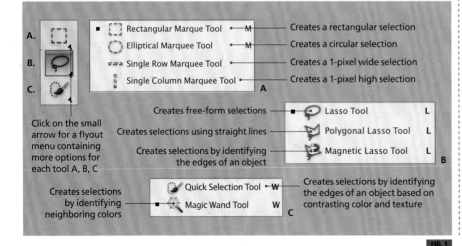

Rectangular Marque Tool M	Creates a rectangular selection
Elliptical Marquee Tool M	Creates a circular selection
Single Row Marquee Tool	Creates a 1-pixel wide selection
Single Column Marquee Tool	Creates a 1-pixel high selection

A. B. C.

Click on the small arrow for a flyout menu containing more options for each tool A, B, C

Creates free-form selections — Lasso Tool L
Creates selections using straight lines — Polygonal Lasso Tool L
Creates selections by identifying the edges of an object — Magnetic Lasso Tool L

Creates selections by identifying neighboring colors — Quick Selection Tool W / Magic Wand Tool W

Creates selections by identifying the edges of an object based on contrasting color and texture

FIG. 1

UNDERSTANDING LAYER MASKS

In Chapter 4, you learned the basics of layers and what a layer mask looks like, but here is a review:

When you are working on a layer mask, you will see a black outline around it in the layers palette. Masks are always represented in grayscale

FIG. 2

If you have ever worked with masking mediums in watercolor painting or friskets in airbrushing then you are probably familiar with how masks work. Masks basically give you the ability to protect one part of an image while you alter another part of an image. But unlike traditional painting methods, both the layer mask and the masked area can be edited. Masks are always indicated in grayscale. The parts of the mask that are black hide that layer's content while the parts of the mask that are white keep the layer's content visible. The parts of the mask that are gray make the layer's content partially visible. As an easy reminder, think of masks in terms of light: Black blocks out all light; white lets light in; gray lets varying levels of light in. Just like any grayscale image, a mask can be created with a paint brush, fill, or gradient, giving you control over their shape and most importantly their transparency.

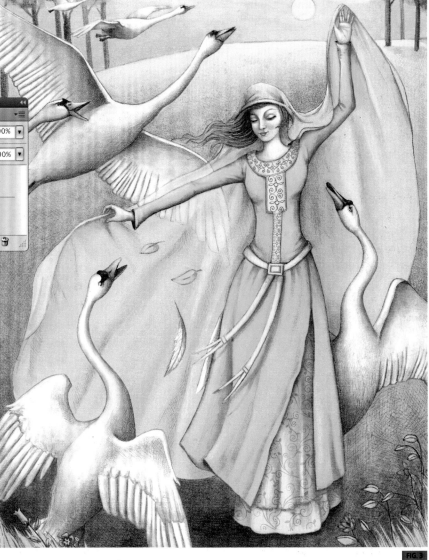

FIG. 3

The Six Swans
This was created with Painter's pastel and pencil brushes. The masking and color correction was done in Photoshop. See the tutorial on p. 27 to learn how to isolate and color correct your painting.

CREATING A MASK

There are two ways to add a Layer Mask:

A. Choose *Layer > Layer Mask > Reveal All* or *Layer > Layer Mask > Hide All.* If you choose *Reveal All* your mask will start with a white fill (making the layer visible). If you choose *Hide All* your layer mask will start with a black fill (making the layer invisible).

B. Select the *New Layer Mask* icon at the bottom of the *Layers* palette (Fig. 2). This will fill your mask with white.

CREATING DIFFERENT MASKS

I added a layer mask to the image with pure black. The black portion of the mask makes those areas of my image have a 0% transparency while the white areas have a 100% transparency.

I added a layer mask to the image with a gradient blend. This mask has gray areas letting portions of my image show through depending on the darkness of the gray.

I added a gray-filled mask, and then with the mask selected, I chose **Filter > Sketch > Conte Crayon** to create a canvas texture. You can apply filters to a mask and edit them any way you can edit a grayscale image.

FIG. 4

USING SELECTIONS AND MASKS TO ADJUST A BACKGROUND

In *The Six Swans*, I felt that the background needed a slightly warmer hue to look more natural. I needed to edit the background pixels, without altering the foreground objects.

STEP 1: MAKE A ROUGH SELECTION

I usually make selections as a rough basis for what will become a mask, so the first step in isolating the evil queen and her swans from the background is to make a rough selection.

1. Select the *Quick Selection* tool.

2. Paint with the *Quick Selection* tool highlighting the areas of your selection. If you need to add to the selection, choose the *Add to Selection* tool from the *Control Panel* (Fig. 6A). If you need to subtract from the selection, choose the *Subtract from Selection* tool from the *Control Panel* (Fig. 6B).

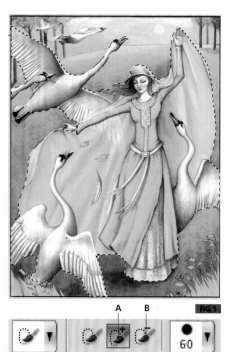

A B FIG. 5

FIG. 6

FIG. 5
The *Quick Selection* tool does a great job choosing foreground objects even against a background of a similar color. The selection is indicated by the dashed line.

FIG. 6
Instead of using the tools below, you can hold down the *Shift* key while you paint to add to a selection and hold down the *Alt* key while you paint to subtract from a selection.

STEP 2: TURN THE SELECTION INTO A MASK

Once a rough selection is in place, I turn that selection into a mask.

1. Duplicate the image that will be adjusted by dragging the layer onto the *New Layer* icon or choosing *Layer > Duplicate Layer*. Name this layer "background adjusted."

2. With the background adjusted layer selected, choose *Select > Inverse* to select the background instead of the foreground.

3. Add a mask to the background adjusted layer by selecting the *New Layer Mask* icon. The layers palette now shows a black and white thumbnail. Remember that all the black areas are protected while the white areas are ready to edit.

4. Next I selected the layer instead of the layer mask (Fig. 7). (You will see the left-hand side thumbnail outlined if you have selected it.)

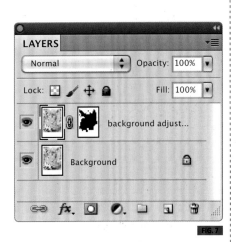

FIG. 7

FIG. 8
A higher fuzziness selects more of the sampled color, while a lower fuzziness selects less of the sampled color.

STEP 3: CORRECT THE COLOR

Now I can freely edit the background without affecting the foreground.

1. Choose *Image > Adjustments > Replace Color.*

2. In the *Replace Color* dialog box, I chose the *Color Sample* tool (Fig. 8A) and clicked on a bright green color in the background of my image. I increased the fuzziness to 200 to select all of the green (Fig. 8B).

3. The color I sampled will now show up in the color window (Fig. 8C). I then changed the hue to a warmer color, lowered the saturation, and increased the lightness. (Fig. 8D). Select *OK.*

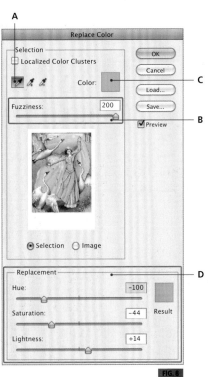

FIG. 8

 Application
PAINTER

PAINTING WITH SELECTIONS

With Painter's selection tools, you can paint inside or outside of a selection or simply ignore the selection without turning it off and having to reload it. Using selections this way can be helpful if you are doing cartoon or cell painting, or if you simply want a sharp edge to a color. To paint using selections:

1. Select the *Lasso* tool (Fig. 9A) and trace the outline of your figure. Make sure the *Anti-Alias* button is checked (Fig. 9B). To modify the selection choose the *Add to Selection* (Fig. 9C) or the *Subtract from Selection* (Fig. 9D) tool in the *Property Bar*.

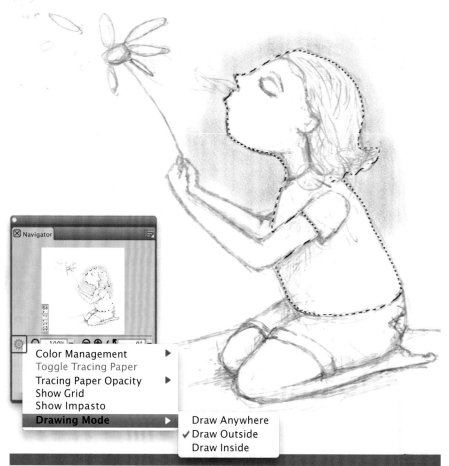

FIG. 10

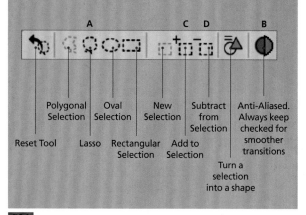

FIG. 9

PROPERTY BAR

Similar to Photoshop, the *Property Bar* changes when you choose this group of selection tools.

A C D B

Reset Tool

Polygonal Selection

Lasso

Oval Selection

Rectangular Selection

New Selection

Add to Selection

Subtract from Selection

Turn a selection into a shape

Anti-Aliased. Always keep checked for smoother transitions

PAINTING CHEAT SHEET

Draw Inside:
Allows painting inside a selection.
Draw Outside:
Used for painting in the background or to paint the inverse of a selected object.
Draw Anywhere:
Used to ignore the selection without losing it.

2. Click on the little gear symbol in the *Navigator* window (*Window > Navigator*), select *Drawing Mode* and then *Draw Outside* (Fig. 10).

3. Choose the brush of your choice and paint in the background. Because *Draw Outside* is selected, you will only be able paint the parts that are outside of your selection.

4. Switch to the *Draw Inside* option and paint in the foreground figure.

5. If you want a softer edge, switch to the *Draw Anywhere* option to ignore your selection.

CREATING A MASK IN PAINTER

Masks in Painter work almost identically to Photoshop's masks. Again, painting in black hides the content in a layer while painting with white allows the layer content to be visible. There are two ways you can add a layer mask. First create a new layer, as you cannot create a mask on the canvas layer.

A. Select the *New Mask* icon at the bottom of the *Layers* palette.

B. Select *Layer > Create Layer Mask.*

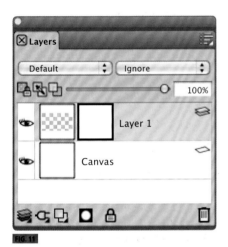

FIG. 11

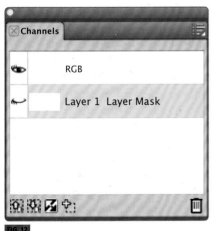

FIG. 12

FIG. 11
To edit a mask (the second square), select it in the *Layers* palette. You will see a thicker, black outline around the mask to indicate you have selected it.

FIG. 12
Similar to Photoshop, every time you save a selection or create a new mask, it appears in the *Channels* palette.

NOTE: You cannot create a mask on the canvas layer.

QUICK TIPS SELECTION

Like in Photoshop, any time you make a selection in Painter it is temporary. If you close the file, the selection is lost, unless you saved it. To save a selection:

1. Choose *Select > Save Selection.* From the *Save To* dialog box choose *New*. That selection will now appear in the *Channels* palette (Fig. 12).

2. When you want to access the selection at a later date, simply choose *Select > Load Selection.*

To hide the selection while keeping it still active, select *Shift + Command/CTRL + H.*

⬆ Use the *Selection Adjuster* tool to move a selection without effecting its content.

06
TAMING THE COLOR BEAST

Application
PAINTER/PHOTOSHOP

In the beastly world of digital painting there are two words guaranteed to make most people weep like an abandoned baby: *color management*. You have two choices. You can either brood over your printouts with endless lamentations of "but it didn't look like that on screen" or stop your whining and learn color management.

To start, you will need a basic understanding of digital color. Hold on tight. I promise to make this slightly less painful than a root canal.

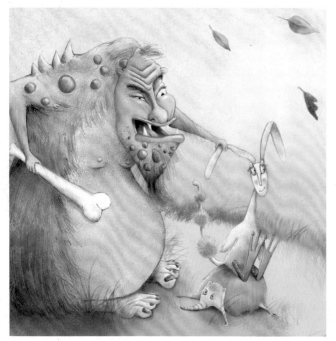

The Garump
Created with Painter's Digital Watercolors.

FIG. 1
Combining red, green, and blue results in pure white light.

FIG. 2
CMYK: that darkness is absorbing all the light.

UNDERSTANDING COLOR

Digital images are made up of millions of tiny dots called pixels. On your monitor, each pixel is composed of three dots which are assigned a color value of red, green, and blue, called RGB. The RGB color model is an additive color model, meaning if you combine red, green, and blue you will get pure white light (Fig. 1). The RGB color space has about 16 million colors. RGB is the Santa Claus of color. It promises big, but delivers . . . well, let's just say that I am still waiting for that pony.

Now meet CMYK—RGB's evil twin. This is the color model that all offset printers use. It stands for cyan, magenta, yellow, and black. (The K is the black, which is added to the inks to darken every color.) CMYK is a subtractive color model, meaning it absorbs light (Fig. 2). The CMYK color gamut is about 55,000 colors . . . pretty tiny compared to the promises of RGB.

Here comes the reality slap: The range of colors you see on your monitor is much larger than the range of colors your printer can produce. And here's another; your computer monitor, scanner, printer, camera, or any other device that captures color has

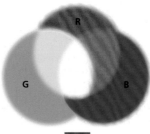

FIG. 1

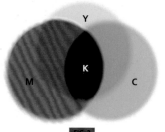

FIG. 2

its own color space so every single device interprets RGB values differently. This is called "device-dependent color," which is techie jargon for "we can't make color consistent between devices." Fortunately, there is a way you can tame the color beast.

STEP 1: CALIBRATE YOUR MONITOR

Monitor calibration is the process of bringing your monitor's colors to a standard brightness and color depth without any color casts in gray tones. Most operating systems walk you through the steps making it quick and painless. Make sure to leave your monitor running for about an hour before beginning these steps. Your monitor need to warm up to show the most accurate color.

MONITOR CALIBRATION

For Windows 7 Users:

1. From the *Control Panel*, Select *Appearance and Personalization > Display.*

2. Select *Calibrate color* in the left-hand menu (Fig. 3).

3. The Wizard will walk you through the steps.

For Mac OS X Users:

1. From within your System Preferences (*Apple > System Preferences*), select *Displays* and then click the *Color* tab (Fig. 4A).

2. Click the *Calibrate* button (Fig. 4B).

3. Answer the questions in the *Display Calibrator Assistant.*

Once you have calibrated your monitor, it will create an ICC monitor profile. Your profile characterizes your monitor, meaning it describes how your monitor "sees" color. But don't confuse calibration with characterization. Think of monitor calibration as teaching your monitor how to speak a language while ICC profiles translate that language so that other devices (like your printer and other monitors) will understand it.

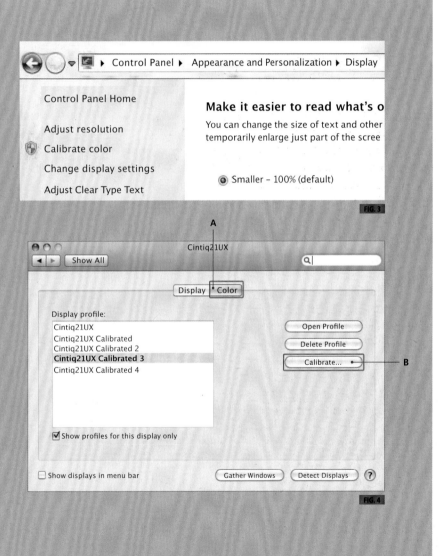

Application
PHOTOSHOP

STEP 2A: PHOTOSHOP'S COLOR SETTINGS

Once you have established your monitor profile from Step 1, Photoshop converts this profile into a document profile called a "working color space" or "working color profile." Long ago, The International Color Consortium got together and decided that they would standardize these color spaces to define the range of colors your monitor can see. Using the language analogy, think of working color spaces as the amount of words your monitor knows in its color language. The most popular ones are sRGB, Adobe RGB, and the more recent ProPhoto RGB, used by professional photographers.

The default working color space for Photoshop is set to sRGB. This is a great working space if you are a web designer because it is a much smaller color space designed to only show consistent monitor color. Continuing the language analogy, it's similar to avoiding big words when teaching a child how to speak.

If your output is for professional printing then sRGB is not so great. Here are the steps for a better working environment, assuming your goal is professional illustration output:

1. In Photoshop, select *Edit > Color Settings.*

2. From the RGB drop-down menu, change the settings to *Adobe RGB (1998)* (Fig. 5A).

3. Unless you are located outside of the U.S., leave the default CMYK drop-down menu to U.S. Web Coated (SWOP). This is the standard specifications for separations using U.S. ink. If you are in contact with your offset printer, select Load CMYK instead. Then navigate to the printer profiles provided by your printer (Fig. 5B).

4. Leave the Gray and Spot settings to the default Dot Gain 20%.

5. Now you need to establish a policy for how to manage color profiles. In the *Color Management Policies* menu (Fig. 6A), I recommend keeping the default setting of *Preserve Embedded Profiles* but under *Profile Mismatches,* check *Ask When Opening* and *Ask When Pasting* (Fig. 6B). Now, when you open

a document or paste in a file with a different profile from your working profile, Photoshop will give you a choice of keeping the document's profile intact or changing it to your working profile. The reason why I check *Ask When Opening* is because if someone sends me a file with an sRGB profile, I will want to convert that particular file to my working space. But if they use ProPhoto RGB I would just leave it alone. Either way, I want the option to make that decision.

6. Under *Missing Profile,* check *Ask When Opening* (Fig. 6C). Once in a while you will receive files from people who have turned off their color management settings in Photoshop. Remain calm. Not everyone has the brilliant color management skills that you do. If you have checked this option, then you have the choice of assigning your working profile or a different profile (you might be feeling vengeful and want to send their file back with the SDTV PAL color space).

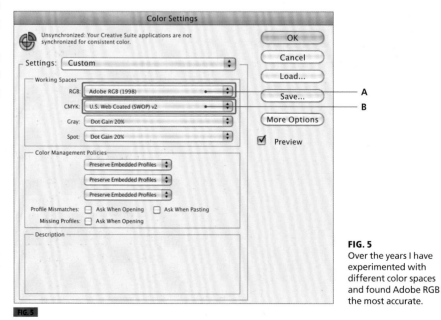

FIG. 5
Over the years I have experimented with different color spaces and found Adobe RGB the most accurate.

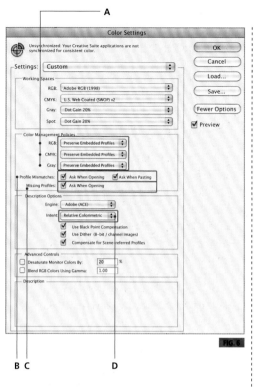

A

B C · · · D

FIG. 6

Application
PAINTER

STEP 2B: PAINTER'S COLOR SETTINGS

The good news: You are done with Photoshop. The bad news: You have to repeat the process for Painter. The better news: Painter's Color Management settings are so similar to Photoshop that this should look familiar. Here are the steps to set up a working profile in Painter:

1. Select *Canvas > Color Management Settings*.

2. Similar to Photoshop, change the *Default sRGB Profile* to *Adobe 1998* (Fig. 7A).

3. Keep the *Default CMYK Conversion Profile* to *U.S. Web Coated (SWOP) V2* (unless you live elsewhere, in which case pick the equivalent).

4. Keep the default *Color Profile Policies* of *Use embedded profile*, but also check *Ask When Opening* for both *Mismatch Profiles* and *Missing Profiles* (Fig. 7B).

5. Then change the *Rendering Intent* to *Relative Colorimetric*.

6. Click *OK*.

QUICK TIP
CMS DEVICES

If color management is keeping you up at night, you can purchase fancy monitor calibration devices. These devices attach to your screen and measure your specific monitor's color display under your specific working conditions and then create an ICC profile for you.

7. Click on the *More Options* button to expand the dialog box.

8. Change the *Intent* setting to *Relative Colorimetric* (Fig. 6D). This setting really depends on how you work. Relative Colorimetric produces more accurate color results while *Perceptual* produces more accurate color relationships. I find Perceptual color works better for photographic images while Relative Colorimetric works better for illustrations.

9. Click *Save* and name your color profile.

Color Management Settings

Presets: Default (modified)

Default RGB Profile: Adobe RGB (1998) — A

Default CMYK Conversion Profile: U.S. Web Coated (SWOP) v2

Color Profile Policies:

RGB Images: Use embedded profile

Convert CMYK Images: Use embedded profile

Profile Mismatch: ☑ Ask When Opening
Profile Missing: ☑ Ask When Opening — B

Color Engine: Apple ICM

Rendering Intent: Relative Colorimetric

Cancel OK

FIG. 7

07
SCANNING & CLEANING SKETCHES

GETTING STARTED:
WAYS TO PUT YOUR SKETCH INTO YOUR COMPUTER

If you are making your sketch on paper or another natural media surface then you will need to transfer it to your computer before painting. Fortunately there are simple routes to choose from.

Flatbed Scanners
Flatbed scanners are the best tool to get 2D and even some 3D images into your computer. You don't need to buy a fancy scanner. Most scanners and even all-in-one printers give sufficient enough resolution.

Wacom Inkling
Wacom (www.wacom.com) offers a product called Inkling which automatically transfers your drawings into your computer by using a digital sketch pen.

Pressure Sensitive Tablets
Alternatively, you can skip sketching onto paper altogether and draw on your screen using a pressure sensitive tablet. These tools are made by a number of manufacturers and have come down in price considerably in the last few years.

CLEANING A SCAN

Unless you have a high-end scanner, most scanned sketches will be washed out or have some color tints that need to be removed.

1. Open your scan in Photoshop.

2. Open the *Layers* menu (*Windows > Layers*). Double click on your background layer and rename it "sketch."

3. From the main option bar select *Image > Adjustments > Desaturate.* By desaturating the image you will force the color artifacts out of your scanned sketch so that it has gray tones only.

4. In the *Layers* menu duplicate your sketch layer by dragging and dropping it on top of the *New Layer* icon (Fig. 1A).

5. Change the layer's *Blend Mode* from Normal to *Multiply* (Fig. 1B).

6. Select *Command/CTRL + E* to merge your "sketch copy" layer down to the sketch layer. You now should have one layer named "sketch."

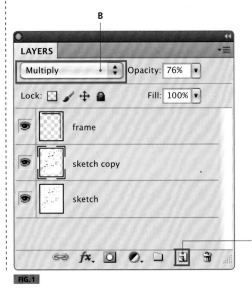

FIG. 1

 ## CLEANING A BAD SCAN

My scanner is so old that I really should get around to donating it to the Smithsonian. Often, my sketches will scan with ugly brown stripes that need to be removed. If you too have a scanner that you would like to drop kick out a high window, don't despair. You can pretty much clean up any image with the right tricks.

1. To remove scanner marks or color casts, select the offending area with your *Square Selection* tool. This will create marching ants around the area selected (Fig. 2). Note: If the whole image has a color cast to the background, you do not need to select anything.

2. From the main menu, select *Image > Adjustments > Levels* to open the Levels dialog box. Click the *Sample White Areas* icon (Fig. 3A).

3. Now, click on the selected area in your sketch that is leaving shadows or color casts and you will see them disappear. Select *OK*.

4. Deselect your selection (*Command/CTRL +D*).

FIG. 2

Final image

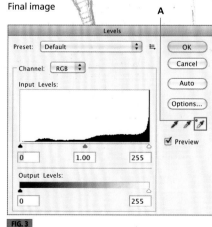

A

FIG. 3

CLEANING SCANS IN PAINTER

You cannot set a white point in Painter, but you do have the tools to quickly darken your scan and remove color casts.

1. Open your scan in Painter.

2. Under *Effects* select *Tonal Control > Adjust Color*.

3. Decrease the saturation slider enough to remove colors casts.

4. Increase or decrease the value slider to lighten or darken your sketch.

5. Select *OK*.

My line work is usually just a guide and will eventually be painted over. If you want to keep your line work in your painting, read "Coloring a Sketch" on the following page.

QUICK TIP

DARKEN YOUR LINES

Sometimes I need to duplicate several layers and set them to Multiply to get my lines dark enough. Follow the steps 4–6 in "Cleaning a Scan" if you want to darken the lines of your sketch.

08
COLORING
SKETCHES

There are two approaches for adding color to your sketches. Often you may want to keep your line work superimposed on top of your color for cartoons, watercolors, or more graphic work. Other times, you will use your sketch as a guide for where to paint.

 Application
PHOTOSHOP

COLORING A SKETCH

To color your sketch in Photoshop:

1. If the sketch is on the background layer, double click on it. Rename this layer "sketch" by clicking on its title in the *Layers* menu.

2. Create a new layer by selecting the **New Layer** icon at the bottom of the *Layers* palette. Name this layer "color." Select the color layer and drag it beneath the sketch layer (Fig. 1).

3. Select the sketch layer. Change its blend mode to *Multiply* (Fig. 1A). Now when you paint on the color layer, all the white in your sketch layer is knocked out (Fig. 2).

Pretty Polly
In this illustration, I wanted to keep my line work visible as I painted in color and patterns beneath it. I also tinted the lines a brown color to give them an old woodcut feel.

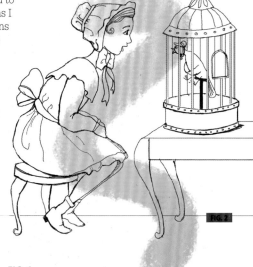

FIG. 1
If you are not scanning in a sketch, simply create a new layer above your background layer and set its blend mode to *Multiply*. All your line work will go on this layer.

FIG. 2
Multiply knocks out all the white in that layer. Now when you paint on the color layer only your black lines are visible.

 Application
PAINTER

COLORING A SKETCH

Coloring a sketch in Painter is very similar to Photoshop. To color your sketch:

1. If the sketch is on the canvas layer, select **Command/CTRL + A** to select all of the sketch.

2. Select the **Layers Adjuster** tool and click anywhere in the document window. This will automatically put your sketch in a layer above the canvas layer called "Layer 1."

3. Rename Layer 1 "sketch."

4. Change the sketch layer's composite method to **Multiply**.

TINTING A DRAWING

You may want to change the color of your lines to help your sketch blend in better with your paint. Other times, you may want your lines tinted to create a cooler or warmer mood.

Painter

1. Create a new layer above the sketch layer by selecting the **New Layer** icon.

2. Using the **Color Wheel** (**Windows > Color Palettes > Colors**) choose brown.

3. With the **Paint Bucket**, fill this layer with brown.

4. Change the brown tint layer's composite method to **Colorize.**

5. Select Layer 1 and the sketch layer by **Shift + clicking** on both. Then select the small right arrow in the **Layers** menu and choose **Collapse Layers**.

6. Change the new collapsed layer's composite method to **Multiply**.

Photoshop

1. Select the sketch layer and click on the fx icon. Check the **Color Overlay** option (Fig. 3) and set the blend mode to **Overlay**.

2. The default color overlay is medium gray. Click on the gray color box to pull up the **Color Selector** box. Select a brown color (Fig. 4).

3. Hit **OK**. Your lines will now be tinted brown (Fig. 5).

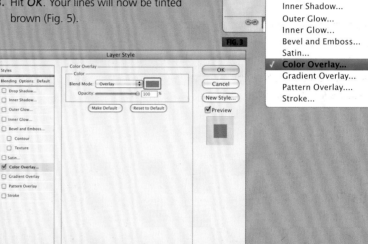

FIG. 3

FIG. 4

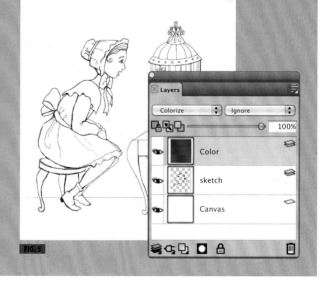

FIG. 5

09
CHOOSING YOUR PAPER

Application
PAINTER

Incorporating paper texture into your art can give it more depth. Unlike Photoshop where the texture must be part of a brush, in Painter, brushes are altered by your paper choice. But not all brushes react to paper in the same way. Just like traditional painting, the dry mediums of chalk, pastel, charcoal, and conte crayons pick up more paper texture than heavier mediums like oils. Generally, any time you see the word "Grainy" in the brush variant title or see a grain slider in the Property Bar, that brush will mimic paper texture.

TEXTURE CHEATS

In this painting of Henry VIII for *The Raucous Royals*, I used **Crackle** paper with the **Hard Pastel** brush to create an aged surface texture.

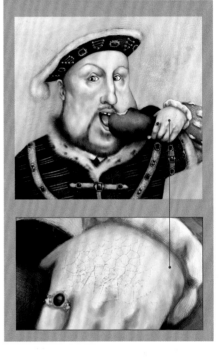

FIG. 1

THE GRAIN SLIDER

The grain slider in the Property Bar (Fig. 1) controls how much paper grain will show through. What can be tricky is that different brushes will need a higher grain to show more grain while other brushes may need a lower grain to show more of the paper. In the example (right), I have chosen the *Pond Scum* paper with different brush variants.

Pastel
The Square Hard Pastel
Grain = 9%
With dry media, the lower the grain the greater the paper texture. You can get more texture with these brushes.

Oils
Real Round
With oil brushes, you will not see an option for grain because the paper does not change the brush.

Digital Watercolor
Course Dry Brush
Grain = 100%
With wet media, the higher the grain the more paper texture. The texture is very subtle with these brushes.

CHANGING YOUR PAPER

There are two locations where you can change your paper.

A. Select the small thumbnail in the *Papers* library (*Window > Paper Panels > Paper*) and choose a new paper from the drop-down menu (Fig. 3B). The Papers library does give you a few more options, allowing you to change the size of the paper texture, the paper contrast, and the paper brightness.

B. In the *Tools* menu, select the paper thumbnail and choose a new paper from the drop-down menu.

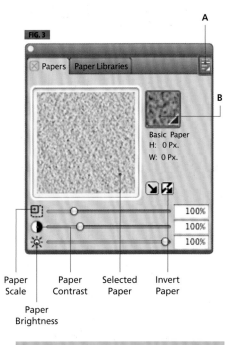

FIG. 3

Basic Paper
H: 0 Px.
W: 0 Px.

100%
100%
100%

Paper Scale · Paper Contrast · Selected Paper · Invert Paper

Paper Brightness

QUICK TIP
EXTRA PAPERS

You can find more paper libraries through the Corel Painter 12 product page. Click on the Resources tab and download the "Extra Content."

QUICK TIP
SAVING PAPER LIBRARIES

You do not need to save paper libraries in the Applications folder. You can save them anywhere, but you should get in the habit of saving all your papers in one location.

TO LOAD A PAPER LIBRARY

1. Select the *Paper Libraries* tab (*Window > Paper Panels > Paper Libraries*) and then the small right arrow to reveal the drop-down menu (Fig. 4).

2. From the drop-down menu, select *Import Paper Library* or *Import Legacy Paper Library*.

3. Navigate to the location of the papers you wish to load. Find the file and click open. Your new library will now appear in a separated tab beneath your default paper library (Fig. 4E).

ORGANIZING PAPER LIBRARIES

1. Once you load a new paper library, you can move a paper into a different library by simply holding down the *Shift* key while dragging its icon into a different library.

2. You can create a new library by selecting the *New Library* icon (Fig. 4B). Name the new library. Now you can add papers by holding down the *Shift* key while dragging a paper icon into your new library.

3. You can also create a new custom paper palette by selecting a paper icon and then holding down the *Shift* key while dragging it out of the *Paper Libraries*. The new paper palette will be named Custom + a number. You can then rename this palette by selecting *Window > Custom Palette > Organizer*. In the Organizer menu, select the new custom palette and then the *Rename* button.

4. To delete a paper: Select the paper icon in the library and then the *Trash Can* icon (Fig. 4C).

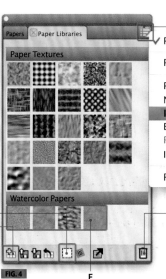

Papers · Paper Libraries

Paper Textures

Paper Control Panel
Paper Library View
Paper Libraries
New Paper Library...
Import Paper Library...
Export Paper Library...
Remove Paper Library...
Import Legacy Paper Library...
Restore Default Paper Library...

Watercolor Papers

FIG. 4

FIG. 4
If you find the *Import Paper Library* function does not work, use *Import Legacy Paper Library*.

MAKING YOUR OWN PAPER

You can make any file into a Paper. In this example, I stole my cat's corrugated scratchboard to make a textured paper. If you try this one at home, try not to get catnip caught in your scanner.

1. I opened the scanned image of the scratchboard in Painter (Fig. 5) and then chose *Effects > Surface Control > Woodcut*. I checked the *Output Black* option and unchecked the *Output Color* option. This filter will posterize your paper by pushing the black and white threshold (Fig. 6). (You can also use *Image > Adjustments > Threshold* in Photoshop too.)

2. I selected the paper (*Select > All*).

3. In the *Papers* library, I selected the *Capture Paper* icon (Fig. 4D, p. 39).

FIG. 6
The white areas will be the peaks of your paper while the blacks will be the valleys where the paint sinks into the paper. To invert the peaks and valleys, select the *Invert Paper* icon in the Papers palette.

4. I then named my paper "cat scratch fever." I increased the crossfade slider to the maximum amount. The crossfade controls how much the edges of my paper will blend.

5. In the *Papers* library (Fig. 3, p. 39), I played with my paper's scale, brightness, and contrast (see below).

PAPER SETTINGS

It is important to vary the paper settings as you paint or your paper will look too tiled. The following examples show the hard pastel brush on my new paper with different paper settings. In the Property Bar, I lowered the grain of my pastel brush to 9% to pick up the paper's texture.

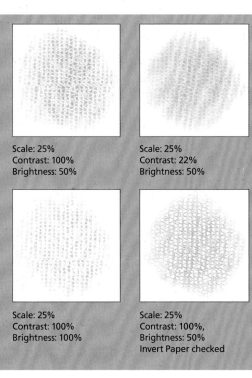

Scale: 25%
Contrast: 100%
Brightness: 50%

Scale: 25%
Contrast: 22%
Brightness: 50%

Scale: 25%
Contrast: 100%
Brightness: 100%

Scale: 25%
Contrast: 100%,
Brightness: 50%
Invert Paper checked

QUICK TIP
LAYING IN PAINT

With the dry media, each successive brushstroke covers more and more of the paper texture until it is opaque. If you keep the grain extremely low (less than 5%) then the paint will not build. The above example uses a square hard pastel brush with a grain of 15% on the Pond Scum paper. Each successive brushstroke builds up more and more paint until the paper is almost covered.

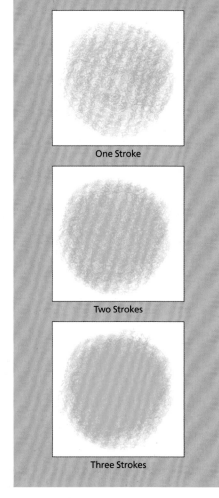

One Stroke

Two Strokes

Three Strokes

Application
PHOTOSHOP

MAKING TEXTURED PAPER

You can also make textured marks in Photoshop. For my cover for *Watership Down*, I used Photoshop to create a crosshatched brush with a little bit of paper grain.

1. Using the same corrugated scratchboard (Fig. 5), I opened the file up in Photoshop and chose *Edit > Define Pattern*. I named this pattern "cat scratch fever."

2. I created a new file (*File > New*) at 300 pixels wide and high.

3. I then drew four simple, scraggly lines using the Pencil tool (Fig. 7).

4. Next, I chose *Edit > Define Brush Preset* and named this "crosshatch."

5. Now, if I use this brush, it doesn't really look like crosshatching because the brush lacks direction and is only going up and down (Fig. 8). I have to tweak it slightly.

6. In the *Brush Presets* menu (*Window > Brush Presets*), I clicked the boxes for *Shape Dynamics* and changed the *Minimum Diameter* to 1%, the *Angle Jitter* to 17%, and the Angle Jitter's drop-down menu to *Initial Direction*. These settings make the lines cross depending on the direction of my hand.

7. In the *Texture* dialog box, I selected "cat scratch fever" from the drop-down menu (Fig. 9A). I changed the scale to 14% (Fig. 9B) and checked the box for *Texture Each Tip*.

8. Lastly, I checked the *Noise* box. My brush now makes textured crosshatching (Fig. 9C).

To make the snarly branches, I drew vector art in Adobe Illustrator. (You can also use Photoshop's vector tools.) For the bunnies, I used Corel Painter's Conte brushes on Sandy Pastel paper. I then added a layer of texture in Photoshop using the brush described in steps 1–8.

My crosshatch brush adds just the right amount of pencil scratches to the background, making it look more hand drawn.

FIG. 7

FIG. 8

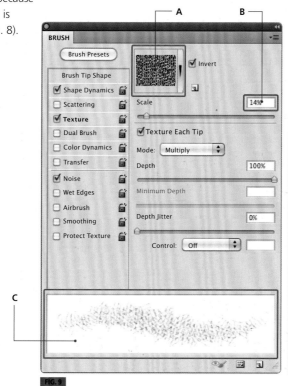

A B

BRUSH

Brush Presets

Brush Tip Shape
☑ Shape Dynamics
☐ Scattering
☑ Texture
☐ Dual Brush
☐ Color Dynamics
☐ Transfer
☑ Noise
☐ Wet Edges
☐ Airbrush
☐ Smoothing
☐ Protect Texture

☑ Invert

Scale 14%
☑ Texture Each Tip
Mode: Multiply
Depth 100%
Minimum Depth
Depth Jitter 0%
Control: Off

C

FIG. 9

10
PALETTE MIXING

MIXING COLORS:
THE MUNSELL METHOD

If Albert Henry Munsell (1858–1918) had his say, we wouldn't still be covering our walls in "robin's egg blue," "pea green," or, my personal favorite, "panther pink." Munsell believed in identifying colors numerically and not by meaningless names. He argued that if we define music by numbers and letters, color should be treated the same. In the Munsell color system, a color's value and chroma is numerically defined while its hue is given a letter combination. For example, a bright yellow-red would be defined as YR 7/10 with YR describing its hue, and 7 and 10 describing its value and chroma. Munsell may not have got his way when it comes to naming paint, but we still see remnants of the Munsell color system in digital painting programs where every color is defined by a number. Once you learn how value and chroma are defined, you will have a fool-proof method for applying color.

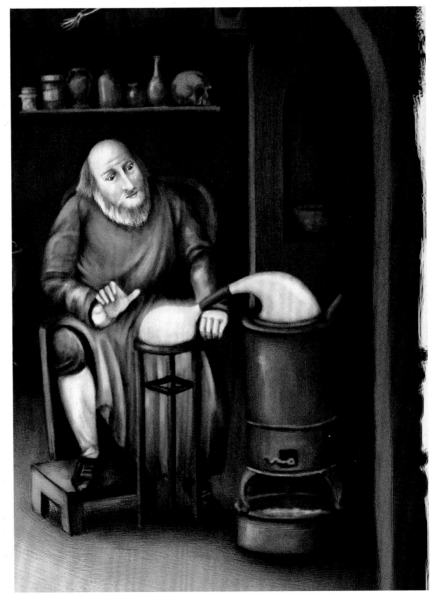

The Alchemist
Detail from I Feel Better with a Frog in my Throat. I created this painting using Painter's Real Media Brushes.

Hue

We are taught hue as children when we get our first box of crayons. Hue allows us to distinguish one color from another. In painting programs, hue is defined by RGB and CMYK. (For more on RGB and CMYK see p. 30.)

Value

Value is the scale of light to dark. In the RGB color mode, pure black is defined as 0 and white is 255.

Chroma

Chroma (or saturation) represents the purity of a color or the strength or weakness of a color. Baby blue has a lower chroma because it is more washed out than fire engine red.

Most people choose colors by hue and use the color sample tool to choose adjacent shades as they paint. If you choose color by hue instead of value, your painting may appear flat because you are always selecting the average of two colors instead of a full range of dark to light values. In the Munsell method, artists mix paint using a "value-based palette." Munsell attributed 80% of a painting's success to getting the correct values, 20% to chroma, and 0% to hue. This is also why so many artists do a value study in grays first, before applying color. You can use Munsell's understanding of color to mix your own digital paint.

FIG. 1 & 2
You can keep these two libraries together or pull them apart by selecting their tabs and dragging.

Application
PAINTER

SELECTING AND SAVING COLOR

In Painter's *Color* menu (*Window > Color Panels > Colors*), the triangle area allows you to choose a color based on value and saturation (Fig. 1). If you move the cursor down the values get darker. If you move the cursor right the saturation gets stronger. The outside ring controls the hue. Using the Munsell system, you should focus on the inside triangle and not the outside ring when applying your initial values. If you find a color that you like and want to add it to the *Color Set Library*:

1. Open the *Color Sets* menu (*Window > Color Panels > Color Sets*).

2. Click on the *Add to Swatches* button. This will add the color to the last color set you opened (Fig. 2B).

ORGANIZING COLOR

The *Color Set Libraries* contain your color swatches (Fig. 2). These are pretty small here, but you can make them larger by clicking on the small right triangle (Fig. 2A) and selecting *Color Set Library View* from the drop-down menu and then medium or large.

Every time you click on one of these swatches, your selected color changes in your Toolbox and your Color menu (Fig. 1A). To help organize color, you can drag colors between color libraries. You can also create an empty color set to add new colors into them by clicking the *New Library* button (Fig. 2C). Lastly, if you want to save a color set, select the *Export Library* button (Fig. 2D) and save it to a location on your hard drive. When you want to load this library at a later date, simply select the *Import Library* button (Fig. 2E).

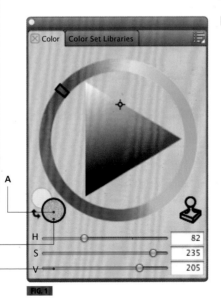

Selected color

Sliders control hue, saturation, and value.

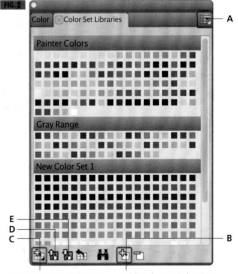

Creates a New Color Set Adds color to Color Set

CREATING COLOR STRINGS

Mixing colors in Painter is so similar to mixing colors traditionally that you may start to look for paint stuck in your fingernails. Painter uses a *Mixer Pad*—a small canvas area where you can mix paint and then dip your brush into it. To use the Mixer Pad:

1. Open the *Color* palette (*Window > Color Panels > Color*) and choose a starting light value.

2. In the Mixer Pad (*Window > Color Panels > Mixer*) select the *Apply Color* brush (Fig. 3B) and apply paint inside the Mixer window. I paint strings from light to dark using value as my guide.

3. Repeat steps 1–2 darkening the value as your paint. Make sure the *Dirty Brush Mode* (Fig. 3A) is selected. This tool will allow you to mix paint in a method very similar to using turpentine. Deselect the *Dirty Brush Mode* when you want to "clean" your brush to begin mixing a fresh color. You can also use your *Mix Color* brush (Fig. 3C) to smear paint together. This brush works like a palette knife.

4. Once you have mixed your colors, you can select a color by using the *Sample Color* tool (Fig. 3D) and begin painting on your canvas. You can also pick up multiple colors by selecting the *Sample Multiple Colors* tool (Fig. 3E and Fig. 4).

5. If you prefer to use swatches, you can create a color set from your Mixer Pad by selecting the small right arrow in the *Color Set* menu and choosing *New Color Set from Mixer Pad*.

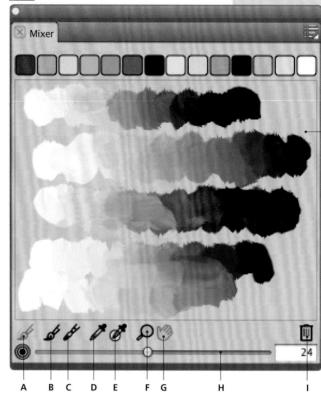

FIG. 3

A. Dirty Brush Mode
B. Apply Color
C. Mix Color
D. Sample Color
E. Sample Multiple Color
F. Zoom
G. Pan
H. Change Brush Size
I. Clear/Reset Canvas

FIG 9
My Mixer Pad may look pretty messy, but at least I do not have to worry about tracking paint through the house.

FIG. 4
If I set my brush to *Sample Multiple Color* (Fig. 3E), I can pick up more than one color at a time, just like in traditional painting.

SAVING YOUR MIXER PAD

The *Mixer Pad* keeps your paint until you click on the *Trash Can* icon (Fig. 3I). I can't tell you how many times I have had to go back and rework a painting only to find I had cleared my Mixer Pad and had not saved the old one. To save your Mixer Pad:

1. Click on the small right arrow in the *Mixer Pad* and select *Save Mixer Pad* from the drop-down menu. Name it, and keep it in the same folder as your painting file.

2. If you need these colors at a later date, in the Mixer Pad window click on the small right arrow and select *Load Mixer Pad* from the drop-down menu. You can then navigate to where you saved your file.

QUICK MIXER TIP

I usually change the background color of my Mixer Pad to match my painting's canvas. To change the background color, click on the small right arrow in the Mixer Pad window and from the drop-down menu select *Change Mixer Background*.

QUICK MIXER TIP

You can change the size of the Mixer by dragging its edges to make it bigger or smaller.

Application
PHOTOSHOP

SELECTING AND SAVING COLOR

Selecting colors in Photoshop is very similar to Painter. To select and save a color:

1. Select the small right arrow in the *Color* palette (Fig. 5A) and choose *HSB Sliders* from the drop-down menu options.

2. Slide the value slider (value is marked by the letter "B") until you get the desired light or darkness. You can also click on the color swatch (Fig. 5B) to bring up the *Color Picker* (Fig. 6) and then choose your color by moving your cursor around the window.

3. Once you have the color that you want, you can save it to your swatches. Click the *Add to Swatches* button (Fig. 7A).

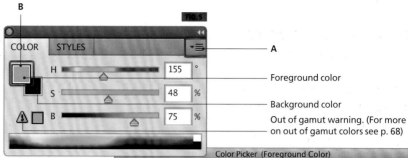

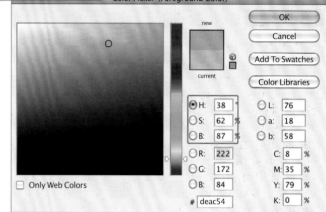

FIG. 5
Anytime that you want to set your foreground color to black, just hit the D key. To set your foreground color as white, hit the D and then the X key.

FIG. 6
The default setting is the RGB model allowing you to mix colors by red, green, and blue. Mixing colors this way makes it much harder to create a range of values. A better option is to change the settings to HSV (Hue, Saturation, Value).

MIXING PHOTOSHOP COLORS

Photoshop does not have a Mixer Pad, but you can open a blank canvas and create a separate file to mix colors:

1. Lay down a string of colors from light to dark using any brush.

2. In Photoshop CS5, you can then select the *Mixer Brush* from the *Tools* menu (found under the regular Brush tool).

3. Select the button for *Clean the brush after each stroke*. (Fig. 8A) Change the mix to 100% (Fig. 8B). These settings will act like turpentine running through the paint to blend the colors together.

ORGANIZING COLOR

Photoshop also comes with additional swatch palettes to replace the lousy standard default swatches. To load a new *Swatch Palette*:

1. Open the *Swatches* menu (*Window > Swatches*) (Fig. 7) and then click on the small right arrow. Select any of the swatch sets from the drop-down menu.

2. You can also save a swatch palette for later use. Click on the small right arrow in the *Swatches* menu and select *Save Swatches* from the drop-down menu.

11
PREPPING YOUR UNDERPAINTING

 Application
PAINTER

The color of the canvas will become the base for your mid-tones and will essentially be the glue that holds all of the colors together. Get this right, and you will have an easier time establishing a range of values.

QUICK TIP
GRISAILLE UNDERPAINTING

For centuries, artists created a grayscale painting on top of a warm gray tone and then added glazes of color, called Grisaille painting (pronounced gris-eye). You can paint in Grisaille digitally by creating a grayscale painting and then adding a layer above it with its Composite Method (or Blending Mode in Photoshop) set to Color. Keep your brush set to a low opacity to resemble glazes.

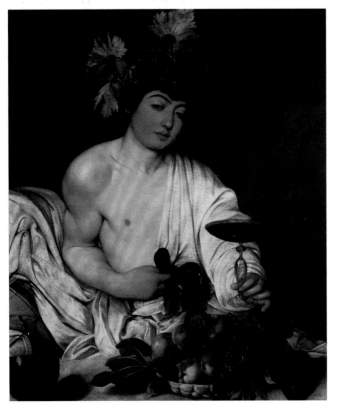

The Young Bacchus c. 1591–1599
Michelangelo Merisi, better known as Caravaggio (1571–1610), turned the art world on its head with his dramatic use of chiaroscuro—deep variations in light and shade. While most artists of the Renaissance painted on a light greenish-gray background, Caravaggio used a dark red-brown as his base. This base served as his mid-tones and he left it unpainted. He then used a single, dramatic light source and a limited palette of earth tones to define his figures.

STEP 1: SET THE TONALITY

1. If your sketch is on the canvas layer, select the canvas layer and then select all (*Command/CTRL + A*).

2. Click anywhere in the document with your *Layer Adjuster* tool. This will put the sketch on a new layer.

3. Name this layer "sketch" and set the composite method to *Multiply*.

4. Select *Window > Color Panels > Color* to bring up your color wheel. Select a base color by clicking anywhere inside the color wheel (Fig. 1).

5. Select the canvas layer beneath your sketch layer and select the *Paint Bucket* from your *Tools* menu. Fill your canvas with your chosen base color by clicking anywhere on your document. My painting is now a sketch overlaying a colored background (Fig. 2).

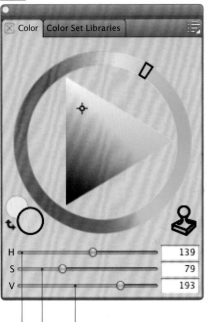

FIG. 1

Color | Color Set Libraries

H ————————— 139
S ————————— 79
V ————————— 193

Hue
Saturation
Value

FIG 2
Your base color will also set the mood for the painting. Is the painting going to be dark and somber? Then pick a brown. Is it going to be an outside scene brimming with light? Then pick a sunny yellow.

STEP 2:
APPLY A LIGHT SOURCE

Now we have to apply our light source. Think of this step as your visual reminder of where your light hits.

1. Start by opening the *Layers* menu and select your canvas layer.

2. Select *Effects > Surface Control > Apply Lighting*. There are several different presets that we can start with, but for this exercise, I have chosen the first box under the preview window—"Gradual Light" (Fig. 3).

3. Next, drag the wand's handle to where you want your light source to come from. If you accidentally click on an area outside the wand, this creates a new light source. If this happens, simply select the unwanted light source and hit delete on your keyboard.

4. Now we need to set the levels of light. Since this scene is in a theater, I set the elevation of the light source to 83 degrees, and increased the distance to 2.25, the spread to 29, and the brightness to 1.13. There isn't any magic to these numbers. Simply play around with the settings to match your painting.

5. Finally, click on the box labeled *Light Color* and this will bring up a color wheel. I chose a lime-ish yellow color. Repeat the same process for *Ambient Light Color* (I chose bright blue). Select *OK* (Fig. 4).

FIG 4
It may look like I am trying to bring back '80s fluorescent colors with this base color, but using green in an underpainting can create more realistic skin tones. Skin blocks the red wavelengths created from our blood and leaves its opposite color—a green tone. In fact, many of the Old Masters like Da Vinci and Michelangelo would create an underpainting in Verdaccio—similar to a Grisaille painting technique (see p. 46).

FIG. 2

FIG. 4

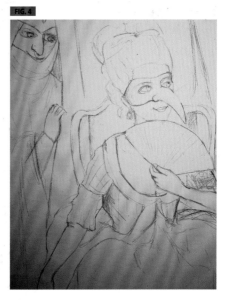

Apply Lighting

Brightness ————— 1.32
Distance ————— 2.34
Elevation ————— 83°
Spread ————— 29°
Exposure ————— 0.84
Ambient ————— 0.23

Preview Light Color... Ambient Light Color...

Gradual Da... | Gradual 2 | Splashy Col... | Blue Drama | Drama | Warm Globe

Center Spot
Lighting Mover...
Library Save Cancel OK

Gradual Light preset window

12
BRUSHES

Application
PAINTER

Imagine walking into a wholesale art store and you are given every art supply in the store . . . all at once. This is kind of what it's like to open Painter for the first time. You have an endless amount of choices and every brush can be customized to your heart's content. It can be a little overwhelming. But once you learn the basics, you will quickly see how much fun it can be to have all these art supplies at your fingertips (minus the noxious chemical smells).

FIG. 1
The **Brush Selector** menu contains endless options of brushes, but you will probably find that you use the same 5–10 brushes. To make life easier, hold down **Shift** while dragging the brush's icon out of the library. This will create a custom library containing your brush variant and all its settings. You can also reorder brushes by **Shift + dragging** them from within the **Brush Library**.

A crow sat on a willow tree,
Eating her tiffin of brie,
The fox below grinned up at her,
"Pretty crow, please sing to me."

"I never saw such grace,
As the curve of your jaw,
But is your regal bill,
As lovely as your caw?"

Crow puffed out her chest,
And arched her feathered back,
Opened her mouth to sing,

And lost
her
tasty
snack.

The Fox and Crow
was created with Painter's oil, acrylic, and impasto brushes. Unlike traditional painting, it is very easy to mix medias without destroying your painting.

STEP 1: PICK A BRUSH

1. The first step is to choose your **Brush Category** (Fig. 1A) from the **Brush Selector** menu. The brush categories are essentially your different mediums (e.g., oil, acrylic, pastels, watercolor, etc.). All of these can be found on the left-hand side represented by a brush icon.

2. The right-hand list contains the **Brush Variants** (Fig. 1B). These are variants of the medium that you have chosen. For example, if you chose the "Oils" brush category then you must next choose the variant of that category (e.g., Real Oil Short, Real Oil Smeary, etc.).

A. The top name is the **Brush Category**.

B. The bottom name is the **Brush Variant**.

C. The arrow expands the **Brush Selector** menu to a longer list showing all brushes.

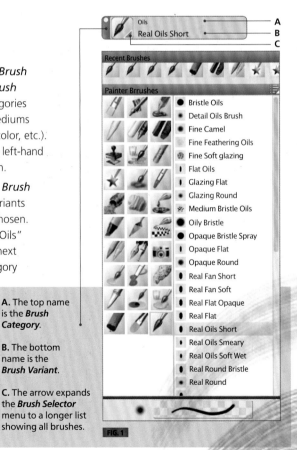

FIG. 1

STEP 2:
CUSTOMIZE YOUR BRUSH

The *Property Bar* (*Window > Property Bar*) lets you further tweak your chosen brush variant. You can alternatively access the same settings through the *Brush Controls* (*Window > Brush Control Panels*).

Controls the amount of bristles. A higher number will have less bristles or act like a very stiff brush.

This button sizes the bristles in proportion to the brush's size.

Controls how much the paint blends with neighboring paint. Similar to adding linseed oil to traditional paint to thin it.

Property Bar

FIG. 2

29.0 100% Feature: 3.5 Blend: 55%

Resets the brush Draws straight lines Size Opacity

FIG. 2
The *Property Bar* is where you can quickly adjust the main features of your brush variant. The right-hand settings will change depending on the brush selected.

BRUSH CALIBRATION

For more control over your paintbrush, you can alter the *Brush Calibration* settings (*Window > Brush Control Panels > Brush Calibration*). The Brush Calibration detects the speed of your hand and also alters the shape of the stroke depending on the pressure of your hand.

DAB PROFILE

The *Dab Profile* controls the shape of your brush. Just like traditional painting, a brush's shape is a very personal choice so I encourage you to experiment making marks before beginning a painting.

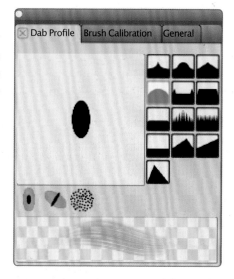

Dab Profile Brush Calibration General

☑ Enable Brush Calibration
Veolocity Scale: 65.14
Velocity Power: 3.17
Pressure Scale: 0.67
Pressure Power: 2.23

Dab Profile Brush Calibration General

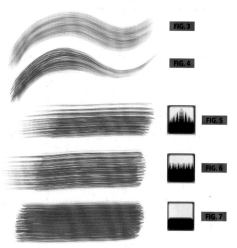

FIG. 3

FIG. 4

FIG. 5

FIG. 6

FIG. 7

FIG. 3
The stroke without any brush calibration.

FIG. 4
The *Pressure Scale* and *Velocity Power* increased. Now, if I use a lighter pressure, the stroke gets thinner.

FIG. 5
I use *The Pointed Rake Profile* for more textured marks.

FIG. 6
The *Flat Rake Profile* is my general brush. It again makes a textured mark with a little less of a pointy trail off.

FIG. 7
I use the *Soft Round Profile* for more detailed areas and to create smoother color.

STEP 3
CUSTOMIZE YOUR COLOR

The *Color Variability* (*Window > Brush Control Panels > Color Variability*) allows your brush to pick up varying degrees of hue, saturation, and value. This makes the brushstrokes look more like traditional paint straight from the tube. I usually choose *In HSV* from the drop-down menu (Fig. 8).

FIG. 9

FIG. 10

FIG. 11

Controls the kind of color loaded onto the brush.

FIG. 8

Color Variability

in HSV

0% — Hue
0% — Saturation
15% — Value

☑ Ignore color variability from color sets

I leave this checked unless I am loading the brush with a color set.

FIG. 9
The hue and saturation increased to 30%. The brush now picks up red and green at the same time. I would use these settings for backgrounds or more abstract art.

FIG. 10
The hue, saturation, and value set to 0%. The brush paints with one flat color. This is fine but doesn't have the energy of Fig. 11.

FIG. 11
The value increased to 15% with saturation and hue set to 0%. This is my preferred setting. Now, the brushstroke looks more textured because it picks up varying degrees of shadow and light.

QUICK TIP
SAVE YOUR BRUSH

Once you create a brush variant that you like, click on the small right arrow in the *Brush Selector* and choose *Save Variant* (Fig. 12A). Then name your variant. Your variant will then be added within that brush category.

✓ Recent Brushes
✓ Dab and Stroke Preview

Category Display
Variant Display

Capture Dab
Capture Brush Category
Brush Library

Save Variant...
Set Default Variant
Delete Variant...
Copy Variant...

Restore Default Variant
Restore All Default Variants

● Bristle Brush
Captured Bristle
● Clumpy Brush
Clumpy Thin Flat
● Dry Bristle
Dry Brush
Glazing Acrylic
● Grainy Dry Brush
Opaque Acrylic
Opaque Detail Bru
Real Dry Flat
Real Long Bristle
Real Wet Brush
Soft Grainy Brush
Thick Acrylic Bristle
Thick Acrylic Flat
Thick Acrylic Round
Thick Opaque Acrylic
Wet Acrylic
● Wet Brush
Wet Detail Brush
Wet Soft Acrylic

FIG. 12

A

If you decide that you have made a mess out of a brush, you can return to the original brush by choosing *Restore Default Variant*.

Painting from a Gradient

You can also set Color Variability to paint from a gradient.

1. Open the *Gradients* library (*Window > Media Library Panels > Gradients*) and choose a gradient.

2. In the *Color Variability* menu select *From Gradient* (Fig. 13).

Color Variability

from Gradient

±H 0%
±S 0%
±V 0%

☑ Ignore color variability from color sets

FIG. 13

FIG. 14

FIG. 14
The Real Fan Short Brush with Color Variability set to *from Gradient* and the *Water Lily Flower* gradient selected.

Painting from a Color Set

Lastly, you can chose *From Color Set* and your brush will paint with whatever colors are in your color set (Fig. 15).

Color Set Libraries

flesh tones

FIG. 15

FIG. 15

FIG. 15
The Real Fan Short Brush with Color Variability set to *from Color Set*. I often use this color set to shadow areas of a face with flesh tones and a slight amount of blue.

ADD A BRUSH VARIANT TO A LIBRARY

You can also add a favorite brush variant to a preexisting library. Try not to get too crazy with brush variants. Large libraries tend to slow Painter down.

1. Close Painter.

2. Copy your brush variant files. These must contain a .jpg, .xml, .nib, and .stk file. Locate the *Painter Brushes* folder:

 MAC: Users > [User Name] > Library > Application Support > Corel > Painter 12 (X) > Default [or custom workspace name] > Brushes > Painter Brushes

 Windows XP: Documents and Settings > [User Name] > Application Data > Corel > Painter 12 (X) > Default [or custom workspace name] > Brushes > Painter Brushes

 Windows 7 or Vista: Users > [User Name] > AppData > Roaming > Corel > Painter 12 (X) > Default [or custom workspace name] > Brushes > Painter Brushes

3. Inside the *Painter Brushes* folder, paste the .jpg, .xml, .nib, and .stk file into the appropriate brush library. Note: They must be put inside a brush category library (Fig. 16).

4. Open Painter. This brush variant will now be loaded under the appropriate brush category.

FIG. 16

Once you create a brush variant inside Painter, it will be saved in the brush category in which you created it. You can now copy these files and send them to friends to use. Just remind them that they must save the brush variant files to one of Painter's Brushes folders to work.

LOADING A BRUSH LIBRARY

If you are feeling really greedy and think you don't have enough brushes already, you can also load a customized brush library into Painter. These brush libraries will appear as a new brush category. Before adding your new brush category, make sure that the brush's folder contains a .xml, .nib, and .stk file and outside the brush folder you must have a 30 x 30 .jpg file.

1. Close Painter.

2. Copy the brush folder and the .jpg file.

3. Paste the files into the *Painter Brushes* folder based on your operating system (Fig. 17):

 MAC: Applications > Corel > Painter 12 (X) > Brushes > Painter Brushes

 Windows XP: Program Files > Corel > Painter 12(X) > Brushes > Painter Brushes

 Windows 7 or Vista: Program Files (x86) > Corel > Painter 12 (X) > Brushes > Painter Brushes

4. Open Painter. These brushes will now appear as a new brush category.

FIG. 17

Brush Category folder within Painter Brushes folder

UNDERSTANDING WATERCOLORS
REAL WATERCOLOR VS. WATERCOLOR

Painter 12 has three *Watercolor* brush categories. These are: *Real Watercolors*, *Digital Watercolors*, and *Watercolors*. Real Watercolors behave more like traditional watercolors, but unless your computer is powerful enough to launch missiles, these brushes paint slower than most. Watercolors are a bit faster (depending on the brush variant), but create less of a wet-on-wet look. Digital Watercolors work more like Photoshop brushes, but allow for slightly more control. Another category called Real Wet Oils creates translucent paint similar to Water Soluble Oil paints. I use a combination of these brush categories.

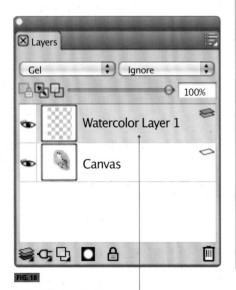

FIG. 18

Watercolor Layers are marked by a dripping water symbol. You can also create a new Watercolor Layer by clicking on the small right arrow and selecting **Create New Watercolor Layer**.

This painting was created using Painter 11's Runny Wash Bristle, the Wash Brush, and the Bleach Splatter Brush. Collage elements were added in Photoshop. Some of my favorite brushes are no longer available in Painter 12, but you can load them by clicking on the small right arrow in the Brush Selector and choosing Painter 11 Brushes (Fig. 19).

FIG. 19

IMPORTANT: You cannot use Painter 11 brushes and Painter 12 brushes at the same time. If you want to use both, you must keep alternating between the Painter 11 and Painter 12 brush library.

Every time you use the Watercolor or a Real Watercolor brush, Painter creates a special layer above your canvas called a "*Watercolor Layer.*" You can only use these brushes on Watercolor Layers. Watercolor, Digital Watercolor, and Real Watercolor Layers will also always have a composite method of *Gel*. If you change it to any other composite method, you will get an ugly white outline around your brushstrokes.

MY FAVORITE WATERCOLOR BRUSH VARIANTS

Wet-on-Wet
The *Wet-on-Wet Paper* brush found in the Real Watercolor brush category creates traditional wet-on-wet techniques. In the Real Watercolor Controls keep the viscosity at 100% and the wetness at 100% to get the maximum amount of pooling at the edges.

Dry-on-Dry
With the *Dry-on-Dry* brush found in the Real Watercolor brush category, I am able to pick up more of the paper texture. Lower the roughness of your paper if you want this brush to go on smoother.

Tinting
I use the *Soft Diffused Brush* found in the Digital Watercolor category for glazing over colors. I often put glazes on a separate layer so that I can lower the opacity afterwards.

Splattering
For splattering, I prefer the *Bleach Splatter* under the Watercolor category. This brush has a runny quality to it that is very similar to traditional splatters.

Detail brush
I use the *Dry Brush* variant found in the Digital brush category for more detailed areas. I prefer the default variant of 100% grain, 0 diffusion, and 10% wet fringe.

Blending
The *Pure Water* brush variant in the Digital Watercolor category does just what it promises—adds pure water to your paint stroke to diffuse and lighten them. I use this brush for softening backgrounds to give a sense of atmospheric perspective.

Erasing
My favorite way to erase watercolors is with the *Wet Eraser Brush* found in the Digital Watercolor category. This brush resembles watercolor paint lifted off the paper with water instead of just merely erased paint.

Salt
In traditional watercolor paintings, using salt gives you either "happy accidents" or tragic accidents. The digital version of the brush is predictable but does give you some nice textural effects. I use the *Salt* brush found in the Digital Watercolor category and always lower the opacity.

Flat washes
For skies and landscapes I prefer the *Runny Wash Bristle* found under the Watercolor category. This brush picks up the texture of the paper beautifully (this paper is Artists' Canvas). Unfortunately, you are going to need a computer that can slice DNA or the patience of a saint to deal with these processor-intensive brushes. I have neither so I use this sparingly.

Sponges
I like to use the *Glazing Sponge* brush found in the Sponges category for trees and clouds. It works great as a glaze to dither two colors together, so the edges of the colors blend into each other. You can also set the color to white and use it like a sandpaper to bring back the white of the paper.

Application
PHOTOSHOP

BRUSHES IN PHOTOSHOP

Photoshop also has enough brushes to keep you experimenting for years, and every brush can be customized into endless possibilities. Start by understanding the basic tools. Every time you choose your Brush tool from the Toolbox, the *Property Bar* changes to the following settings:

FAVORITE BRUSH SETTINGS:

Brush Tip Shape: This is the main control panel for your brush that controls the shape of your brush tip and the spacing of the brush.

Shape Dynamics: Controls the variance of your shape.

Texture: Picks up a "pattern" texture as you paint.

Dual Brush: Combines the settings of two brushes.

Color Dynamics: Varies saturation, hue, and brightness of color as you paint.

Noise: Blurs the edges of (or "dithers") your brush.

Wet Edges: Creates a watercolor effect pooling the paint at the edges.

BRUSH TOOL PRESETS

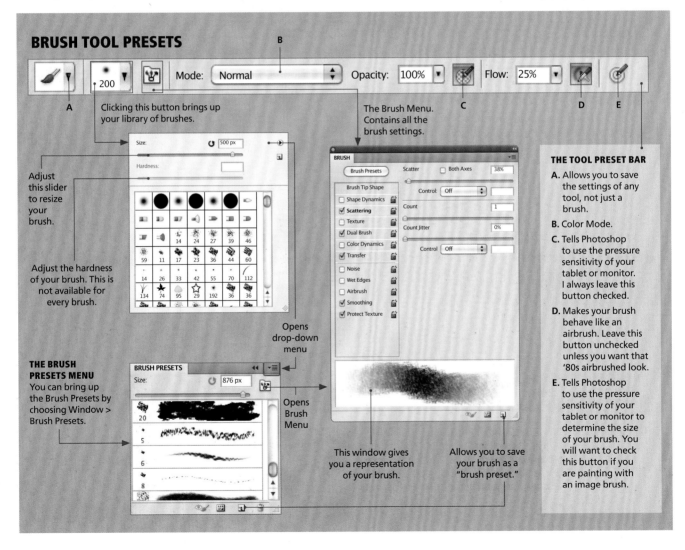

A. Clicking this button brings up your library of brushes.

B. The Brush Menu. Contains all the brush settings.

Adjust this slider to resize your brush.

Adjust the hardness of your brush. This is not available for every brush.

Opens drop-down menu

THE BRUSH PRESETS MENU
You can bring up the Brush Presets by choosing Window > Brush Presets.

Opens Brush Menu

This window gives you a representation of your brush.

Allows you to save your brush as a "brush preset."

THE TOOL PRESET BAR

A. Allows you to save the settings of any tool, not just a brush.

B. Color Mode.

C. Tells Photoshop to use the pressure sensitivity of your tablet or monitor. I always leave this button checked.

D. Makes your brush behave like an airbrush. Leave this button unchecked unless you want that '80s airbrushed look.

E. Tells Photoshop to use the pressure sensitivity of your tablet or monitor to determine the size of your brush. You will want to check this button if you are painting with an image brush.

CUSTOMIZING A BRUSH

In this example, I am going to take the simplest Photoshop brush (the Hard Round Brush) and show how you can customize it.

1. Open the *Brush* menu (*Window > Brush*) and choose the *Hard Round Brush* (Fig. 20A).

2. Highlight the *Brush Tip Shape* (Fig. 20B).

3. Change the size to around 8 px (Fig. 20C) and check the button for *Spacing* (Fig. 20D). Now drag the spacing slider to around 300%. This will spread out the brush, creating a stippling effect.

4. Save the brush by clicking on the *New Brush Preset* button (Fig. 20E). Name your brush "stipple brush" and click *OK*.

5. Make some marks with your new brush varying the pressure of your hand.

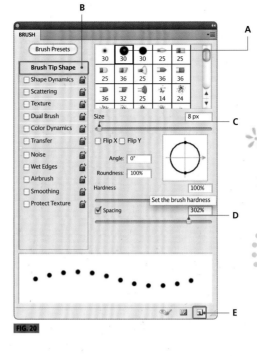

FIG. 20

FIG. 21
The stipple brush applied to a doodle. You could use this same technique to make a brush look like stitching by using a dash instead of a dot.

FIG. 21

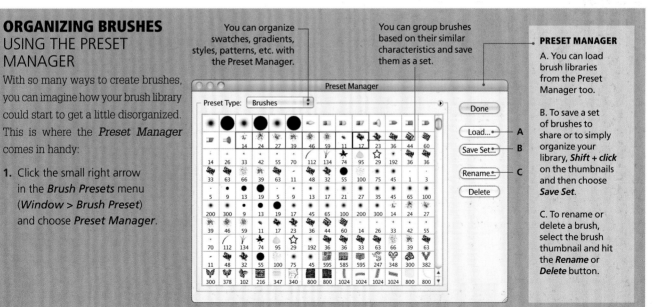

ORGANIZING BRUSHES
USING THE PRESET MANAGER

With so many ways to create brushes, you can imagine how your brush library could start to get a little disorganized. This is where the *Preset Manager* comes in handy:

1. Click the small right arrow in the *Brush Presets* menu (*Window > Brush Preset*) and choose *Preset Manager*.

You can organize swatches, gradients, styles, patterns, etc. with the Preset Manager.

You can group brushes based on their similar characteristics and save them as a set.

PRESET MANAGER

A. You can load brush libraries from the Preset Manager too.

B. To save a set of brushes to share or to simply organize your library, *Shift + click* on the thumbnails and then choose *Save Set*.

C. To rename or delete a brush, select the brush thumbnail and hit the *Rename* or *Delete* button.

MAKING A BRUSH FROM AN IMAGE

In Photoshop you can quickly create a brush out of any image. In this example, I created a distressed brush from a scanned texture.

1. To make this brush, I took one of my many rejection letters (you get a lot in publishing) and wrinkled it up. Then I turned the paper over and scanned it (Fig 22).

2. Next I selected *Image > Adjustment Levels* and moved the black and white point sliders (these are the end sliders) towards the middle to increase the contrast (Fig. 23).

3. I made a circular selection around an area with a lot of texture using my circle selection tool.

4. Unless you want a hard edge to your brush, you must feather the selection by choosing *Select > Modify > Feather*. I entered 30 px. Hit *OK* (Fig. 24).

5. I turned the selection into a brush by selecting *Edit > Define Brush Preset* and named the brush "rejection grunge." Hit *OK*.

6. Lastly, to add a bit more texture to the brush, I selected the texture option in the *Brush* menu (*Window > Brush*) and chose *Dirt* from the drop-down menu under the thumbnail.

NOTE: If you have not previously loaded the Dirt texture, click on the texture thumbnail and then the small right arrow. Choose Rock Patterns from the drop-down menu.

FIG. 22

FIG. 24

FIG. 23

FIG. 25

FIG. 24
You can also choose the square selection tool to create a blockier brush.

FIG. 25
My new textured brush has just the right amount of angst.

LOADING BRUSHES

Photoshop comes with additional brushes containing everything from Wet Media to Special Effects.

These brushes are not loaded into Photoshop by default. To load extra brushes:

1. Click the small right arrow in the *Brush Presets* menu (*Window > Brush Presets*) and choose any of the extra brush libraries from the bottom part of the menu.

2. When asked if you would like to "Replace Current Brushes" choose *Append*, unless you want your whole library replaced with the new set.

You can also load other artists' brushes. To load an additional brush library:

1. Click the small right arrow in the *Brush Presets* menu (*Window > Brush Presets*) and choose *Load Brushes*.

2. Navigate to the location that the brushes are saved on your computer. Select the brush file (it should have the extension .abr) and hit *Open*.

FEATURED ARTIST MATT DIXON: TEXTURED PHOTOSHOP BRUSHES

www.mattdixon.co.uk
mail@mattdixon.co.uk

FIG. 1
PotBelly

FIG. 2
King Pellinore

FIG. 3
Introversion

"Digital art first caught my imagination as a child in the days of 8-bit home microcomputers, though I'm not entirely sure that the collages of ASCII characters and pixel doodles coded in BASIC could really be labeled "art." Thankfully, three decades of progress since that time means digital artists now have rather more sophisticated tools at their disposal and the ability to create custom brushes is one of the most powerful of all. Your brush really is the point at which you and your chosen software meet—the interface between your brain and your virtual canvas—so the importance of selecting the right brushes cannot be overstated. My preference is for irregular, textured brushes that produce interesting marks. These shapes build up into surface texture as the painting progresses, which helps give the finished piece life and added depth."

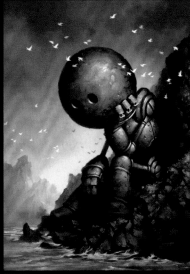

FIG. 3

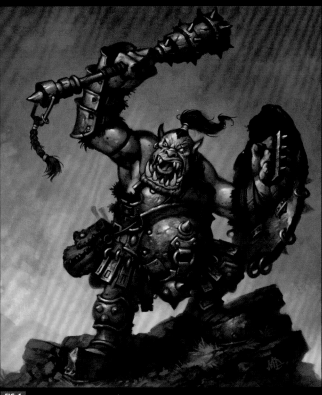

FIG. 1

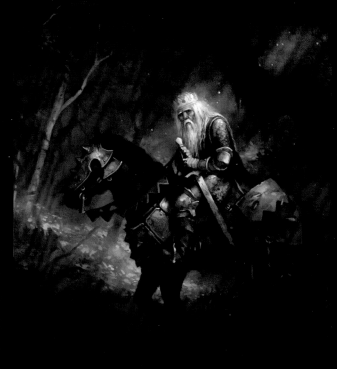

FIG. 2

13
DIVINE PROPORTION

 Application
PAINTER

After I had completed my sketch for the Portrait of Drama tutorial (p. 116), I realized that the composition was pretty boring. Every painting goes through this stage. I call it the ugly baby stage, where your painting resembles something only a mother could love. What is important is that you don't give up. Instead, take a step back and think about how the eye moves around the canvas and if the characters are in harmony with each other. One of the best ways to re-evaluate your composition is to apply a trick from the Renaissance masters: divine proportion.

Divine proportion is sometimes referred to as the Golden Proportion, Golden Number, or, if you are a real geek, the Fibonacci Series. This golden number is 1.6180339887 and is called Phi (pronounced fi . . . like fly). The best way to visualize it is through a diagram that demonstrates the ratios (above). The diagram is formed from a large rectangle. Inside it is another rectangle that has an exact ratio of 1:1.618. Inside that rectangle is another rectangle with a perfect ratio of 1:1.618 and so on and so on.

Divine proportion can be found in everything from the Ancient Egyptian pyramids, the Parthenon, and classical music to the symmetrical curves in a sea shell. Divine proportion is a tool that many artists naturally incorporate into their art and don't even realize they are doing it. For the rest of us, Painter has the *Divine Proportion* tool to whip our compositions into mathematical beauty.

EXAMPLES OF DIVINE PROPORTION

The golden ratio can be seen in many examples of nature such as a peacock's plumage or the curves of a sea shell. Leonardo da Vinci was especially obsessed with the mathematics of art and nature. His Vitruvian Man is a perfect example of divine proportion along with his most famous portrait, the *Mona Lisa*.

FIG. 1

USING DIVINE PROPORTION IN PAINTER

The *Divine Proportion tool* forces your eye to see where the most interesting areas of your composition should fall and makes you more aware of how the empty space frames your composition. In music, this is called the "build up." In art we call it the "negative space." The term "negative space" makes it sound like it is unimportant, but this space is essential for framing the drama.

1. In my first sketch, the figures are crowded next to each other so that the composition feels weighted to the right. There really isn't any negative space to lead your eye into the drama either. The Divine Proportion tool tells me that the most interesting areas of the sketch are getting lost.

2. In my second sketch, I placed Scaramouche over Colombina's left shoulder and draped a curtain behind Colombina to delineate the foreground to background relationship. Now the eye moves to her mask and the curve of her fan frames her face to keep the viewer on my focal area.

PAINTER'S DIVINE PROPORTION TOOL

1. In the *Menu* toolbar go to *Window > Composition Panels > Divine Proportion*.

2. Check the box for *Enable Divine Proportion*. This will create an overlay of non-printing guides over your canvas.

FIG. 4

3. You can now alter your Divine Proportion tool to match your composition by changing the orientation, size , and rotation (Fig. 4). Alternately, you can also select the Divine Proportion tool in the Toolbar and manually move it around the canvas.

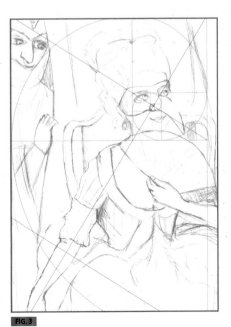

FIG. 2

FIG. 3

14
LINEAR PERSPECTIVE

Ps Application
PHOTOSHOP

Getting angles right can make the difference between a believable scene and a cockeyed scene. It's important to first learn some linear perspective basics.

Before beginning any perspective drawing, you must establish the eye level and keep it consistent throughout your drawing. The eye level is the horizontal plane that marks the position from which we view a painting. The vanishing point is the point at which all parallel lines converge. In one-point and two-point perspective, the vanishing point will always be on the same line as the eye level. That eye level can be from above (for example, a bird's-eye view), or below, or somewhere in between, but there should be only one eye level if linear perspective is your goal.

EXAMPLES OF STRONG LINEAR PERSPECTIVE
ONE-POINT PERSPECTIVE

In one-point perspective (Fig. 1), all receding parallel lines meet at a single point. The classic example of one-point perspective is da Vinci's *The Last Supper*. Leonardo, a mathematician, painted the scene so that the architectural elements all meet at one point: Jesus.

TWO POINT PERSPECTIVE

In two-point perspective (Fig. 2), one set of receding lines meet at one vanishing point and another set meet at another vanishing point. Notice that in the example, the artist created a vanishing point where he wanted the viewer to focus.

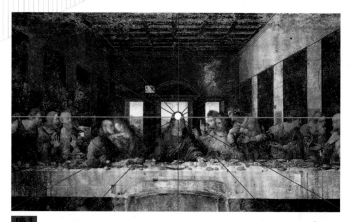

FIG. 1

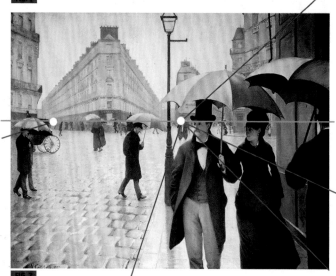

FIG. 2

FIG. 1
The Last Supper,
Leonardo da Vinci
One-point perspective:
The white dot shows
the vanishing point.
The green line is the
eye level.

FIG. 2
The Rainy Day,
Gustave Caillebotte
Two-point perspective:
The two white dots
represent the two
vanishing points.
The green line is
the eye level.

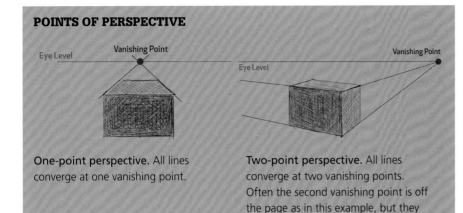

FIG. 3

CREATING A PERSPECTIVE GRID

Both Painter and Photoshop have perspective grids, but I prefer to use Photoshop because it allows you to create more than one grid on one painting, and you can also map art in perspective (see p. 63). I often use these perspective tools to check my perspective lines and make sure the eye level and vanishing points match up.

Before beginning a drawing, I first mark the eye level. In my painting for *Bull in a China Shop*, I wanted the eye level to be around the bull's mouth, as if he is about to say something to the viewer. If my figure is the same height as my viewer then the eye level will usually be at my subject's eyes. But everyone knows that upright bulls are taller than humans. Thus the eye level will be at his mouth.

1. I first selected a red color from the swatch palette and then selected the *Line Shape* tool. In the *Property Bar*, I changed the line weight to 5. Holding down the *Shift* key to keep the cursor straight, I drew a line to mark the eye level. Vector shapes are always created on their own layer so I can easily turn this layer off when I bring it into Painter (Fig. 3).

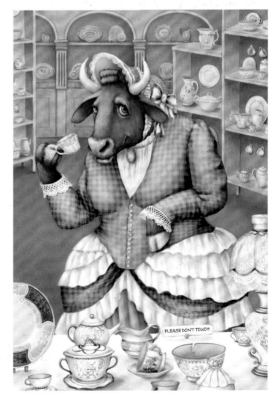

Bull in a China Shop

In this example I have focused on linear perspective instead of atmospheric perspective. But remember, perspective can also be created through value, color, scaling, overlap, and even distortion. For example, I have glazed blue tones into the background and made the values less saturated. Blues and duller values always help your backgrounds recede.

FIG. 4

FIG. 5

FIG. 6

2. Next, I marked my vanishing point and drew some perspective lines converging from it (Fig. 4).

3. Now I put Photoshop to work making a one-point perspective grid. I created a new layer by clicking the **New Layer** icon in the *Layers* palette, then renamed it "perspective grid."

4. Next, I selected *Filter > Vanishing Point*.

5. By default the **Create Plane** tool is selected. My curser turned into a tiny crosshair and square shape over the document window.

6. I clicked on the four corner points to define my perspective grid.

7. Next, I adjusted the grid with the **Edit Plane** tool. If my grid is the correct perspective then it turns blue. If the grid is red or yellow it means I've drawn a perspective that is impossible. When this occurs, I adjust one of the four corner points until it turns blue (Fig. 5).

8. Once the first grid is in place, I click the **Create Plane** tool again to create another grid for the left side, and repeat steps 5–6. I now have two perspective planes.

9. Lastly, I selected the small arrow to the right of the **Create Plane** tool and from the drop-down menu chose **Render Grids to Photoshop** (Fig. 6). I then clicked *OK*. My grid now appears as blue lines in the perspective grid layer. When I take this document into Painter, I will use this guide layer to keep my lines in the correct perspective.

QUICK TIP
BREAK RULES

Now that you know some perspective rules, feel free to break them. Whenever "rules" become the focus of a painting, it can strip the life out of it. Paul Cézanne's impressionist landscape hardly has the hilltops converging into one vanishing point. The result is a landscape with more movement and energy. The Cubists argued that because the viewer can always change their eye level, so should the perspective. As with using divine proportion, keep in mind, that mathematics can only take you so far. Rules are made to be broken and if they feel too confining, it is time to use your intuition over logic.

*Monte Sainte-Victoire
above the Tholonet Road*
c. 1896–1898 Paul Cézanne

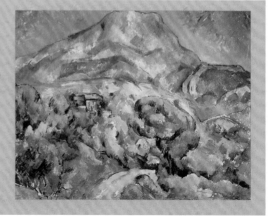

MAPPING ART IN PERSPECTIVE

Photoshop also allows you to map a design or texture to any perspective grid. In this example, I transposed an antique map to the back wall in my *Cabinet of Curiosities*.

1. I opened the map image and selected *Command/CTRL + A* to select all of the image.

2. I selected *Command/CTRL + C* to copy the image to the clipboard. I will use this copied image in step 5.

3. Next, I opened *Cabinet of Curiosities* and selected *Filter > Vanishing Point*.

4. By default the *Create Plane* tool is selected. I clicked on the four corner points that will define my wall and adjusted it until it turned blue (Fig. 7).

5. Next, I selected *Command/CTRL + V* to paste the map image from the clipboard.

6. I dragged the map onto the perspective grid until I saw it conform to my grid.

7. I selected the *Transform* tool and dragged the corner points to my desired size and then hit *OK* (Fig. 8).

QUICK TIP
WHO IS YOUR VIEWER?

Eye levels become important when you consider your viewer. For example, children's book illustrators often make illustrations from a low eye level because small children are often looking up at their world. Creating a low eye level can also make your subjects feel larger than life while creating a high perspective gives the viewer more control over the scene. In this example, I used a slightly lower perspective to make the figures look more fantastic.

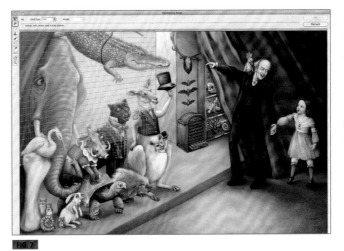

FIG. 7

FIG. 7
The image without the antique map. The blue lines indicate the perspective grid.

 FIG. 8
The image with the antique map. You can also create multiple perspective grids within the *Vanishing Point* filter. To create multiple grids, select the *Create Plane* tool for each new grid.

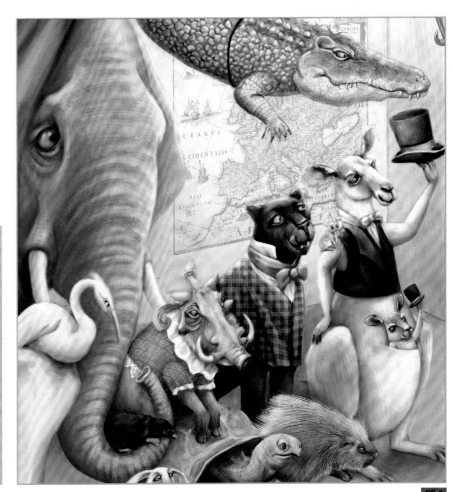

FIG. 8

15
PRINTING

INKJET PRINTING

So, now that you have created your masterpiece, you may want to print on that antiquated medium called paper. The three most common home office printers are: laser, "all-in-one printers," and inkjet printers. Currently, the inkjet printers are the best choice to give you decent quality prints.

INKS:
CHOOSING THE RIGHT ONE

Inkjet printers spray tiny microscopic dots to create a printed image. Many years ago, inkjet printers used only four inks, but then the manufacturers figured out that if they put more ink in the printers, they could sell more ink. (OK, it also created a more detailed image.) Now most low-end inkjet printers take around 6–8 inks while the fancier ones use 10 inks. And trust me, if you have ever had to purchase ink for one of these printers then be prepared to consider that second mortgage. Most ink cartridges cost between $25 and $35 per cartridge and some printers (Epson especially) waste ink when cleaning the print heads after so many prints. I personally have had more success with HP and Canon printers, but if you are pricing printers, look at the reviews and see which printers gobble up ink and which are more efficient. It can make a big difference in your investment.

The next factor to consider is whether you want archival prints. Currently, there are two types of ink: pigment and dye inks. Pigment inks are used in archival printing because they are more resistant to fading than dyes. Not all inkjet printers accept archival pigment inks

FIG. 1
Princess in the Tower
Created with Painter's Acrylic and Pastel brushes

FIG. 1

so you need to check with the manufacture if producing archival prints is your goal.

PAPER:
CHOOSING THE RIGHT ONE

Your paper choice can also make a big difference in the quality of your printouts. If you're new to digital painting, you might think shiny is best, but glossy paper tends to create an undesirable glare and it also fades more than other papers. I prefer matte papers. For proofing, I use Staples generic matte paper and the Epson Enhanced Matte Paper. Both give me a good quality print and are affordable enough that I don't have to sell my firstborn. If I am creating an archival print, I use the Museo papers. For watercolor paintings, I like Strathmore's inkjet watercolor paper while for oil, acrylic, and mixed media paintings I use Strathmore's inkjet canvas

paper. These papers may dull colors so you can bump up the saturation in Photoshop by selecting *Image > Adjustments > Hue / Saturation* or you can glaze your print with a medium like Microglaze.

SEALERS:
CHOOSING THE RIGHT ONE

Lastly, sealing your prints can greatly extend their lifespan. I like the Golden Archival Varnish and sometimes I print on Strathmore inkjet Canvas paper and then rub Microglaze into the inks before they dry. It brightens the inks up and also allows me to paint over my printout to create a mixed media piece. Just remember that for inkjets that use water-based ink, you will need to seal your print if you want to apply paint over it.

QUICK TIP
KEEP OUT THE SUN

Keep your work out of the sunlight if you want your great grandchildren to see it. Sunlight and humid environments will fade inks over time.

Application
PHOTOSHOP

PREPARING TO PRINT

So now you have your printer, paper, and have spent a small fortune on inks. You are ready to prepare your final painting. I prepare files for printing in Photoshop because I prefer its color controls and sharpening tools.

STEP 1: COLOR CORRECT

Next, I evaluate my range of values and color correct the image.

1. Duplicate the flattened layer by selecting *Layer > Duplicate Layer*. Name this layer "color corrections."

2. Open the *Histogram* (*Window > Histogram*). The Histogram allows me to see how each color channel is mapped out. When I looked at the Histogram for *Princess in the Tower* (Fig. 1), I noticed that the red channel was looking a little flat (Fig. 2A). A healthy channel should have peaks and valleys from left to right. These peaks represent the range from dark to light. Sometimes you will want one color's midtones to stay flatter while another color dominates, but this is not one of those paintings. This is an outside scene so it should have more of a balance between red, green, and blue. I realized I had made a classic painting mistake—I had overdone the greens. Thankfully, this is easy to fix.

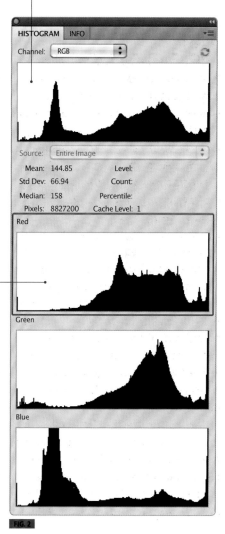

This window maps your overall values. This one is not bad. In an outside scene, you should see many peaks and valleys.

The blue and green have peaks and valleys that continue from darks (the left side) to lights (the right side). But the red is too flat missing a range of values.

FIG. 2

3. Select *Image > Adjustments > Curves*. From the *Channels* drop-down menu (Fig. 4A), select *Red*. Because it is the midtones that are missing red, I then click on the middle of the curve and drag upward a tiny amount (Fig. 4B). Hit *OK*. Now, my midtones have more red and look less unnaturally green (Fig. 3).

4. Lastly, I bump up the saturation of my colors by Selecting *Image > Adjustments > Hue/Saturation* and increase the saturation slider.

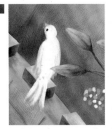

The Original Color-corrected

FIG. 3

The corrected image has more red in the midtones. Green is one of those controversial colors that many artists ban from their palette, preferring a more chromatic yellow-green. You don't need to fear green as long as you balance it against its opposite—red.

STEP 2:
SHARPEN YOUR IMAGE

Next, I sharpen my painting to better define the edges. I prefer the *Smart Sharpen* filter because it gives me more control on where the sharpening occurs. On most paintings, I like my highlights to be sharper.

1. Select *Filter > Sharpen > Smart Sharpen*.

2. Click the *Advanced* button (Fig. 5A) and check the *More Accurate* button (Fig. 5B).

3. Use the amount slider (Fig. 5C) to increase or decrease the sharpening. I usually use about 100%, but if my painting has impasto effects then I increase the amount to make my brushstrokes crisper.

4. For the radius (Fig. 5D), I use around 0.3 px.

5. For the remove tab (Fig. 5E), I prefer *Gaussian Blur* because it creates less of a haloed edge.

6. Click the *Shadow* tab (Fig. 6A) and adjust the fade amount, tonal width, and radius.

 The Fade Amount (Fig. 6B) Controls the amount of sharpening in just the shadows while the amount slider (step 3) adjusted the amount of overall sharpening. This number will greatly depend on your painting, but I usually go with about 30%.

 The Tonal Width (Fig. 6C) Controls the point the shadow's sharpening tapers off when it reaches the midtones. A smaller number will only sharpen the darkest shadows. I like my sharpening to gradually taper so I usually set tonal width to a medium amount.

 The Radius (Fig. 6D) Controls how many neighboring pixels are considered a shadow. A smaller amount will create more edge highlights.

FIG. 5
These settings are just an average. Each painting will require different amounts of sharpening. Photoshop saves the last settings used so that you can easily adjust your image using these settings as your starting point.

7. Click the *Highlight* tab. Now I adjust the same settings except I am using the highlight information. Under the highlights tab, I lower the fade amount to 30% because I want the sharpening to occur in only the lightest lights. I lower the tonal width to 12% because I want the sharpening to taper off before it reaches the midtones. Lastly, I lowered the radius to 10 px because I want the highlights to have a very sharp edge without effecting neighboring pixels.

8. If the image is looking too sharp, you may have to go back to the *Sharpen* tab and reduce the amount of overall sharpen. When satisfied with the results, click *OK*.

FIG. 7

STEP 3:
PROOF COLORS ON SCREEN

Next, I create a custom proof for my inkjet printer and paper combination to indicate how color is being interpreted. These steps do not change your actual colors, but only how Photoshop simulates colors on screen.

1. Select *View > Proof Setup > Custom*.

2. Under *Device to Stimulate*, choose your printer/paper profile. Your printer/paper profile usually installs with your printer's driver, but sometimes you will need to download the profile from the manufacturers' site. I am using the Epson Enhanced Matte paper so I have installed a printer profile that uses the Epson 1400 printer and this paper. Every printer is different so you will need to check your print manual to know where to install your printer profile (Fig. 7A).

3. Uncheck *Preserve RGB Numbers* (Fig. 7B).

4. Under *Rendering Intent*, choose either *Relative Colorimetric* or *Perceptual*. Epson recommends Relative Colorimetric for my printer (as do most printers). Every printer is different so you will need to consult your manual (Fig. 7C).

5. Check *Black Point Compensation* to get the darkest blacks (Fig. 7D).

6. *Save*. Photoshop now opens the *Proofing Folder*. You will want to keep your profile here. Name your profile with the printer name and paper type making sure to keep the .psf extension. Hit *OK*.

QUICK TIP SHARPEN EDGES ONLY

To sharpen the edges in your painting, use the High Pass filter: Duplicate your background layer; set its blend mode to *Overlay*. Select *Filter > Other > High Pass* and change the radius to around 2 px. Hit *OK*.

FIG. 6

COMMERCIAL OFFSET PRINTING

Sometimes you may need to prepare your file for an offset printer for larger print runs. Offset printers produce images by running color plates of cyan, magenta, yellow, black, and sometimes a fifth and sixth spot color. Most printers will have a checklist of requirements so you will need to consult your printer first. Still, there are steps to follow that will ensure the colors you see onscreen will be closer to your printed piece.

STEP 1: CREATE AN OFFSET PRINTING PROFILE

Create a custom printing proofing profile for commercial printing.

1. Select *View > Proof Setup > Custom*.

2. Under *Device to Stimulate*, most printers recommend choosing U.S. Web Coated SWOP V2 (the standard profile for offset printing in the U.S.). Some printers will send you their printer profile. You will then need to hit the *Load* button and navigate to where you saved the profile (Fig. 8A).

3. Under *Rendering Intent*, choose *Relative Colorimetric* (Fig. 8B).

4. Check *Black Point Compensation* (Fig. 8C).

5. Save. Photoshop now opens the *Proofing Folder.* You will want to keep your file here. Name your profile "offset printing" and make sure to keep the .psf extension. Hit *OK*.

STEP 2: CORRECT OUT-OF-GAMUT COLORS

The first step in getting accurate printouts is called soft proofing. The "soft" part is another of those techni-misnomers because there is nothing soft about being told which colors won't print correctly. These offending colors are called out-of-gamut colors because they are out of the CMYK color space. They look pretty onscreen, but they strangely disappear when you want them to appear on paper. When you convert an image from the RGB to CMYK color space, Photoshop automatically shifts these out-of-gamut colors. But what if this shift is not the color that you intended? Fortunately, Photoshop lets you know which colors are not going to print correctly so that you can correct them before your hopes and dreams are shattered. To identify out-of-gamut colors:

1. Select *View > Gamut Warning*. Now, the colors that will not print correctly are marked by a grayish mask (Fig. 9). It is possible that you may not see any gray, but a grayish mask appeared over the most of the apples in my fruit painting. I need to fix these colors.

2. Using the *Magic Lasso* tool, select the out-of-gamut colors marked by the gray mask.

3. Select *Command/CTRL + J* to put these colors on a new layer. Double-click the layer title and rename it "out of gamut."

4. Change the layer mode to *Color*.

FIG. 9

An out-of-gamut red color is marked by a gray mask and will not print correctly. Out-of-gamut colors are usually the colors that you most want to keep—the really pretty, highly saturated ones.

FIG. 8

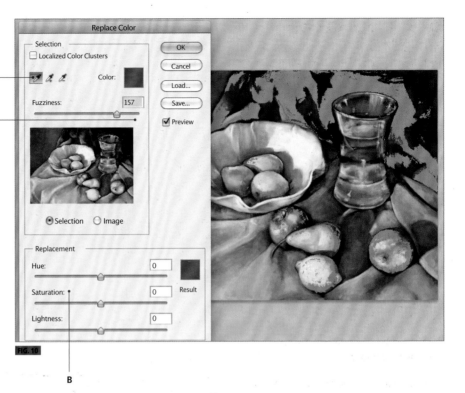

A

C

FIG. 10

B

5. Select *Image > Adjustments > Replace Color*. Using the *Color Picker* tool (Fig. 10A), click on an out-of-gamut color.

6. Sometimes just lowering the saturation slightly (Fig. 10B) will get rid of the offending color. As you move the sliders to change the out-of-gamut color, you will notice that some of the gray mask goes away indicating that the color is no longer out-of-gamut. If not enough goes away then you can adjust the fuzziness slider (Fig 10C). The fuzziness lets you select more or less of a color. Keep in mind that you do not have to get 100% of the out-of-gamut color shifted. Just get enough of the color in gamut so that you see the gray mask broken up. You don't want large areas of color out-of-gamut. Hit *OK*

7. Toggle off the out-of-gamut warning (*View > Gamut Warning*) to see how the colors have changed. If the shift is too dramatic, try lowering the opacity of the "color corrected" layer and toggling the gamut warning back on. Repeat steps 2–6 for each out-of-gamut-color.

STEP 3:
CONVERT RGB TO CMYK

Now that the out-of-gamut colors have been corrected, prepare your file to be sent off. At this point, you will need to convert the file to CMYK. To convert RGB to CMYK:

1. Click on the small right arrow and choose *Flatten Image* from the *Layers* drop-down menu.

2. Select *Image > Mode > CMYK Color*. Your colors are now in the CMYK color mode.

3. Save this file with the name "finalPress" added to the end. The reason why I do this is because if you have to later make edits, you should always make them in RGB mode and not CMYK.

QUICK TIP
WHEN TO CONVERT TO CMYK?

Because CMYK is a smaller color space, you should always paint in RGB and only switch to CMYK when you are ready to pass your work off to an offset printer. Unfortunately, you cannot convert Painter files to CMYK. When you are ready to prepare your Painter files for press, save your files as .PSD and open them in Photoshop.

FEATURED ARTIST
JEREMY SUTTON: DIGITAL ART MASTERY

Corel Painter Master Jeremy Sutton is a leading digital artist and instructor, author of the popular *Painter Creativity* series, and founder of the online training site PaintboxTV.com. Originally from London, Jeremy, who has a degree in Physics from Oxford University, studied fine art at the Ruskin School of Drawing and Fine Art, Oxford, and at the Vrije Academie in The Hague, The Netherlands. In 2010–11 Jeremy portrayed Edgar Degas and Vincent van Gogh at the de Young and Legion of Honor Museums in San Francisco.

JEREMY SUTTON
Sutton Studios &
Gallery, San Francisco,
California, USA
jeremy@jeremysutton.
com
+1-415-641-1221

ARTWORK:
www.JeremySutton.
com

**ONLINE LEARNING,
BOOKS, DVDS, AND
WORKSHOPS:**
www.PaintboxTV.com

FIG. 1
Summer Afternoon

FIG .2
Cityshapes ~ Rock

FIG. 3
Moment in Time

FIG. 4
Dance Rehearsal

FIG. 1

FIG. 2

FIG. 3

FIG. 4

CLASSIC SAN FRANCISCO
BEYOND THE PRINTER

"The large heart, titled *Classic San Francisco*, is an example of an artwork that combines digital with traditional art media. The design includes contemporary color images of San Francisco on one side and black and white, film noir scenes of the city on the other. It was originally painted digitally using Corel Painter software, a Wacom Intuos4 pen tablet, Macintosh computer, and a 30-inch Apple Cinema display. Here are the steps I used to transform the printed page into a 3D work of art:"

1. "Using an Epson wide format inkjet printer I first printed the front and back images onto a total of 32 feet length of 44-inch-wide coated canvas."

2. "This canvas digital print was then wrapped around the huge heart and adhered to it with acrylic gel."

3. "I then spent many weeks adding acrylic paint applied thickly with a palette knife for impasto texture. I also added metal leaf and, as a tribute to the success of the local baseball team, a Giants World Series ticket (the World series was played as I was painting the heart)!"

4. "The whole heart was then coated in multiple layers of spar varnish for UV and water protection since the heart would spend it's first six months exposed to the elements in Union Square, looked at, photographed, and touched by an estimated nine million visitors."

FIG 5
Classic San Francisco
2011
by Jeremy Sutton,
Corel Painter Master
5' x 5'9" x 3'3", 400 lbs.
Pigment ink, acrylic gel medium, acrylic paint, metal leaf, Giants World Series ticket, and spar varnish on canvas over a fiberglass mold with steel internal support structure and base.

On display in lobby at 595 Market Street (at Second Street), San Francisco.

More information and images of the Heart to be found at: www.jeremysutton.com/classicsf.html

FIG. 5

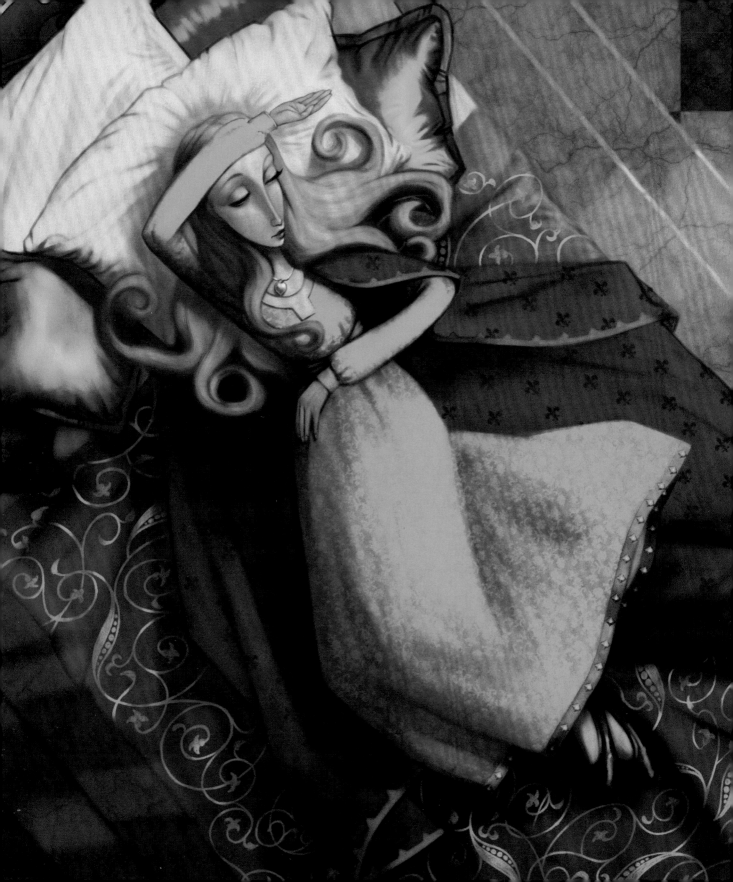

DIGITAL PAINTING
TUTORIALS

01
PLAYING DRESS UP

 Application
PHOTOSHOP

Going beyond decorative purposes, patterns add visual interest by playing with the relationships between the foreground and background. Henri Matisse broke the rules of academic perspective by using bold color and decorative patterns to trick the eye into perceiving space. Use patterns when you want to frame a subject, make an object appear in the foreground, or separate negative and positive space.

In my painting, *Cowgirl Fashionista*, at right, I used patterns on the wallpaper, girl's vest, skirt, pillows, and drapery to help distinguish the foreground and background shapes. This tutorial looks at using patterns, beginning with how to dress the cowgirl in a checkered skirt.

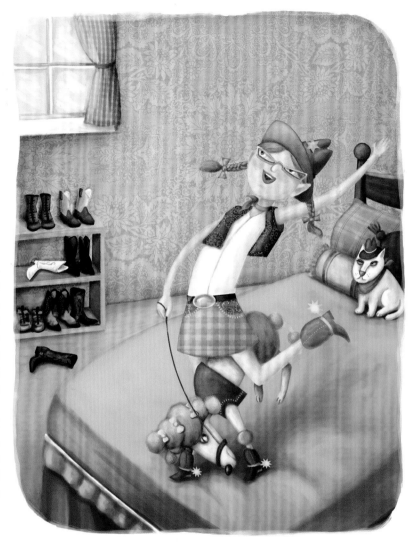

Wallpaper pattern

Vest pattern

Pillow pattern

Drapes pattern

Skirt pattern

STEP 1: LOADING A PATTERN

You can download checkeredblue.pat from the resource site, www.carlynpaints.com, if you want to follow along with this tutorial.

1. Within the **Control Bar**, I clicked on the pattern drop-down menu (Fig. 1A) and then the small arrow to the right (Fig. 1B). From the drop-down menu I selected **Load Patterns** (Fig. 1C).

2. Next, I navigated to where I had saved checkeredblue.pat and selected the file. The new pattern was now loaded into my pattern library.

STEP 2: APPLYING A PATTERN FILL

1. I opened the Cowgirl image and made a selection around the girl's skirt using the **Lasso** tool. (See p. 24 for tips on making a selection.)

2. I created a **New Layer** and named it "plaid skirt."

3. I selected the **Paint Bucket** tool. From the **Control Panel**, I changed the fill type to **Pattern** (Fig. 2A) and selected the yellow plaid pattern from the drop-down menu (Fig. 2B). I kept the rest of the default settings.

4. I then clicked within my selection to fill the skirt with the checkered pattern (Fig. 3).

5. In the **Layers** menu, I changed the Layer blend mode from **Normal** to **Overlay** and lowered the opacity to 50%.

6. I also followed the steps below to change the pattern's color. And voila! A new look for my fashionista.

FIG. 1

FIG. 2

FIG. 3

QUICK TIP
CHANGING THE PATTERN COLORS

You can also change the color of your pattern. The images to the left all have a pattern set to Normal with a 50% opacity, but I have changed the pattern's hue in each.

1. Select the layer that contains the pattern.

2. Select **Image > Adjustments > Hue/Saturation**. Drag the hue slider to your desired color.

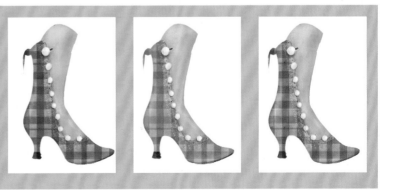

APPLY A PATTERN
AS A LAYER EFFECT

Sometimes, I want to apply a pattern to an object that is already on its own layer. To do this, I use the **Layer Effects** menu. This method gives me more control on how the pattern combines with its underlying color.

1. I selected the *fx* button at the bottom of the *Layers* menu and chose *Pattern Overlay* from the drop-down menu.

2. Next, I changed the Pattern Overlay blend mode to *Overlay* (Fig. 4A).

3. From the pattern drop-down menu, I selected the blue checkered pattern from the patterns loaded in Step 1 (Fig. 4B) and then clicked *OK*.

FIG. 4
In the *Layer Style* menu you can apply more than one style at a time and also change each of those layer style's blending modes. This gives you more flexibility to play around with different effects.

FIG. 4

DO IT YOURSELF
MAKING YOUR OWN PATTERN

Just like brushes, you can make a pattern out of virtually anything. Sometimes I create patterns from scans of retro fabrics, fall leaves, or paint splashes. To make a pattern in Photoshop:

1. Open the file that you want to turn into a pattern and choose *Select > All*.

2. Next, select *Edit > Define Pattern*. The pattern will now become part of your pattern library.

QUICK TIP ADVANCED PATTERNS

Fill vs. opacity becomes important when layer effects are applied. In the first example (A) the shoe has a pattern layer effect applied without any change to opacity or fill. If you just lower the opacity, the image merely looks screened back into the white of the paper (B). But if you lower the fill, then the blue colors from the checkered pattern combine with the green of the shoe. The last image (C) looks less flat because of this more nuanced color blending.

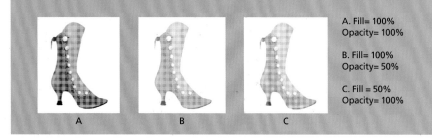

A. Fill= 100%
Opacity= 100%

B. Fill= 100%
Opacity= 50%

C. Fill = 50%
Opacity= 100%

WARNING!

Painter does not recognize Photoshop's layer effects. If you use them, you must follow these steps to keep your effects in Painter.

1. Create a new layer by selecting the *New Layer* icon.

2. Select the new layer and the layer with the effect applied to it by *Shift + clicking* on both layers.

3. With both layers selected, merge them by selecting *Command/CTRL + E*.

DO IT YOURSELF
MAKING YOUR OWN REPEATING PATTERN

Collecting patterns can get addictive, but remember, if you plan to use them for commercial use then you will need to purchase a license. A better bet is to simply make your own pattern.

1. I created a new document (*File > New*) and set its dimensions to 500 x 500 pixels at 300 dpi.

2. I created a simple doodle and named this layer "swirly."

3. Next, I selected *View > New Guide* and checked the *Vertical* option. In the position field, I entered 250 px (Fig. 5) and then hit *OK*.

4. I selected *View > New Guide* again, but this time checked the *Horizontal* button. In the position field, I entered 250 px and then hit *OK*. This will set up crosshair guides for me to position my drawing directly in the center.

5. Using the *Layer Selection* tool, I dragged my drawing to the exact center using the guides as my center markers.

6. I duplicated the swirly layer by dragging it onto the *New Layer* icon. I named this layer "swirly offset."

7. I selected *Filter > Other > Offset* and made sure *Wrap Around* was checked. Then, I changed the horizontal right and the vertical down silders to 250 px (Fig. 6). These are not random numbers—they are half the width and height of the document (500 pixels).

8. I selected the original swirly layer (the center drawing) and then *Edit > Transform > Scale*. I grabbed one of the corner points and held down the *Alt/ Option + Shift* key to scale it uniformly from the center point.

9. I selected *Edit > Define Pattern* and also named this "swirly."

10. I opened my image, *Les Liaisons Dangereuses*, and selected the *Paint Bucket* tool. In the *Control Panel* I changed the fill type to *Pattern* and selected my new pattern (Fig. 2, p. 75).

11. Lastly, I clicked on the background portion of my painting to fill the wallpaper with my new pattern (Fig. 7).

FIG. 5

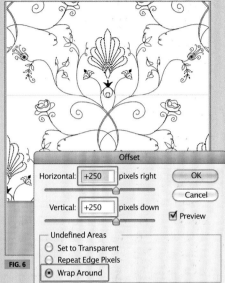

FIG. 6

FIG. 7
I used Painter's Real Bristle brushes in this painting and then decorated the background with the pattern that I created in Photoshop.

FIG. 7

Application
PAINTER

STEP 1: MAKING AND USING PATTERNS

The process for creating a pattern out of another file in Painter is very similar to the method used in Photoshop. To follow the steps in this tutorial you can download the yellowplaid.psd file from the book's website www.carlynpaints.com.

FIG. 8

FIG. 9

1. I opened yellowplaid.psd in Painter.

2. I then opened the *Patterns* palette (*Window > Media Library Panels > Patterns*) and clicked the *Capture Paper* icon (Fig. 9A).

3. In the *Patterns* control panel (*Window > Media Control Panels > Patterns*) I lowered my pattern's offset (Fig. 10A) and scale (Fig. 10B).

4. To use this pattern, I selected the pattern from the drop-down menu (Fig. 10C).

5. I then selected the *Paint Bucket* tool and in the *Property Bar*, I set the fill to *Source Image* (Fig 11).

6. Lastly, I filled my selection with my new pattern fill.

FIG. 10
Remember that there are two *Pattern Libraries*, one controls pattern settings and the other controls which paper is selected.

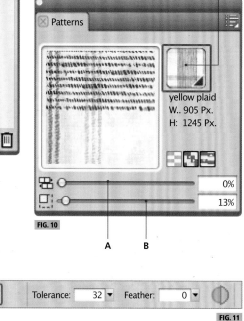

FIG. 10

STEP 2 MAKING YOUR OWN SEAMLESS PATTERNS

Painter's strength lies in creating less tiled, more organic patterns. In complicated patterns, it is often very difficult to blend the seams together. Luckily, Painter makes this task easy. To make a seamless pattern:

1. I created a new document (*File > New*) at 400 by 400 px.

2. Next, I filled the background with yellow using the *Paint Bucket*.

3. I wanted my background to have a bit of texture to it. Before applying a paper texture, you must first choose a paper. In the *Paper Textures* window located in the *Toolbox*, I selected *Linen Canvas* (Fig. 12).

4. Next, I selected *Effects > Surface Control > Apply Surface Texture* and kept all the default settings (Fig. 13).

5. I wanted the effect to be very subtle, so I selected *Edit > Fade* and chose 80%.

Paper Textures

Linen Canvas

FIG. 12

Fill: Source Image Tolerance: 32 Feather: 0

FIG. 11

FIG. 13

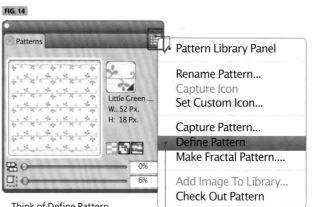

FIG. 14

Think of Define Pattern
as a magic wrapping tool

FIG. 13
I used the default settings for my paper texture but you may want to play around with the direction of the light and the depth.

FIG. 15
It would normally be very difficult to match up the edges of a pattern like this. Painter's **Define Pattern** function makes wrapping complicated patterns easy.

6. From the *Patterns* contol panel (*Window > Media Control Panels > Patterns*) I then clicked on the small right arrow and selected *Define Pattern* (Fig. 14). With Define Pattern, anything that I draw on the right-hand side past the canvas will wrap to the left-hand side and vice versa. Anything I draw from the top past the canvas will wrap to the bottom and vice versa.

7. I created a new layer by selecting the *New Layer* icon and named this layer "vines." Next, I selected the *Square Conte* from the Conte brush category and, with a dark blue color, began drawing in my doodle. When I was done with my basic lines, I filled them in with pinks and greens using the same brush. I tried to pay attention to balancing each vine and keeping the negative space even.

8. I created another new layer by selecting the *New Layer* icon and named this layer "spongy texture." I dragged this layer beneath the vine layer. Next, I selected the *Loaded Wet Sponge* brush found in the Sponges brush category and pushed my brushstrokes from left to right and from top to bottom so that the texture would be seamless (Fig. 15).

9. Once satisfied with my sketch, I flattened it to turn it into a pattern. It is a good idea to save your file before flattening the layers so you can edit the layers later. To flatten the image, I selected the small right arrow in the *Layers* menu and then *Drop All* from the drop-down menu.

10. Next, I clicked on the small right arrow in the *Patterns* library and selected *Capture Pattern* from the drop-down menu. The pattern was now saved to my library.

11. To use this pattern in my art, I followed steps 4–5 in "Making and Using Patterns" on p. 78.

FIG. 15

QUICK TIPS

To organize your patterns, you can create a new library by clicking the *New Pattern Library* button (Fig. 9B, opposite page). Then drag and drop patterns between libraries.

When you select the Paint Bucket tool, you can fill objects by staying within the lines by turning on the *Fill Cell* button located in the Property Bar (below).

02
PAINTING WITH KALEIDOSCOPES

Application
PAINTER

Before you begin this tutorial you should bring enough food and water into your office for three days, because once you start playing with kaleidoscope painting, you are not going to want to leave your desk. The *Kaleidoscope Painting Mode* basically allows you to make perfectly symmetrical patterns by drawing upon a number of axes. There are two tools that allow you to create symmetrical drawings—Mirror mode (Fig. 1) and Kaleidoscope mode (Fig. 2). Mirror mode allows you to paint along one axis so that everything from left to right or top to bottom is mirrored. Kaleidoscope mode allows you to create up to 12 axes to make more intricate mirrored patterns. In this tutorial, I used Kaleidoscope mode to create the red ruff pattern for *Queen of Hearts*.

FIG. 1

FIG. 2

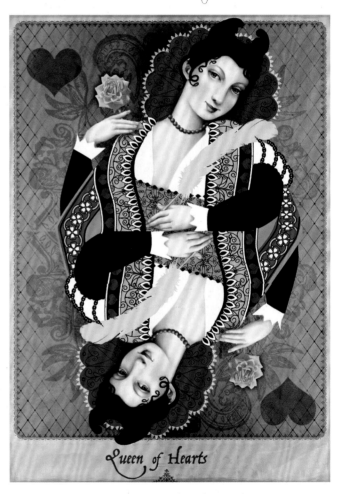

Queen of Hearts

STEP 1: SET YOUR KALEIDOSCOPE

In my painting for *Queen of Hearts*, I painted the ruff on a separate layer and created a pattern on top of it. To make a kaleidoscope:

1. In the toolbox, I selected the *Kaleidoscope Painting* tool (Fig. 2).

2. Under segment number, I changed the number of planes to 8 (Fig. 3B).

3. Then, I put my cursor over the kaleidoscope's center until a crosshair icon appeared. Next, I dragged my kaleidoscope to the center of her ruff.

4. I then moved my cursor to one of the segment lines until I saw the *Rotate* icon appear (Fig. 3C). I rotated my kaleidoscope to match the seams of her ruff (Fig. 4). Now I am ready to draw a pattern.

5. I created a new layer above the ruff layer and named it "ruff pattern."

6. I then selected the *Ball Point Pen* brush variant from the *Pens* brush category.

7. I selected the *Straight Line Strokes* icon (Fig. 5) and drew straight lines along the seams of her ruff. As I painted in my pattern, a mirror image appeared on the corresponding axis.

8. I then selected the *Kaleidoscope* tool and rotated it again, but this time I rotated the lines so that they aligned with the center of each segment (Fig. 6).

9. Next, I drew a twisted heart pattern. I wanted a freehand look to my drawing, but I still wanted it to be symmetrical (Fig. 7).

10. Finally, I made the ruff and the pattern smaller by selecting the *Transform* tool and grabbing the corners inward.

FIG. 3

A B C D E

FIG. 4

FIG. 5

QUICK TIP
TURN OFF THE GUIDES

If the segment guides get distracting you can change their color (Fig. 3D) or just hide them by selecting the *Toggle Planes* icon (Fig. 3E). When you are ready to disable kaleidoscope painting, click the *Toggle Kaleidoscope Painting* button off (Fig. 3A).

FIG. 6

FIG. 7
Here is the pattern I created to use on the fabric.

FIG. 7

03
SPEED PAINTING
PAINTING WITHOUT FEAR

Application
PAINTER

Picasso said, "It took me four years to paint like Raphael, but a lifetime to paint like a child." If you have ever watched a kid paint, then you understand this sentiment. Children will smear blood-red finger paint on their paper with about as much fear as a shark eating its lunch. It is only when they get older that the self-consciousness sets in, and those once fearless children worry about being "real" artists.

When the oil painting masters created paintings in one session, they called it Alla Prima, literally meaning "at once." I use the term "digital speed painting." I do speed paintings to loosen up my hand and turn off that overly critical part of my brain. Sometimes, what results is a painting that a five-year-old wouldn't care to put on their fridge. Other times, my rogue doodling has some spunk to it.

For this tutorial, I chose to portray William Shakespeare arrested in thought. For speed paintings, I always use the paint with 100% opacity to resemble thick paint being applied directly from the tube. I prefer Painter's Dry Acrylic brush because it reminds me of a stiff bristled brush loaded with paint, but you can do this exercise with any of Painter's opaque mediums.

Marcel Renoux Painting
Jules Ernest Renoux

" "

MORE PICASSO WISDOM
"Every child is an artist. The problem is how to remain an artist once we grow up."

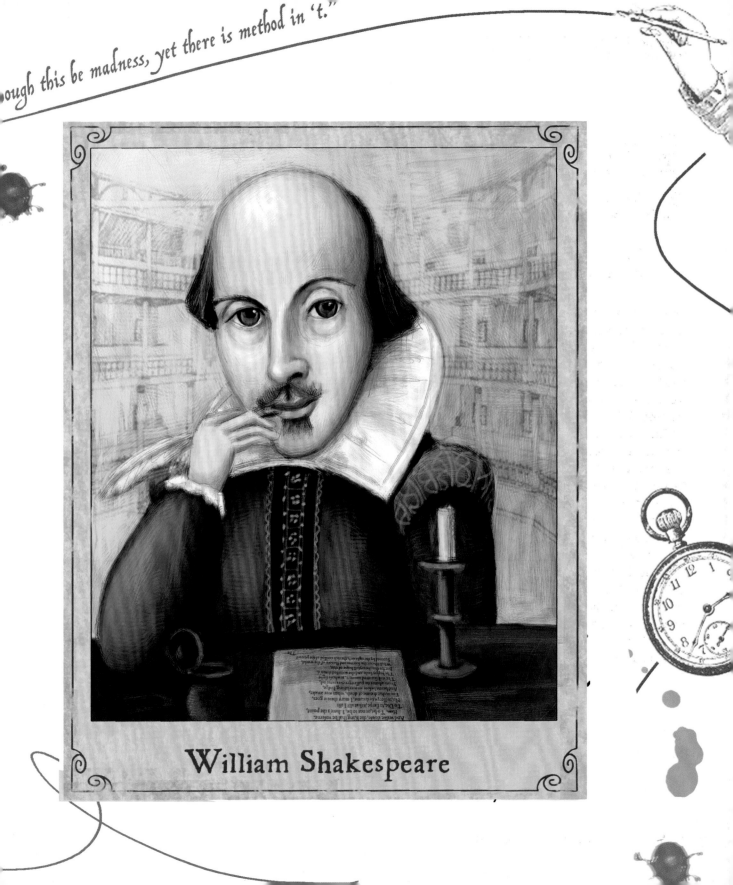

William Shakespeare

STEP 1: CONTOUR DRAWING

I started my speed painting with a quick contour drawing focusing on the edges of my portrait. I always pay attention to how each line follows through to another line.

1. I created a new document in Painter (*Command/CTRL + N*) at 8.5 x 11 inches and 300 dpi.

2. I created a new layer by selecting the *New Layer* icon at the bottom of Painter's *Layers* palette (Fig. 1A). I double-clicked on this layer, named it "sketch," and then changed its composite method to *Multiply* (Fig. 1B).

3. I selected the *Pencil Tools* brush category from the *Brush Selector* menu (*Window > Brush Selector*) and then chose the *Real 2B Pencil* variant from the drop-down menu.

4. I selected the *Brush* tool from the main *Toolbox* menu (*Window > Toolbox*) and drew a quick contour drawing using the *2B Pencil* on the sketch layer.

5. I then selected the canvas layer and chose a base color from the *Color* palette menu (*Window > Color Panels > Color*). With my *Paint Bucket* tool selected, I clicked on the document to fill the layer with light brown (Fig. 2).

FIG. 1

FIG. 2

QUICK TIP
UPSIDE DOWN DRAWING

When you have drawn your initial shapes, try finishing your contour drawing by turning it upside down using the *Rotate Page* tool.

FIG. 1
At the end of this step, I had two layers: a background layer filled with light brown and a sketch layer with its composite method set to *Multiply*. Multiply will always ignore the white in the layer.

SPEED PAINTING THE RULES:

You can look at a photo reference before you begin to paint, but then you must put it away and paint from memory.

1. You cannot work from a tight sketch.

2. You must use 100% opacity to mimic pure color.

3. You have to complete the painting in under an hour.

4. No Judging! Assume that no one will ever see your painting except the family pet.

STEP 2:
BLOCKING IN COLOR

I created an underpainting using a Dry Acrylics brush. I set up my color strings using browns, blues, and reds. (For more about color strings see p. 44)

1. I created a new layer beneath my sketch layer by selecting the *New Layer* icon (Fig. 1A). I then double-clicked on this layer's title to name it "paint."

2. I chose the *Thick Acrylic Bristle* from the *Acrylics* brush category and changed the opacity to 100% (Fig. 3A), the resaturation to 100% (Fig. 3B), the bleed to 0% (Fig. 3C), and the feature to 3.6 (Fig. 3D).

3. In the *Color Variability* menu (*Window > Brush Control Panels > Color Variability*), I increased the value slider (the bottom one) to 25%. Altering the color variability will give more textured brushstrokes.

4. Lastly, I painted in an underpainting using crosshatching brushstrokes (Fig. 4).

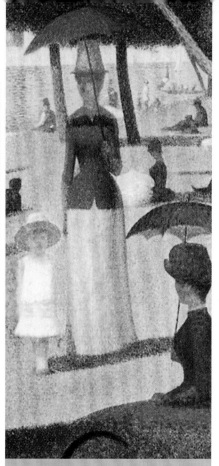

A. To create thick, undiluted paint use 100% opacity.

B. A high resaturation makes paint dry quicker so that it won't blend with its underlying color.

C. A low bleed prevents brushstrokes from bleeding into underlying brushstrokes. If you want to blend colors for a wet-on-wet technique set the bleed higher and your brush will paint with wetter, thinner paint.

D. A high feature decreases the amount of bristles and spreads the hairs of the brush out similar to painting with a stiff brush.

FIG. 3

A brown base

On top of the muted brown, I use a bright color with the brush set to a high Feature.

Your eye blends the brown base with the bright blue creating a muted blue.

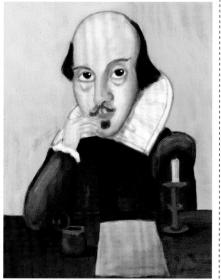

FIG. 4

QUICK TIP
BRUSH POINTILLISM

Georges Seurat created a painting technique called Pointilism using tiny dots of pure color. In Pointilism, your eye blends neighboring colors in a process called "optical mixing." Optical mixing results in brighter colors with more depth. Using a crosshatching at 100% opacity is similar to Pointillism except you are using strokes instead of dots. This is a good exercise because it forces you to "see" how your eye blends neighboring colors naturally. You could get the same muted blue by just smearing blue and light brown together but it would not have the same depth.

STEP 3:
PAINTING FINAL DETAILS

As I worked on smaller areas, I lowered the feature of my acrylics brush so that the bristles were not as spread out. I continued to crosshatch brighter colors over less saturated colors, but with a lower opacity.

1. For finer details like the eyes, I switched to the *Opaque Detail* brush also in the *Acrylics* brush category and set it at a lower opacity.

2. To create more texture in the background I switched to the *Impasto* brush category and chose the *Thick Bristle* brush variant and increased the bleed to 75%. I wanted the feel of impasto, but for it to go on smoothly and not "dry" (Fig. 5).

3. To scrape back some of the texture in places, I choose the *Palette Knife* brush variant found in the *Impasto* brush category. I set the size to less than 2 to create the look of a sharp knife cutting away at the paint (Fig. 6).

STEP 4: ADDING
COLLAGE ELEMENTS

Lastly, I added texture to the background. I wanted a texture that added narrative rather than just decoration. This woodcut of the Globe Theatre provided the perfect backdrop for my quizzical Shakespeare.

1. I opened the Globe Theatre file and selected all of the image (*Command/ CTRL + A*). With my *Layer Adjuster* tool, I dragged it on top of the Shakespeare painting layer.

2. I changed the composite method to *Multiply* and lowered the opacity to 50%.

3. Then, I added a layer mask by clicking on the *New Mask* icon. With black, I painted over Shakespeare and behind his head to mask out those areas. I wanted less of the background texture to come through behind his head so it would not compete with the portrait (Fig. 7).

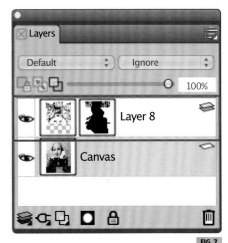

FIG. 7

FIG. 7
Everything painted black is invisible. Before you begin painting with black, make sure you have the mask selected in your layers palette and not your paint layer. The mask layer is always the right-hand thumbnail.

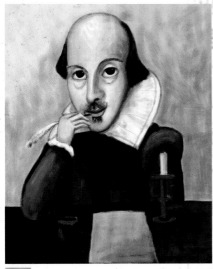

FIG. 5

FIG. 5
I use the Acrylics brush in speed painting because just like traditional acrylic paint, it dries faster than oil paint, forcing you to work quickly. Obviously, digital paint doesn't really "dry" but each brush has a certain about of bleed and resaturation which mimics the drying process of paint.

FIG. 6

SPEED PAINTING

Now I am out of time. I may go back to this painting at a later date and add more detail or I might just leave it as is.

Speed painting is a good exercise to keep the energy in your painting. Everyone runs out of steam at certain points. If the painting is no longer exciting you, put it away and return to it later. (Unless you have a client breathing down your neck, in which case, tick tock, you'd better keep working.)

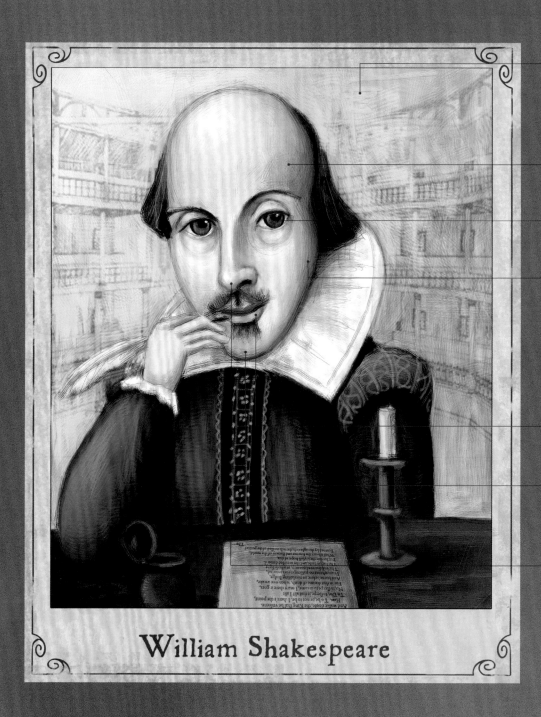

William Shakespeare

Adding small impasto effects creates visual interest. Just be mindful of where you put them. Don't place interesting marks in the far corners because you don't want the eye drawn there.

In speed painting, I look for large, flat shapes of colors that I can define quickly.

Don't forget those catchlights in the eyes. It only takes two seconds to dab a little white light into the eye.

Remember to pull in the background color so that the figure and background have a color relationship. You don't want the figure to look unrelated to its background. In this example I used blue to shadow the face quickly. Increasing the color variability will also integrate blue strokes into the flesh-colored paint.

The lower lip should always be lighter and have a few highlights to add definition and make it look round.

I always use more blue in the chin because it is more shadowed. Men especially will have more blue undertones in their chin and beneath their nose.

Noses are usually slightly redder than the rest of the skin on most skin types. Don't forget the nose highlight and the shadow underneath or your nose will not look round. When you start painting the nose think of painting a sphere.

04
SINGING WATERCOLORS

Application
PAINTER

Before beginning this tutorial, I have two confessions. First, I really couldn't come up with a better name than *Singing Watercolors*. Second, I'm terrible at watercolor painting. Usually, my watercolor paintings look like some muddy mess that has been left out in the rain.

When I first tried digital watercolor painting, I was still bad at it. But I wasn't as bad as usual for one simple reason: multiple undos. With digital watercolor, you can have the same spontaneity in your art, but if that spontaneity leans more toward the messy side then just "Control Z" (undo) till your heart's content. You can also adjust colors so muddy messes can look like happy, sunny colors.

NO WATER NEEDED

If your goal is to mimic traditional watercolors, you will want to experiment with many different watercolor brushes. I find the more variance in your brushes, the more spontaneous it looks. In my study of a wren, I used the *Real Wet Flat Fringe* brush variant found in the *Real Watercolor* category and then overlaid it with the *Real Wet Wash* brush, also found in the Real Watercolor category. To finish, I added some splattering using the *Bleach Splatter* variant found in the *Watercolor* category.

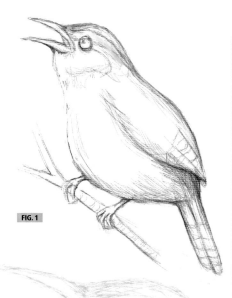

FIG. 1

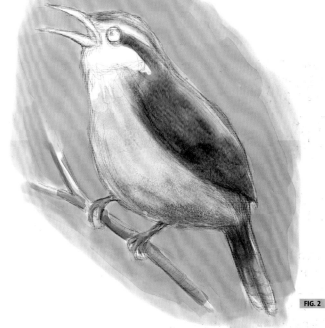

FIG. 2
Areas that will need a more detailed brush like the eyes and beak will be left white at this point. Keep your washes very light. You are just establishing a color relationship.

FIG. 2

STEP 1:
DRAW YOUR SKETCH

1. I created a new document in Painter (*Command/Ctrl + N*).

2. I created a new layer by selecting the *New Layer* button at the bottom of Painter's layer palette and named it "sketch."

3. I selected the *Pencil Tools* brush category from the *Brush Selector* menu (*Window > Brush Selector*) and chose the *Real 2H Drafting* pencil variant from the drop-down menu.

4. Next, I drew a quick sketch varying the thick and thinness of my lines.

STEP 2:
WASH IN BASE COLORS

1. I selected the *Real Wet Flat Fringe* from the *Real Watercolor* category. In the *Property Bar*, I set the concentration to 100% (Fig. 3A), the settling rate to 100% (Fig. 3B), and the weight to 15% (Fig. 3C).

2. In the *Real Watercolor* settings (*Window > Brush Control Panels > Real Watercolor*), I changed the wetness and viscosity to 90%. A higher wetness added more

water to the paint. A higher viscosity kept the paint from pooling at the edges.

3. Next, I blocked in my color washes. I put each wash of color on a separate *Watercolor layer* so that I could adjust the opacity of my layer. As I painted, I decreased the viscosity in the Real Watercolor settings to allow some pooling at the edges.

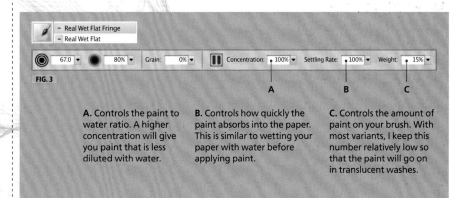

FIG. 3

A. Controls the paint to water ratio. A higher concentration will give you paint that is less diluted with water.

B. Controls how quickly the paint absorbs into the paper. This is similar to wetting your paper with water before applying paint.

C. Controls the amount of paint on your brush. With most variants, I keep this number relatively low so that the paint will go on in translucent washes.

STEP 2: BUILD UP COLOR

1. From the *Layers* menu, I selected the *New Layer* icon and named this layer "wash."

2. I selected the *Real Wet Wash* brush from the *Real Watercolor* category. In the *Real Watercolor* settings (*Window > Brush Control Panels > Real Watercolor*), I changed the wetness to 100%, the concentration to 65%, viscosity to 100%, the evaporate rate to 15%, the weight to 15%, and the pickup to 0%. These settings create a wet-on-wet technique with very thin washes and some pooling at the edges. If you would like more pooling, increase the pickup. 100% pickup will mimic painting with pure water (Fig. 4).

3. For areas that are out of focus like the background branch, I used the *Round Water Blender* brush. In the *Property Bar*, I increased the diffusion to 5. I used this brush on areas that I wanted more rounded-looking, like the chest.

4. For more detailed areas like the beak and the eyes, I used the *Wet* pencil variant found in the *Real Watercolors* category at an opacity of less than 50% (Fig. 5).

STEP 3: ADDING TEXTURE

1. I selected the *Real Wet Sponge* variant found in the *Real Watercolor* category. In the *Property Bar*, I lowered the opacity to less than 50% and the weight to 100%. With this texture brush, I then built up washes of texture over the feathers and stomach area.

2. To add some interest to the background, I used the *Bleach Splatter* brush variant found in the *Watercolors* brush category. In the *Property Bar*, I lowered the jitter to 2 to have more control over where my splatters fell.

3. I scanned in a pattern and *Select > All*. I then dragged the pattern on top of the painting and set its composite method to *Overlay*.

4. I selected black and added a layer mask by selecting the *New Layer Mask* icon in the *Layers* palette. I then clicked on the layer mask in the layers palette (the right-hand thumbnail) and painted out the areas that covered the bird (Fig. 6).

QUICK TIP
CLEANING UP THE MUD

Working in translucent mediums can be tough. If you are like me and find the way colors build confusing, keep your colors on different layers so that you can easily tweak their value, hue and saturation as you paint.

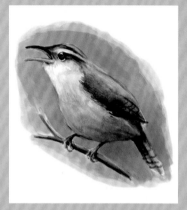

As usual, my watercolors leaned toward the muddy-mess side. Thankfully colors can be quickly adjusted in Painter.

To tone down the darkness of my colors, I selected *Effects > Surface Control > Dye Concentration*. I then set the drop-down menu to *Uniform Color* and changed the max value to around 75% and the minimum value to around 15%.

FIG. 4
Just like traditional watercolors, be mindful of when you pick up your brush and put it back down. Every time you do, you build up more paint.

FIG. 5
You can also switch to a pastel or chalk brush for final details. Just remember that you need to paint on a non-watercolor layer if you use a different medium.

FIG. 4

FIG. 5

BREAKING IT DOWN

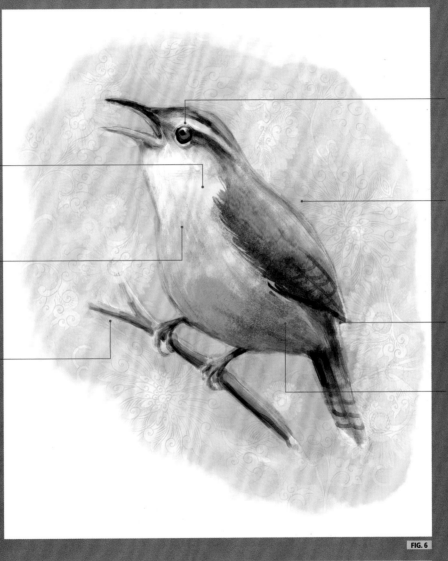

For areas that need sharp strokes like the feathered wings, try the *Real Wet Filbert* brush variant found under the *Real Watercolor* category.

To strip back color on lighter areas, try the *Fractal Dry Erase* found in the *Real Watercolor* category. It works like sandpaper on paper to lightly erase colors.

Keep background elements softer so that they do not compete with the foreground objects. For a softer brush try the *Wet-on-Wet Paper* brush in the *Real Watercolor* category.

For more detailed areas like the eyes and beak use the *Wet* pencil variant found in the *Real Watercolor* category set at a smaller size.

Use the *Bleach Splatter* brush found in the *Watercolor* category to create splatters of color in the background.

Leave spots where the paper shows through if you want a traditional watercolor feel.

To create texture in areas, you can lightly overlay your watercolors with the *Real Wet Sponge* brush in the *Real Watercolor* category.

FIG. 6

QUICK TIP

Digital watercolor painting is not your "use just one brush" sort of painting. The more your vary your brush, the more you will create a more painterly look. The good news is that none of the brushes require much customizing to work like traditional watercolors.

05
MY NOVEMBER GUEST

Application
PAINTER/PHOTOSHOP

For *My November Guest* I used Painter's pen and ink tools and colored it in with the digital watercolor brushes. I then used Photoshop to collage in different textures to give it an antique feel. These techniques could be used for digital scrapbooking, journaling, or commercial endeavors such as art licensing or greeting cards.

In creating this painting, I was inspired by one of my favorite poems, "My November Guest" by Robert Frost. Pick your favorite poem and start sketching the first thing that comes to mind.

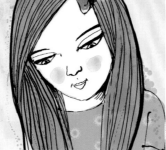

Digital Collage
In this tutorial, you will learn how to make a color study, create an aged paper, use digital pen and ink with Watercolors, and collage with patterns and photos.

The faded earth, the heavy sky,

She loves the bare, the withered tree;

She walks the sodden pasture lane.

The love of bare November days

-Robert Frost

STEP 1:
MAKE A COLOR STUDY

Whenever I paint with digital watercolors, I try to use color sparingly. In this example, to keep myself working within a limited palette, I created a color swatch study so that I could see how colors looked next to each other and on different backgrounds. You might ask, "Why not just use the swatches palette?" Unfortunately, in Photoshop and Painter's swatch palette you cannot change the background color or have different sized swatches in one palette. This simple workaround gave me a roadmap for applying colors effectively.

1. I opened Photoshop and selected *Command/CTRL + N* to create a new document. I set my dimensions to 300 px wide and 300 px high.

2. I picked a color from the *Color* dialog box (*Window > Color*) and then selected the *Rectangular Shape* tool from the *Tools* menu.

3. While holding down the *Shift* key, I clicked and dragged in my document to make a uniform box. Now, I had a vector shape on a new layer.

4. I held down the *Alt* key and dragged my box to the right. This created a new box in the same color.

5. I repeated step 4 until I had 5–8 color boxes in the same color. I resized some of the boxes (*Edit > Transform*) to make them smaller. These smaller boxes will contain the colors that I don't intend to use as much.

6. Next, I changed the color of each box by double-clicking on the shape layer in the *Layers* palette and choosing a new color from the *Color* menu.

7. Once I had a harmonious palette of swatches, I saved the file as "swatches.psd" and opened it in Painter.

8. I opened Painter's *Color Sets* menu by selecting *Window > Color Panels > Color Sets*. I then clicked on the right arrow and selected *New Color Set from Image* (Fig. 3). This created a color set based on my swatch file.

QUICK TIP: FEEL THE MOOD
I kept the colors muted to reflect the mood of the poem and used mostly browns and reds because they reminded me of the last falling leaves in November.

FIG. 2

FIG. 1
I looked at old Victorian postcards to help get a sense of the color I wanted. In this postcard, I liked the softness of the reddish browns and greens.

FIG. 2
Use smaller boxes for your accent colors and larger boxes for the colors that will cover a wide area of your canvas. This will give you a better sense of how much of each color to use.

FIG. 3
You can also open any photo or painting and use it as a basis to create a color set.

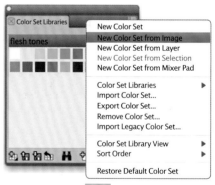

FIG. 3

STEP 2: SETTING YOUR BASE

I tend to use muted browns and yellows as my base colors, but it's a personal choice. Just keep in mind that we perceive colors differently on different backgrounds. To create an aged watercolor paper:

1. I scanned in my sketch and opened it in Photoshop (see p. 34 for more on cleaning up a scan).

2. I selected all of my sketch layer (*Command/CTRL +A*).

3. I put the sketch on its own layer by cutting it (*Command/CTRL + X*) and then pasting it (*Command/CTRL + V*) (Fig. 4).

4. I named this layer "sketch" and set its blend mode to *Multiply*.

5. From the *Color* palette, I selected a muted brown color that resembled aged paper.

6. I selected the background layer and then the *Paint Bucket* tool. I then clicked on my document to fill the background layer with light brown (Fig. 5).

I used a very rough drawing to approximate the position of my figure in relation to the trees that will envelope her. Because I traced over this sketch, I was not concerned with the quality of the line work.

My layers palette had two layers: a background layer and my sketch layer. Remember to set your sketch layer's blending mode to *Multiply* so that all the white drops out.

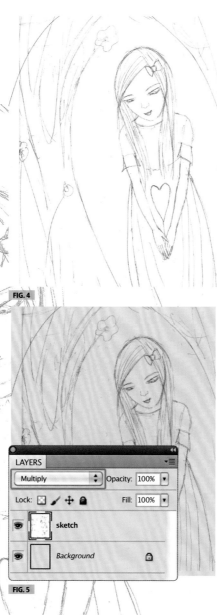

FIG. 4

FIG. 5

see p. 34

STEP 3:
AGED TO PERFECTION

I aged my paper using a textured Photoshop brush and combined it with a scan of an old book. Follow Part 1, Chapter 3 to make your own textured brushes or download them at www.carlynpaints.com.

1. I created a new layer by clicking on the **New Layer** icon at the bottom of the **Layers** palette. I double-clicked on this layer to name it "aged." I then changed the blending mode to **Multiply**.

2. I loaded the weathered.abr brush into Photoshop's **Brush** menu. For steps on loading brushes, see the sidebar on p. 56.

3. I selected the weathered.abr brush from the **Brush** menu and painted on the aged layer. I varied the opacity and hue slightly so that my background would not looked tiled.

4. Next, I painted with Photoshop's **Dry Media Brushes** and **Thick Heavy Brushes** over the base texture. These brushes are found by clicking on the **Brush Preset** menu (Fig. 6A) and then clicking on the small right arrow to bring up the drop-down menu (Fig. 6B & 6C).

5. My brushes created some nice texture but it needed a bit more of an aged feeling. I scanned in water-damaged paper and selected the **Layer Selection** tool. I then dragged the paper onto my painting.

6. I selected **Command/CTRL + T** to scale it to my composition and then changed its blend mode to **Multiply**. I then double-clicked on the layer and named it "old book" (Fig. 7).

7. I **Shift + clicked** on the aged layer and the old book layer to select them both. I merged the two layers by selecting **Command/CTRL + E**. I now have just two layers: a water-stained background layer (Fig. 7) and a sketch layer (Fig. 8).

FIG. 7
I used an old book to give the paper water stains, but you can use any texture to give the appearance of age. Try scanning in a wrinkled piece of paper, a weathered leaf, a napkin with coffee stains, or handmade watercolor splashes.

FIG. 8
I painted in a lighter color around the girl using one of the **Dry Media Brushes** in Photoshop. I wanted this area to be lighter so that my watercolors would show through from beneath. This lighter color also serves as my light source.

FIG. 6

FIG. 7

FIG. 8

STEP 4:
INKING IN A SKETCH

Painter has some fantastic ink brush tools that mimic traditional pen and ink brushes minus those messy ink stains on your fingers. You can do these steps in Photoshop using the Pencil tool, but you won't get the same variation in the line work or those messy blobs of ink that occur when you slow down the speed of your hand.

1. I opened NovemberGuest.psd in Painter and added a new layer above the sketch layer by selecting the *New Layer* icon at the bottom of the *Layers* palette. I named this layer "pen and ink."

2. I selected the *Real Drippy Pen* brush variant found in the *Pens* brush category. In the *Spacing* controls (*Window > Brush Control Panel > Spacing*), I changed the max spacing to 25% and the min spacing to 0.5%.

3. On the pen and ink layer, I then traced over my pencil lines.

- ● Real Drippy Pen
- Real Fine Point Pen
- Real Variable Tip Pen
- Real Variable Width Pen

FIG. 9
I varied the thickness of my lines to create the feeling of movement. On the barks of the tangled trees I made quick, long marks to create thin lines. On the flowers and her hair, I used slower methodical strokes to give them a weightier feel. I wanted her hair to look like it's dragging her down while the trees are lifting her up.

FIG. 10
For finer detailed areas like her eyes, nose, and mouth, I switched to the *Real Fine Point Pen* also found under the *Pens* subcategory. This pen will have a "less nervous" or cleaner quality to it, meaning you won't get blobs of paint occurring when you rest your hand. This is also my favorite pen for creating scratchboard art.

FIG. 9

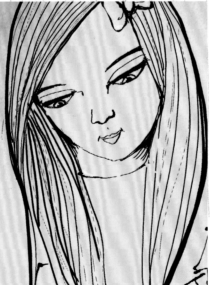

FIG. 10

The Real Drippy Pen works very similar to traditional pen and ink. Like any brush tool, it picks up the pressure of your hand as you paint. If you press down harder, you will get thicker lines (A). Press down lighter, you will get thinner lines (B).

C.

D.

What you will really love about the Real Drippy Pen is that it also recognizes the velocity of your strokes. If you make a fast and careless line, it will begin and sometimes also end with a tiny glob of ink similar to a traditional bamboo pen or calligraphy pen (C). If you make a very careful and slow line then you won't see this variance in ink as much (D). The end result is line work that looks more hand drawn. You can change the speed of any brush by opening the *Size* menu (*Window > Brush Control Panel > Size*) and changing the expression to *Velocity*.

STEP 5:
WASHING IN WATERCOLORS

In this next step, I washed in a layer of color using Painter's *Digital Watercolors*. You can get a very similar effect using Photoshop's *Watercolor Brushes* found in the *Brushes* menu. Just remember to check the option for *Wet Edges* in the *Brush Preset* menu (see pp. 54–55 on customizing brushes).

1. I chose the *Simple Water* brush variant from the *Digital Watercolors* brush category.

2. In the *Property Bar*, I changed the opacity to around 15%, the grain to 20%, the diffusion to 0, and the wet fringe to 100% (Fig. 11). These settings will create strokes that pool the paint slightly at the edge, similar to using a very wet brush.

3. I created a new layer by clicking on the *New Layer* icon at the bottom of the *Layers* palette. I named this layer "green dress." Using the *Wash* brush and a green color, I painted the dress.

4. I repeated step 3 for her hair and the heart. I put each area on a separate layer so that I could easily adjust the color and add patterns (Fig. 12).

5. I then adjusted any colors that looked too muddy (see sidebar to the right).

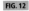

FIG. 11

The Simple Water brush with 100% Wet Fringe. You may want to lower the Wet Fringe if you want less pooling at the edges.

FIG. 12
In traditional watercolors, the white of the paper is the reflective base for all colors and also serves as the white in the painting. The same applies with digital watercolor. This means that colors will be muddier if you choose to paint on a brown paper, because the color absorbs into the paper. In this painting, I used the eraser tool to cut out the face and hands to bring back a traditional watercolor feel.

FIG. 12

QUICK TIP:
ADJUSTING COLOR

If you find any of your painted layers are not the right color, you can quickly adjust the hue, saturation, and value/lightness.

To adjust colors in Photoshop:

1. Select the layer you want to adjust. Select *Image > Adjustments > Hue/Saturation*.

2. Drag the hue, saturation, and lightness sliders to the desired shade.

To adjust colors in Painter:

1. Select the layer you want to adjust.

2. Select *Effects > Tonal Control > Adjust Colors*.

3. Drag the hue, saturation, and value sliders to the desired shade.

STEP 6:
DRESSING YOUR FIGURE

This painting felt as though it needed some brightness to bring it to life. I know of no other way to brighten someone's day than to put on a pretty dress.

1. I choose a floral pattern and opened it in Painter. (You can download this pattern from www.carlynpaints.com.)

2. I opened the *Patterns* library (*Window > Media Library Panels > Patterns*) and selected the *Capture Pattern* button (Fig. 13A). I named the pattern "floral dots green." The pattern was now saved into my library.

3. From the *Patterns* control panel (*Window > Media Control Panels > Patterns*), I cllicked on the horizontal pattern type (Fig. 14A) and changed the amount to 50% (Fig. 14D). I used the same amount for the vertical pattern type (Fig. 14B). I set the scale (Fig. 14C) to 12%.

4. I selected the new "floral dots green" pattern from my *Patterns* library (you see a green line around it when it is selected).

5. I then selected the green dress layer from Step 5 and *Command/CTRL* clicked on the layer to load it as a selection.

6. I selected the *Paint Bucket* tool from the *Tools* menu. In the *Property Bar*, I changed the fill to *Source Image* (Fig. 15).

7. In the *Patterns* library, I clicked inside the selected area to fill the dress with the pattern.

FIG. 13

FIG. 14

FIG. 15

STEP 7: WATCHING THE GARDEN GROW

In this next step, I overlaid several brightly colored flowers to balance the background with the bright, flowered pattern of the girl's green dress.

1. I opened my painting in Photoshop along with several images of eighteenth-century botanical drawings.

2. I selected the *Lasso* tool and made a rough selection around one of the flowers (Fig. 16).

3. I dragged my flower selection into my painting using the *Selection* tool.

4. I then added a layer mask to remove the background bits that I did not want. To add a layer mask, I selected the *Layer Mask* button in the *Layers* menu (Fig. 17A).

5. I then selected the *Paintbrush* tool. Painting with black selected, I masked out the flower's background. I repeated this process for all my flowers.

6. I selected all the flower layers by *Shift + clicking* on them and then selected *Layer > Merge Layers.* I named this merged layer "flowers."

7. With the flowers layer active, I selected the *fx* button at the bottom of the *Layers* menu and then "stroke" from the pull-down menu (Fig. 17B). This brought up the *Layer Style* menu (Fig. 18). I changed the stroke to 8 pixels and kept black as the stroke color.

FIG. 17

B A

FIG. 18

QUICK TIP
PICKING FLOWERS

FIG. 16

If you want to add to your selection, **Shift + click** as your draw with the **Lasso**. If you want to subtract from your selection, **Option/Alt + click** as you draw with the lasso. The above image is of Arctotis fastuosa by Nikolaus Joseph, Freiherr von Jacquin. You can find tons of botanical drawings by leafing through rare books.

FIG. 19

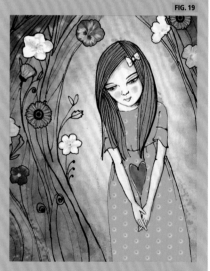

I outlined the flowers in black to help them blend into the line work. You can also scan in pressed flowers or real flowers to give your collage even more dimension.

8. While still in the *Layer Style* menu, I selected the *Color Overlay* option (Fig. 18B). I changed the color to a yellowish color, the blend mode to *Overlay*, and the opacity to 50%. By changing the overlay color, all my flowers from different sources look related.

FIG. 20

9. Next, I decided to add some green leaves to the background for additional texture (Fig. 20). I dragged this pattern into the file and changed its blend mode to *Overlay.*

10. Next, I added a layer mask by clicking on the *Layer Mask* icon at the bottom of the *Layers* palette. Making sure the color black is selected, I used one of the *Dry Media Brushes* to paint out areas of the layer mask and painted out a hole in the middle behind the girl.

11. Next, I added in some red butterflies. I created a new layer and named it "butterflies."

12. I loaded the *Butterfly* brush, which you can download from www.carlynpaints. com. (For instructions on loading brushes, see Part 1, Chapter 3.)

13. I then selected the *Butterfly* brush

C

I found these leaves on the end papers of a nineteenth-century book. End papers from out-of-print books make great textures.

from the *Brush* menu. I kept the opacity at 100% and made sure to turn on *Pressure Sensitivity* so that opacity (Fig. 21A) and shape (Fig. 21B) was determined by the pressure of my hand.

14. I opened the *Brush Presets* menu (Fig. 21C). I selected *Shape Dynamics* and increased the size jitter and angle jitter to 20%. These settings varied the size and rotation of my butterflies by the pressure of my pen.

15. Next, I selected *Scattering* in the *Brush Presets* menu, set the count at 1, and increased the count jitter to about 70% (Fig. 22). These settings scattered the amount and distance between each butterfly (Fig. 23).

A

B

FIG. 21

FIG. 21
These settings are just an estimate. Play around with the brush options to get your desired variation.

FIG. 23
This shows the leaves background and butterfly brush work without the girl and line work.

FIG. 24
The leaves and butterflies give the background depth. You want your shapes to lead the eye around the composition.

FIG. 22

FIG. 23

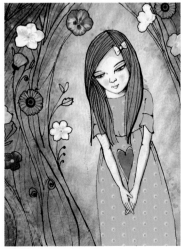

FIG. 24

STEP 8: FRAMING THE COMPOSITION

This image felt like it needed a border to open it up and give it some breathing room. Sometimes a simple border can help give a calm feel to a painting and keep the eye on the page.

1. In Photoshop, I flattened all my layers by clicking on the small right arrow in the *Layers* menu and selecting *Flatten Image* from the drop-down menu. I saved the file as NovemberGuest2.psd

2. I selected *Image > Canvas Size* and added about an inch and a half to the width and height of the canvas (Fig. 25A). I double-clicked on the canvas

extension color and selected a yellowish color (Fig. 25B). This created a yellow border around my image (Fig. 27).

3. I created a new layer (*Shift + Command/CTRL + N*) and named this layer "deckle edge." I selected the *Color Sample* tool and clicked on the background layer to select the same yellowish color that I used in the background.

4. From the *Brush Options Bar*, I selected the *Hard Pastel on Paper* brush. This is part of the default Photoshop brushes.

5. In the *Brush* menu (*Window > Brush*), I checked the box for *Texture* (Fig. 26A). I selected one of the *Artists Surfaces* textures. (If you don't see them in the list, click on the small right arrow to load them from the drop-down menu.)

6. I painted on the edges of my painting, varying the pressure of my hand (Fig. 28).

FIG. 27

FIG. 28

FIG. 25

[Canvas Size dialog box]
Canvas Size
Current Size: 24.1M
Width: 8.5 inches
Height: 11 inches
OK
Cancel
New Size: 32.2M
Width: 10 inches
Height: 12.5 inches
Relative
Anchor:
Canvas extension color: Other...

A
B

FIG. 27
A simple border can give your composition a pause and a much quieter feel, while elements breaking out of the border communicate action.

FIG. 28
A deckled edge gives a more hand-painted feel.

FIG. 29
I also scanned in some lace ribbon and used it to add more interest to the border. Raid that junk drawer and see what you can find.

[Brush panel]
BRUSH PRESETS BRUSH CLONE SOURCE
Brush Presets
Invert
Brush Tip Shape
Shape Dynamics
Scattering Scale 100%
Texture
Dual Brush
Color Dynamics Texture Each Tip
Transfer Mode: Color Burn
Noise Depth
Wet Edges
Airbrush Minimum Depth
Smoothing Depth Jitter
Protect Texture
Control: Off

B
A

FIG. 26

FIG. 29

STEP 9: GESSOING YOUR BACKGROUND

I call this step the gesso step because it is similar to applying a thin layer of gesso to a collaged image to screen it back.

1. I created a new layer (*Shift + CTRL/ Command + N*) and named this "gesso."

2. I selected the color white from the *Swatch* palette.

3. Next, I selected the same *Dry Media Brushes* used in Step 8 but lowered the opacity to less than 10%.

4. I painted lightly over the background, careful not to cover the girl.

5. I created another layer and named it "gessoed border." I painted over the border edges using increased pressure (Fig. 30).

STEP 10: ADDING TEXT

To finish this image, I added some text around the border of the image from Robert Frost's poem, "My November Guest."

1. I selected the *Type* tool from the *Tools* menu and changed the font to a handwritten font from the Control Panel's drop-down menu. I used P22 Dearest (www.p22.com/ihof/dearest.html).

2. I clicked at the top of the painting and typed in the poem on the top border.

3. I repeated this last step, typing in a different line of the poem.

4. I selected *Edit > Transform > Rotate 90 CW*.

5. I selected the *Move* tool and dragged the type to the right-hand side.

6. I repeated this process for the left and bottom sides, varying the rotation (Fig. 31).

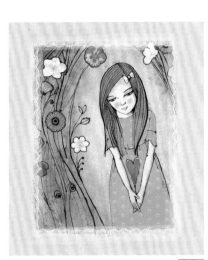

FIG. 30

FIG. 30
The gessoed brushstrokes give a softer feel to the image.

FIG. 31
The type is not just a beautiful poem, but also frames the composition keeping your eye on the center.

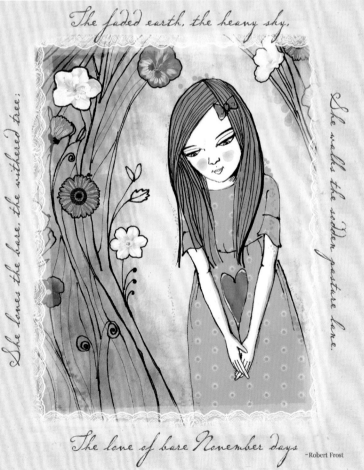

FIG. 31

06
CAPTURING LIGHT

Application
PAINTER

When Michelangelo was finishing the *Pietà* in Rome he devoted almost a year to just polishing the marble with pumice, Tripoli chalk, leather, and even straw. Why was Michelangelo so obsessed with polishing his masterpiece? The reason is simple. Michelangelo understood that light penetrates real skin. To turn marble into translucent skin, the top layer had to be polished into a semi-transparent hardness. For those who slept through Physics 101, here is a quick refresher on color theory: color is not really in an object but is actually the light that strikes the object, scatters, and then exits at a different point, eventually reaching our eyes. Five hundred years later, 3D graphics programs would give a fancy title to what Michelangelo knew: subsurface scattering or "SSS."

All objects in nature exhibit subsurface scattering to some degree, with the exception of metallic objects and glass. Hold your hand up to the sun and you will see subsurface scattering in action. In the sun, the edges of your skin will take on a redder hue. Another example of subsurface scattering is grapes. If you stroll through a vineyard on a sunny day, the skin of green grapes will look yellow, but when you bring them back inside they appear green again. This color change is in part caused by subsurface scattering.

In this tutorial, I will give you some basic tips to capture realistic light that can be used for tricky objects like skin, fur, and fire.

Pietà
Michelangelo's *Pietà* may have been a little too realistic. In 1972, a crazy tourist took a nine-pound iron hammer to the Virgin's nose while screaming, "I am Jesus Christ, risen from the dead!" Restoration artists painstakingly matched her original translucence with a mixture of marble dust and resin.

Bellerophon Slaying Chimaera
You have probably already guessed that fembots and fantasy creatures are not my thing, but I make an exception for Greek mythology. If you are ever looking for something narrative to paint, you can find tons of inspiration in Greek myths.

STORY OF THE PAINTING

The painting opposite tells the story of Bellerophon. Bellerophon was one of those warriors who made all the Greek ladies get a little sweaty under their chitons. The story goes that after capturing the winged horse Pegasus, Bellerophon caught the eye of Queen Stheneboea. But Bellerophon spurned her advances, and as punishment, he was ordered to slay the Chimaera—a fire-breathing monster with a lion's head, a second goat's head, and a snake's tail. Don't go petting this pup. Does Bellerophon succeed in his task? Well, if I told you that then it just might kill the suspense in this painting.

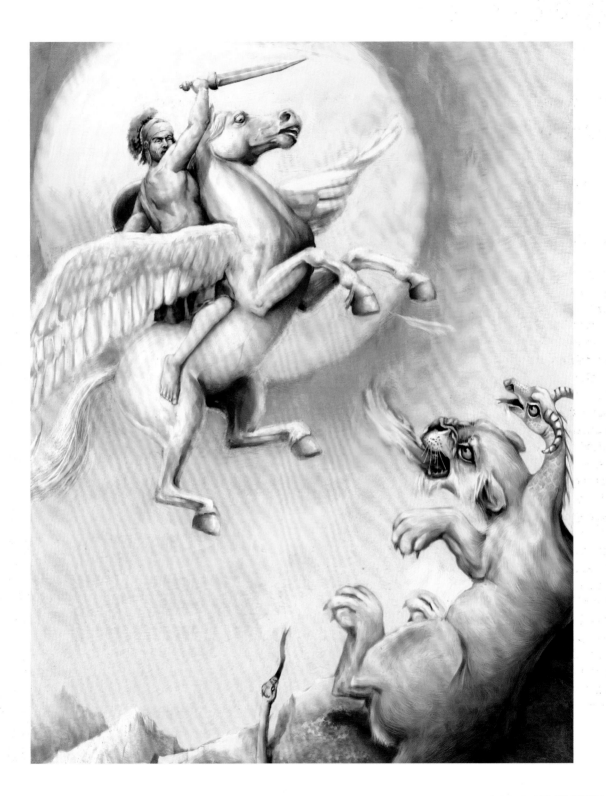

STEP 1: PREPPING YOUR UNDERPAINTING

For this painting, I used a color I never use in an underpainting: bright yellow. Skin can sometimes look very unnatural with a yellow cast. Fortunately, these characters are not in your typical outdoor setting, but are going to be lit by a fireball sun. First off, you should understand how to set a base color and light source, which I'll review again here. If this is brand new to you, go back and have a look at Part 1, Chapter 8.

1. I followed the steps for "Coloring a Sketch" on p. 36 and put my sketch above my canvas layer with a composite method of *Multiply*.

2. I chose a bright yellow color from the *Color* palette (*Window > Color Panels > Color*).

3. I selected my canvas layer and the *Paint Bucket* tool. I clicked inside my document to fill the entire canvas with yellow.

4. I selected *Effects > Surface Control > Apply Lighting*. In the *Lighting* menu, I selected the first box under the preview window for *Gradual Light*. I dragged the wand's handle to control the direction of my light source and increased the elevation slider. I clicked on the box labeled *Light Color* to bring up the color wheel and chose a warmer yellow. I repeated the same process for *Ambient Light Color* and chose a muted blue color. Finally, I selected *OK* (Fig. 1).

FIG. 1

FIG. 2

STEP 2: PAINT IN YOUR UNDERPAINTING

Next, I used the *Real Fan Short* brush to block in color. I love this brush because its shape really resembles a flat fan brush so you can easily blend colors or get a sharp edge.

1. I selected the *Real Fan Short* brush variant from the *Oils* brush category and set the blend at 0% (Fig. 2B) and the feature to 3.2 (Fig. 2A). Setting the bleed low kept my colors from blending with each other.

2. Next, I blocked in my first layer of color, paying attention to my color relationships. As I painted, I varied the feature in the brush, increasing it when I wanted a more bristly mark (Fig. 3).

FIG. 3

STEP 3: BLENDING AND GLAZING

Next, I glazed in more paint to model Pegasus and Bellerophon. As I painted, I resisted the urge to use the Blender brushes because they tend to blur the brushstrokes too much. Instead, I adjusted the *Real Fan Short* brush.

1. I lowered the opacity of the brush to less than 30%. In the *Color Variability* menu, I increased the hue, saturation, and value sliders slightly to vary the color of the paint loaded on the brush.

2. In the *Property Bar*, I increased the bleed to about 25%. I continued to increase the bleed as I painted thinner and thinner glazes. I used this brush to glaze in yellows on top of Pegasus and Bellerophon.

3. For areas like the wings and tail that should have softer edges, I switched to the *Real Fan Soft* brush in the *Oils* brush category. I kept this brush at its default settings (Fig. 4).

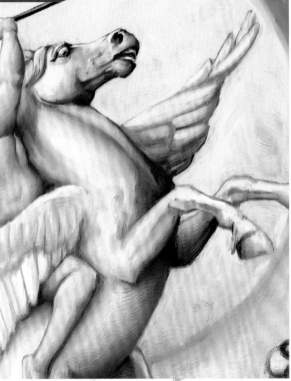

Because I use the *Oils* brush category so frequently, I have created a *Custom Palette* to quickly switch back and forth between the Real Fan Short, Real Fan Soft, and Real Round. To create your own custom palette hold down the *Shift* key while dragging the *Brush* icon from the *Brush Selector*. Painter will automatically create a new palette. Then continue to drag brushes into your new palette.

FIG. 4
The reason I use the Real Fan brush at a higher bleed is because I can pick up a color and blend that color into the underlying color as I paint. You might ask why I don't use the blender brushes to blend. The blenders do not apply colors in a glazing manner. They only blend the colors already there (see sidebar).

FIG. 4

STEP 4: PAINTING FUR

Now it's time to give the beastly Chimaera some fur. The trick to painting fur is to always lay light on top of dark. If you look at the way the light catches animal fur, there is an underlying shadow beneath the lighter hair.

1. I selected the *Brush* tool and then the *Real Round* brush from the *Oils* brush category. I increased the feature to a number greater than 5 and picked a dark umber color to create the underlying shadows in the fur. When doing hair, I always keep the brush at 100% opacity because I want the bristle marks to be opaque and not blend with the underlying layer.

2. Next, I switched to a lighter color and increased the Feature. I used short dabs on the hair near his legs to resemble shorter hair and longer strokes on his back and the hair coming off his face.

3. At the last step, I created a new layer by selecting the *New Layer* icon. I set the layer's composite method to *Hard Light*. Using a warm yellow, I used the same brush to paint in where the light catches the fur. Hard Light works like a flashlight creating dramatic lighting on top of my values (Fig. 5).

FIG. 5

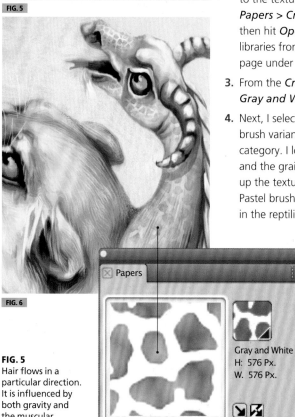

FIG. 6

FIG. 5
Hair flows in a particular direction. It is influenced by both gravity and the muscular structure.

FIG. 6 & 7
Remember to vary the size of the paper texture.

Papers

Gray and White
H: 576 Px.
W. 576 Px.

225%
204%
50% ————— A

FIG. 7

STEP 5: PAINTING SCALES

Painting textures on top of animals is one of my favorite digital painting techniques as I can "try on" different textures. Here are the steps I used to give the scary goat's head a reptilian texture.

1. I created a new layer by selecting the *New Layer* icon and named it "scales."

2. In the *Paper Library* menu **(***Window > Paper Panels > Paper Libraries***)** I clicked on the small right arrow and selected *Import Legacy Paper Library* from the drop-down menu. I navigated to the textures folder (*Extra Content > Papers > Crack Textures.papers*) and then hit *Open* (you can download extra libraries from the Corel Painter Product page under the Resources tab; see p.39).

3. From the *Crack Textures* library, I chose *Gray and White Paper* (Fig. 7).

4. Next, I selected the *Square Hard Pastel* brush variant from the *Pastel* brush category. I lowered the opacity to 10% and the grain to 8%. This brush picked up the texture of my paper. Using the Pastel brush and a red color, I painted in the reptilian skin. For the beast's neck, I increased the size of his scales in the *Papers* menu (*Windows > Paper Panels > Papers*) and increased the size to 225% (Fig. 7A).

STEP 6: PAINTING FIRE

Next, I gave the Chimaera fire-breathing capabilities to to make him more threatening. There are a thousand ways to paint fire, but this is the technique I use:

1. I created a new layer by selecting the *New Layer* icon and named it "fire."

2. Using the *Real Fan Short* brush with the feature set to 2, I blocked in the general movement of the fire in a streamer shape. Think of this stage as creating ribbons of light (Fig. 8).

3. Next, I created a new layer and named it "smear." I selected the *Smear* brush variant from the *Blenders* category and set its opacity and bleed to 100%. This is a brush that really pulls the paint. I created some direction to the fire by painting in an upward motion, starting from the core to the edge. Fire never follows a straight path unless there is absolutely no wind. Pegasus' wings would definitely be sucking the fire upward (Fig. 9).

4. Lastly, the fire would be coloring the underbelly of Pegasus and his hooves in a harsher light, so I created a new layer above my smear layer and set its composite method to *Hard Light*. Then, I chose the *Square Hard Pastel* brush and chose the *Sandy Pastel* paper from the *Paper Library*. This brush and paper combination created diffused light. I wanted the underbelly to have a stronger yellow cast, but for it to hit the horse and gradually fall off in the gray values (Fig. 10).

FIG. 8

FIG. 9

FIG. 10

QUICK TIP FIRE COLORS

To create convincing fire, it should have three main parts: a white-hot core; a middle, orange/yellow layer; and a darker, redder edge. I sometimes see painters use blue in the core of the fire, but I personally think this is a bad idea, because if your flame is shooting outward the larger flames engulf the blue flames. Your fire will also look more convincing if you paint it on a darker background as the colors will appear more vibrant.

FIG. 8
I blocked in the strokes using a flat brush. Remember to create movement in the flames by creating teardrop shapes.

FIG. 9
Next, I used the Smear tool to create direction and blend the colors together. Sometimes I use multiple layers to get the right amount of blurring. Remember to only blur in the parts of the flame that have the most movement.

FIG. 10
Lastly, I applied Hard Light to where the fire would hit the horse.

STEP 7:
ATMOSPHERIC PERSPECTIVE

I generally like to keep my wild brushstrokes in my backgrounds without much blending, but I just can't get away with it here. The yellows and oranges are too vibrant, and, as a result, they pop forward, becoming too distracting. I want them to recede, so I am going to have to do a little blurring to create a sense of depth. You might ask why I don't use one of the handy blur filters. The reason is that your eye does not uniformly blur backgrounds when focusing on a subject in the foreground. So, to create a more natural atmospheric perspective, I will have to skip the filters and get painting.

1. I created a new layer by selecting the *New Layer* icon in the *Layers* palette and named it "blended bg."

2. To blend the background, I first needed the right brush. I like the *Grainy Blender* brush variant found under the *Blenders* category because it blends without losing too much of the brushstroke. I lowered the opacity of this brush in the darker orange areas and increased it on the edges where the sun meets the sky.

3. Next, I used the same brush on the wings to create softer feathers (Fig. 12).

> **QUICK TIP**
> **FEELING BLUE**
>
> When objects are in the distance, colors appear less saturated because the atmosphere scatters light. Blue, with its shorter wavelengths, scatters more than other colors. (This is why the sky is blue.) So, the best way to make objects appear more distant is not through blurring, but through simply adding blue. Still, rules are made to be broken. I would lose the sense of a burning, hot sun if I muted the background with blue, so blurring is going to have to do.

FIG. 11
The original's brushstrokes in the background were too sharp.

FIG. 12
After applying the Grainy Blender brush the background appeared hazier. I recommend using blurring to create atmospheric perspective only when you cannot create it with hue and saturation.

Sharp brushstrokes

Hazier background

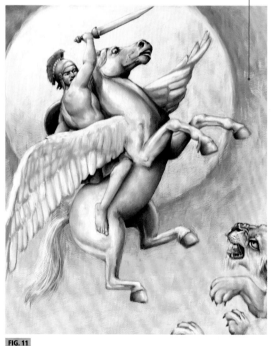

FIG. 11

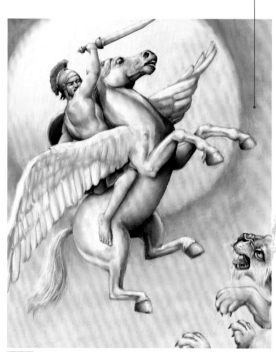

FIG. 12

STEP 8: REFINING THE EDGES

The edges of your forms are an integral part of creating realistic forms. They also lead your eye around the painting. Because I used a flat brush, I now have too many sharp edges, which can be confusing, as it will give the painting too many focal points. In this step, I look to see where the edge should be blurred into the background and where it should be kept sharp. Here are a few brush tricks to create a more blended edge.

1. I created a new layer by selecting the *New Layer* icon in the *Layers* palette and named it "softer edge." I set the composite method to *Overlay* and lowered the opacity to 50%.

2. Next, I selected the *Square Hard Pastel* brush variant from the *Pastel* brush category. I lowered the grain to 9% and the opacity to 15%.

3. I then selected the *Sandy Pastel* paper from the *Paper Library* (Fig. 13). Painting on this paper will create a grainy brushstroke. I looked for edges that should recede into the background as I painted.

4. For even softer edges, I used the *Confusion* brush variant found under the *FX* brush category (Fig. 14). This is a strange little brush that mixes up the pixels to create a hazy effect. I used this brush on the wings farthest from the viewer. I increased the grain to 50% and used a light touch (Fig. 17).

Paper Libraries

Paper Textures

FIG. 13

F–X
Confusion

38.1 25% Grain: 50%

FIG. 14

QUICK TIP
SOFT OR SHARP?

Round objects should generally have a softer edge unless the round object has a high value contrast with its background or neighboring objects.

FIG. 15

FIG. 16

FIG. 17

FIG. 15
Original. Too many hard edges.

FIG. 16
Putting Hard Light on edges with Pastel brush and Sandy Pastel paper blends the background into Pegasus.

FIG. 17
I use the Confusion brush to create haze and a much softer edge on the flapping wings.

FIG. 18

FIG. 19

FIG. 20

STEP 9: FIXING COMPOSITION PROBLEMS

A good trick to check for anatomy mistakes is to flip your image (*Edit > Flip Horizontal*). It may be that flipping your image wakes your brain up and forces you to see things differently. When I flipped the image, I literally gasped in horror. I had made a million mistakes. His eyes were too low. The helmet wasn't sitting on his head right. His head was not in line with his body. His tricep muscles didn't look long enough, and the muscles in his back would be more stretched, if he were truly sweeping his sword backward (Fig. 18). I am not too proud to say that I had made a mess of things. Whenever I have these anatomy problems, I reduce things back to shapes and lines. So, I got out my trusty pencil tool and drew over the figure paying attention to how I knew the muscles should connect (Fig. 19).

Next, I found some compositional problems. First of all, the figures are the same size, so I don't have a clear indication of who is in the distance and who is in the foreground. Size is one of the many ways to create spacial depth.

The second compositional problem was the direction of the motion. Currently, the action sweeps the eye into very boring corners (Fig. 21). Even worse, the dramatic curve makes the horse look like he is flying up, not down.

To fix these problems, I rotated Pegasus so that he has a less dramatic slant upward (see

Step 10 opposite). He now appears to be flying down rather than up. Lastly, I painted some happy little mountains into the corner. These mountains create a wall to force the eye to stay on the page (Fig. 22).

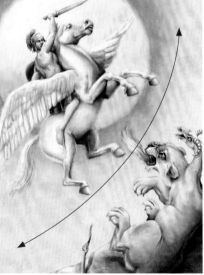

FIG. 21

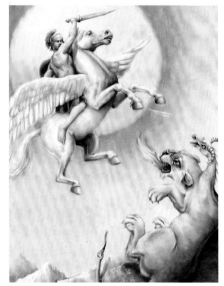

FIG. 22

STEP 10: RESIZING, ROTATING, AND MOVING FIGURES

If you are like me and prefer to dive right in without a lot of preliminary sketches and model fees, then the digital medium can be a lifesaver. It would have taken me days to fix these composition problems with traditional paint. Thankfully, it will only take a few minutes on the computer. Follow these steps to resize, rotate, and move any item into a stronger composition.

1. I selected the background layer because it contained Pegasus.

2. Using the *Lasso Selection* tool found in the *Toolbox*, I made a rough selection around the top left half of the painting.

To make a selection with the *Lasso* tool, just draw with it like a paintbrush. If you want to add to your selection, hold down the *Shift* key as you draw. If you want to subtract from your selection, hold down the *Alt/Option* key as you draw (Fig. 23).

3. I selected *Edit > Copy* and then *Edit > Paste in Place*. This created a duplicate of the selection over the original.

4. From the *Toolbox,* I selected the *Transform* tool (Fig. 24B). The Transform tool is hidden underneath the fly-out menu of the *Move* tool (Fig. 24A). So if you don't see the Transform tool, click on the Move tool and then pull to the right.

5. In the *Property Bar*, I clicked on *Scale* mode (Fig. 25A). Then I clicked on the

corner circle of the selction and held down *Shift* as I dragged inward. Holding down Shift constrained my proportions.

6. Next, I rotated Pegasus by selecting the *Rotate* tool (Fig. 25B). To rotate, click on the corner circle and rotate your item to the desired position (Fig. 26).

7. When I was happy with my changes, I checked *Commit Transformation* (Fig. 25C).

8. Lastly, I painted in the areas that now needed to be filled in with the *Real Fan Short* brush.

FIG. 23

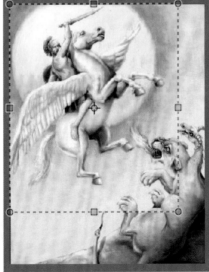

FIG. 26

QUICK TIP
COPY, DON'T CUT

The reason why I copied and then Pasted in Place vs. Cut and then Pasted in Place is because cutting will create ugly white gaps that need to be filled in. It is far easier to fill in areas seamlessly if they have bits of the background to match up with.

BREAKING IT DOWN

Reflective, hard objects should have a sharp edge.

I used more blending on distant elements to make them recede.

The falling feathers give the painting a feeling of gravity.

Pay attention to your edges. I used hard edges on the right legs to help project them toward the viewer, and soft edges on the left legs to help them recede.

I used more blue at the bottom for a hazy effect.

Remember that jagged shapes will feel harsh while rounded shapes will feel calmer. I used a round sun to emphasize Bellerophon while the Chimaera is framed with jagged, pointy cliffs. There are always exceptions, but generally, the good guys get round shapes while the bad guys get angular shapes.

I lowered the opacity of my brush and used more blue to make the distant mountains recede.

"As a painter, I always strive to be true to what I feel when creating an image. I start by establishing the darkest areas, typically the shadows, and work my way up to the lightest areas. Subtle areas of light and shadow become very important, to keep the image from having too much contrast. You can achieve these subtle areas by choosing paint colors from the darkest and the lightest areas of the image. I then adjust these colors to be slightly lighter or darker, and I introduce other colors from the same color families. Painting with light digitally can be very similar to painting with traditional paints."

www.DennisOrlando.com
dennisorlando@verizon.net

FIG. 1
Flowers in Light and Shadow

FIG. 2
Dock with Colorful Boats

FIG. 3
Canoe Trip at Cedar Water

FIG. 4
The Old Balcony, Venice

FIG. 1

FIG. 2

07
PORTRAIT OF DRAMA

Application
PAINTER/PHOTOSHOP

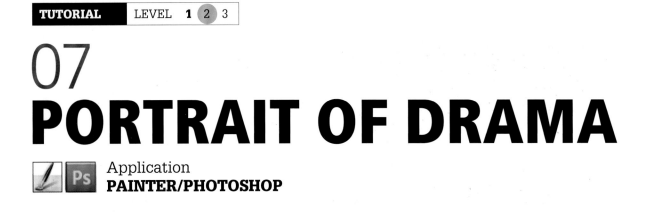

This painting was inspired by the Commedia dell'arte theater of the sixteenth through to the eighteenth century. Commedia dell'arte means "comedy of the actor's guild," and it was essentially the improvised comedy of its day. Actors did not follow a script, but rather a general plot outline that would be remarkably similar to popular sitcoms today.

Men disguised themselves as women to win the girl, jealous rivals fought in slapstick battle scenes, and thwarted lovers met in secret. One of the most fascinating aspects of the Commedia dell'arte was the sinister-looking masks worn by the actors. Without the use of their facial expressions, we can imagine that actors had to convey emotions through every part of their body. I believe a good painting is like the Commedia dell'arte. It begins with a rough outline and then unfolds with every gesture communicating the drama.

In this painting, the man is playing the role of Scaramouche—a Spanish captain better known for his skirt-chasing skills than his seafaring. The woman is playing the role of the foxy Colombina, and, unbeknownst to her, Scaramouche is lurking in the background about to do something diabolical.

Colombina
For the style of this painting, I was inspired by the bold brushwork of impressionists like John Singer Sargent and Giovanni Boldini. This tutorial covers how to translate the impressionists' painting style into the digital medium.

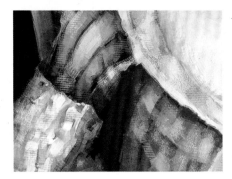

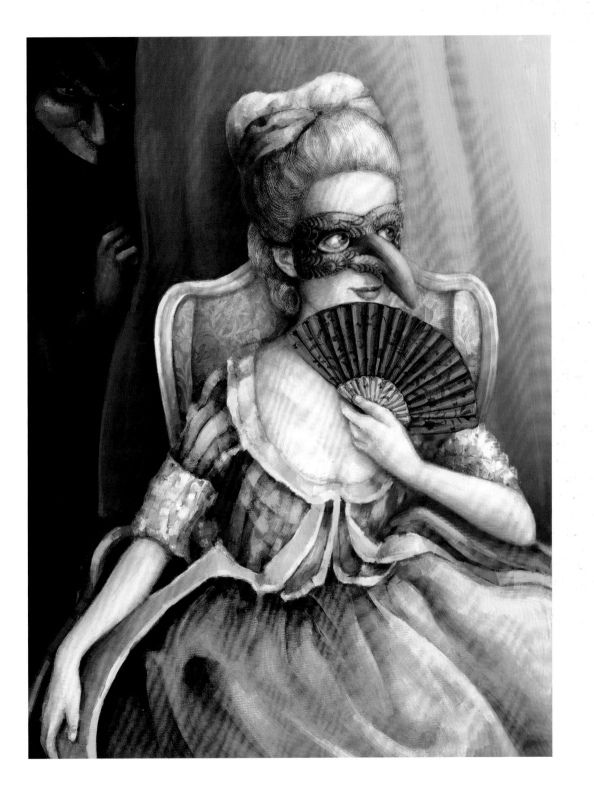

STEP 1: GATHER VISUAL REFERENCES

For this painting, I collected a library of my favorite John Singer Sargent portraits and a sixteenth-century Flemish painting of the Commedia dell'arte. For costume resources, I found a book containing eighteenth-century fashion plates and a history blog with many examples of eighteenth-century clothing (18thcenturyblog.com). However, keep in mind that working from photos can be deceptive. The dynamic range of color in a photograph (especially onscreen) is very different from how your eye interprets a subject in real life. In a photograph, blacks appear black and whites appear white, but in real life, shadows and highlights are full of color. Copying a photo will sometimes make your art appear too flat unless you use your artistic eye to fill in the missing details.

FIG. 1

FIG. 2

FIG. 3

FIG. 1
Lady Agnew of Lochnaw, 1892
John Singer Sargent

FIG. 2
An eighteenth-century Polonaise
Gallerie de Modes, 1770

FIG. 3
The Commedia dell'Arte Troupe Gelosi
Late 16th-century Flemish painting

STEP 2:
APPLY YOUR BASE

Before I began my painting, I followed the steps for setting a base color and light source on p. 46–47. I chose a grayish-green base to create a Verdaccio underpainting. For my brushes, I started with the *Dry Bristle* brush set at 100% opacity. I like the paint to go on really thick.

1. I selected the *Dry Bristle* brush from under the *Acrylics* brush category in the *Brush Selector* (Fig. 4).

2. Then, I changed the dab type to a *Square Bristle* brush (Fig. 5).

3. Next, I opened the brush's *General* settings (*Window > Brush Control Panels > General*) (Fig. 6). I changed the opacity expression (Fig. 6A) and the grain expression to *Pressure* (Fig. 6B).

4. Next, I selected the *Paintbrush* tool and then selected the canvas layer. I started by using quick long strokes. This part is like finger painting: I just slapped the color on. I tried not to focus on the details, but instead on how color defined the foreground and background relationship.

5. After I had mapped out a general idea of color, I dropped my sketch layer down because I don't need it anymore as a guide. To drop the sketch layer, I clicked on the right arrow under the *Layers* palette and selected *Drop*.

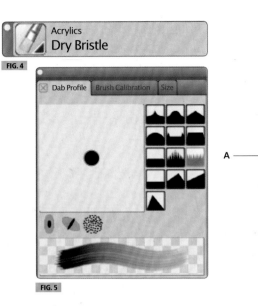

FIG. 4

FIG. 5

FIG. 6

FIG. 7

FIG. 7
When first laying down color, I make fast brushstrokes. Your marks at this stage will hold the energy of the painting. If you make timid brushstrokes then your painting will feel timid. Be bold. This is digital painting, so you can always "undo" (*Command/CTRL + Z*).

STEP 3:
APPLY THICKER PAINT

At this stage, I am still resisting the urge to add details so I am going to switch to one of my favorite brushes—the *Sargent Brush*. Sargent painted much like a sculptor, by using flat planes of color to define his subject. The Sargent Brush is a square-shaped brush, perfect for forcing artists to define shapes with blocks of color. To use this Brush:

1. I selected the *Sargent Brush* from the *Artists* category in the *Brush Selector* (Fig. 9).

2. Sargent used tons of paint when he began his portraits, but I kept the opacity to around 20% because this brush picked up more of my brushstrokes at a lower opacity (Fig. 10).

STEP 4:
APPLY THINNER GLAZES

Next, I painted in glazes to model the figures with thinner paint. To do this I had to first tweak my Sargent brush.

1. I created a new layer by selecting the *New Layer* icon.

2. In the *Menu Toolbar,* I opened the brush's *General* settings by selecting *Window > Brush Control Panels > General*. In the method drop-down menu, I selected *Cover* (Fig. 11A). In the subcategory drop-down menu, I selected *Soft Cover* (Fig. 11B).

FIG. 8
The Sargent Brush is a good brush to keep you from getting caught up in details. Think about the direction of your brushstrokes. Every stroke should follow through to another stroke, which is why it is important to move around the painting continually instead of zooming in on one area.

3. In the *Property Bar*, I set the opacity to 35%, the resaturation to 25%, and the bleed to 100%.

4. As I painted in glazes, I varied the resaturation to pick up different amounts of paint. I also sometimes set the resaturation to 0% so I could use the brush like I would use turpentine, blending two colors together (Fig. 12).

FIG. 8

Artists
Sargent Brush

FIG. 9

General

Dab Type:	Captured	
Stroke Type:	Single	
• Method:	Cover	
• Subcategory:	Soft Cover	
Source:	Color	

FIG. 11

A
B

FIG. 12
I painted more blues into the background to help it recede. Blues will help an object recede while warmer colors such as the color of her dress will come forward.

| | 20.4 | | 20% | Grain: | 100% | Jitter: | 0.00 |

FIG. 10

FIG. 12

STEP 5:
ADD CANVAS TEXTURE

Now that I have begun to model my figures, I need to bring back some of the canvas texture that has been lost.

1. I created a new layer by selecting the *New Layer* icon.

2. In the *Menu Toolbar*, I opened the brush's *General* settings by selecting *Window > Brush Control Panels > General*. In the method drop-down menu, I kept the brush set to *Cover* (Fig. 14A). In the subcategory drop-down menu, I selected *Grainy Hard Cover* (Fig. 14B). These settings add canvas texture as I paint.

3. In the *Property Bar*, I set the opacity to 100% (Fig. 13A), the grain to 100% (Fig. 13B), the resaturation to 25% (Fig. 13C), and the bleed to 100% (Fig. 13D).

4. Next, I changed my paper (*Window > Paper Panels > Paper Libraries*) to the *Gessoed Canvas* paper. These settings created a blocky brush that picked up a slight canvas texture. To allow varying levels of texture, I lowered the grain (Fig. 13B) as I painted. It is important to vary the level of grain in your brushwork or the texture will look like one big tile (Fig. 16).

QUICK TIP
SAVING BRUSHES

If you like any of these modified Sargent brushes, save the brush as a brush variant by clicking the small right arrow in the Brush Selector's drop-down menu and selecting *Save Variant*. The brush will now appear in the list of brush variants in the *Artists* brush category.

A B C D

FIG. 13

FIG. 14

FIG. 15
When adding in texture in traditional painting, the white areas would have thicker paint and the darker areas thinner washes, letting the canvas show through. To make your texture more believable, use this same principle and apply the more textured brushes on the darker areas.

FIG. 15

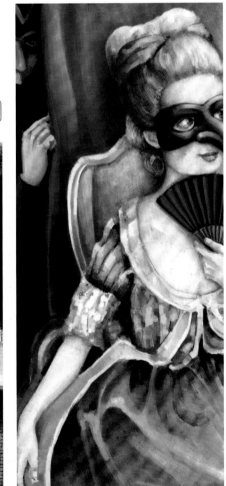

FIG. 16

STEP 6: STEP AWAY FROM THE PAINTING

Go run an errand. Visit your mom. Visit a museum. At this point, you need to detach yourself from your work and come back to it with fresh eyes. After I had taken a break from my painting, I realized that my midtones were looking a little flat. If your painting does not have enough contrast between dark and light, then it is going to lack dimension. A common mistake is to use a darker or lighter version of a color to define a shape. For example, if you are modeling a green ball, you use a darker green for the shadows and a light green for the highlights. However, for more dynamic contrasts I use complementary colors to define objects.

STEP 7: INCREASE CONTRAST

One of the tricks I use to paint with more light is to paint on a new layer set to *Hard Light*. Switching to Hard Light does just that—it shines a hard light on your colors. This forces any colors that are below a 50% tonality lighter and above a 50% tonality darker. The result is a greater dynamic range of dark to light. To paint with hard light:

1. I created a new layer by selecting the right arrow in the *Layers* menu and then selected *New Layer*. I then changed the composite method to *Hard Light* (Fig. 17).

2. I painted with a complementary color on the areas that looked washed out. I used light green and yellows on the highlighted areas, like her forehead, and blues in the shadowed folds of her dress.

FIG. 17
You may need to lower the opacity of your Hard Light layer to decrease this effect.

FIG. 18
I set a layer to Hard Light to warm up the skin tones and punch up the colors in her dress. I defined many of the highlights with a light yellowish-green and the shadows with a dark blue.

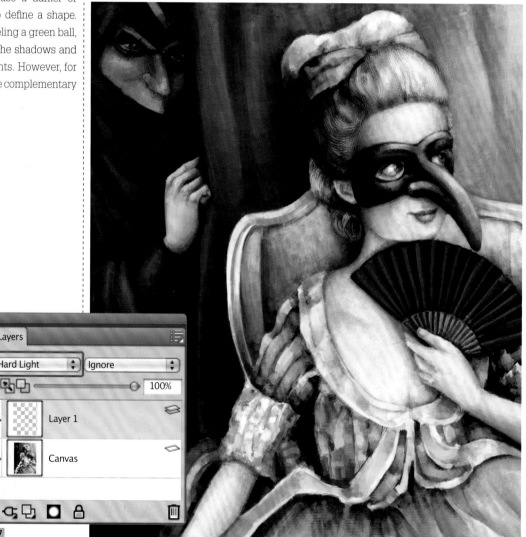

FIG. 17

FIG. 18

STEP 8:
ADD SURFACE PATTERNS

Surface patterns not only give your work more visual interest, but they also give narrative clues to your painting's time period. In this painting, I used an eighteenth-century fabric to decorate the chair (Fig. 19). You can find publications with royalty-free images and also use patterns in vintage fabric books with expired copyrights.

1. I opened my fabric pattern in Painter and chose *Select > All* from the main *Menu* bar. A dotted line around my canvas area indicated that it was a selection.

2. Next, I dragged my pattern selection onto my painting. This created a new layer on top of the canvas layer. I named this layer "chair fabric."

3. I added a layer mask by selecting the *New Layer Mask* icon in the *Layers* palette and selected the right-hand thumb in the *Layers* palette. Using black, I masked out the areas that went past the chair.

4. Next, I set the layer's composite method to *Overlay* and lowered the opacity to 50%.

5. Often, I am done at this point, but because I used a very painterly brushstroke, I need to make the chair fabric blend in with the rest of my brushstrokes. So I selected the *Sargent Brush* and used the pattern as an outline to paint over it. (Fig. 20).

6. The pattern for the fan uses the same process, but I am not going to paint over it. I want this pattern sharper than the chair fabric because it is in the foreground (Fig. 23).

7. The last area that needs a little decoration is Colombina's mask. I drew the pattern in Illustrator and then pasted it (*Command/Ctrl + V*)

FIG. 22

FIG. 23

FIG. 19
Eighteenth-century fabric to cover the chair.

FIG. 20
I didn't want the pattern of the chair to look stuck on so I used my Sargent Brush to trace over it. This gave it a painterly feel.

FIG. 21
To add a pattern to the mask, I set the pattern layer to Hard Light because I wanted a more dramatic effect.

FIG. 22
The fan pattern before setting the layer to Overlay.

FIG. 23
I masked out the pattern in between the folds so that it only appears where the light is hitting it.

on top of my painting. I set the pattern layer's composite method to *Hard Light* (Fig. 21).

QUICK TIP
RESTRAINT!

At this point, it would be very tempting to start putting patterns on everything—the curtain, Colombina's dress, Scaramouche's clothes, random tattoos—but it is better to show restraint. The surface patterns we use will pull the eye to those areas. I chose the fan, the mask, and the chair because they are the focal areas of the painting. I wanted these patterns to give an air of realism, but not steal the show.

FIG. 19

FIG. 20

FIG. 21

BREAKING IT DOWN

I could work on this painting until I was too old to hold up my stylus and it would still never look like a Sargent. But, I'm okay with that. Be inspired by other artists, but make it your own.

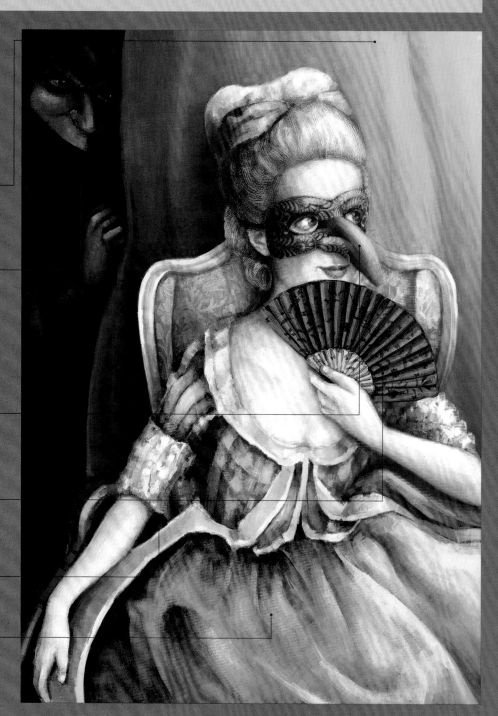

Green can be a tough color to use as a base because it gives off a ghastly light. I would normally use it more sparingly, but this time I wanted a garish lighting.

To make Scaramouche even more sinister-looking, I deepened the shadows surrounding him. This also put more focus on Colombina. Always keep in mind where you want the viewer's eye to go first. I want the viewer to see Colombina first and what is lurking in the shadows second.

In this portrait, I put the focus on her dramatic nose. I then made all the elements point to that one dramatic feature. Try to pick one feature to emphasize.

In the final edits, I raised Colombina's fan so that she was covering her face in a more coquettish fashion.

For white highlights, I sometimes switch to an Impasto brush to get a deeper build up of paint.

The folds of the dress should have looser brushstrokes. This creates a feeling of motion.

Don Seegmiller is a successful artist, author, and instructor. Don teaches both traditional and digital painting and conducts classes for the Academy of Art University online. He is the author of *Digital Character Design and Painting*; *Digital Character Painting Using Photoshop CS3*: and *Advanced Painter Techniques*; he also co-authored Ballistic Publishing's *Digital Painting 2*. Don conducts regular sold-out workshops for the CG Society and is on the Corel Painter Advisory committee.

www.seegmillerart.com
don@seegmillerart.com

Don Seegmiller's painting processes closely follow the same methods used when traditionally painting. While his first choice in tools on the computer is Corel Painter, he also uses Photoshop extensively.

FIG. 1

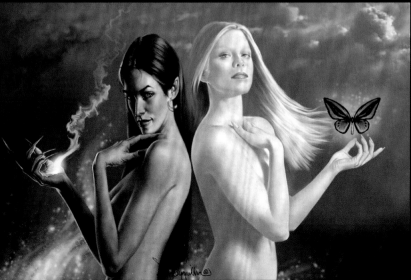

FIG. 2

FIG. 1
*The Princess and
the Pea*

FIG. 2
Redcoat

FIG. 3
Heaven and Hell

08
EDIBLE IMPASTO

 Ps Application
PAINTER/PHOTOSHOP

Before attempting this still life, I was a firm believer that fruit was for eating and not painting. But painting fruit did force me to think about the importance of each brushstroke. To start, I learned that still life paintings are a lot harder than they look. Each brushstroke has to convey a sense of drama. And yes, even a simple apple can tell a dramatic story.

As the great Paul Cézanne said, "I would like to astonish Paris with an apple." And astonish he did. In one of his first exhibitions, Manet refused to exhibit next to him, describing Cézanne as "a bricklayer who paints with his trowel." Ouch. Things went downhill from there. The exhibition proved an utter failure with one critic bitingly writing, "Mr. Cézanne merely gives the impression of being some sort of mad man who paints in delirium tremens." Well, I wouldn't recommend delirium tremens, but it seems to have worked for Cézanne.

Paul Cézanne
Still Life with Apples
From far away it looks like Cézanne used a big brush to create large, flat planes of color. But when you get up close to his paintings, you realize he used a very small brush, painting dabs on top of dabs. Just like with Pointilism, discussed on p. 85, your eye combines these small dabs to form one color.

Another characteristic of Cézanne's paintings is that he really didn't use one strong light source. It's as if light passes through all the objects.

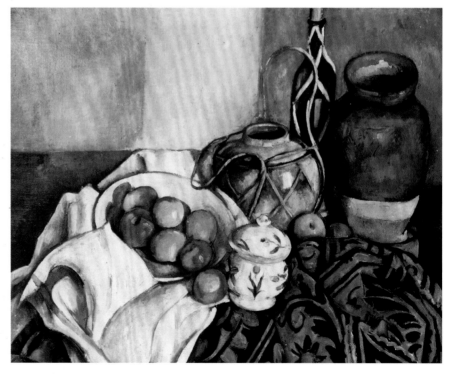

> " "
> **PAUL CÉZANNE**
> *"I would like to astonish Paris with an apple."*

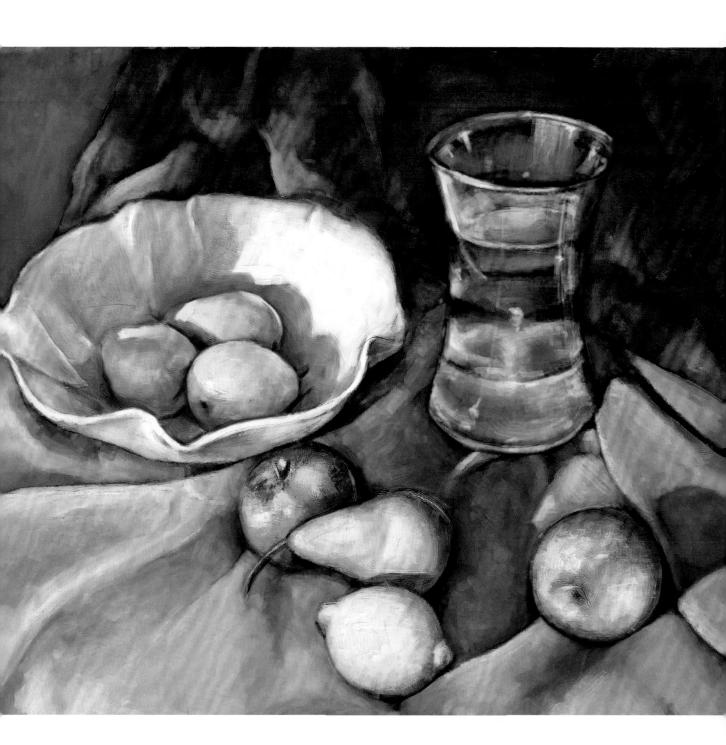

STEP 1: PREPARING PHOTO REFERENCES

In this painting, I did the unthinkable. I took a photograph to work from and then . . . I ate my still life. It was tasty. You really don't have to be an expert photographer to take a good reference shot. Here are a few tips to help get you started:

Lighting:

- If you don't have fancy lighting equipment, just use a window. Natural light can often take better pictures than expensive lighting gear. Just make sure that the window light is behind you when you take the picture and turn off your flash.

- Think about how the light is going to lead the eye around the painting. I shot this fruit near a big window so I had tons of light playing off each of the shapes.

Arrangement:

- Every still life has a rhythm to it. By rhythm, I mean how each object leads the eye from foreground to background. Sometimes just simplifying your arrangement can make a stronger composition. Start with the most important objects and then slowly add more objects. If something doesn't feel right, take it out.

- It can help to have one tall object to anchor the eye to a fixed point and provide balance against lower objects. In most cases, you will not want this "anchor" object in the center. Think of the anchor object as marking the boundaries of your composition.

- Try taking photographs from several different angles and then select three shots to create one composition.

- Don't feel like you have to paint fruit. Empty out your pockets. Use found objects. Paint snakes and toads, your pet squirrel, dirty socks—whatever interests you. But do try to find a theme among your objects so that they feel related to each other.

- Keep color to a minimum and make sure your foreground and background colors are related.

Background:

- Your background can also make or break your composition. I prefer to use neutral backgrounds because they make the foreground objects more pronounced.

- If you have light objects in your foreground, use a darker background, and vice versa.

- Textured fabric can make an interesting background, because it scatters the light on its surface, making it a good choice for more impressionistic brushwork.

- Use a black background to add intensity. (Black will punch up the saturation of your foreground colors.)

- Use a white background if you want a softer feel.

Slow it down:

- Most cameras allow you to turn down your shutter speed. This will allow your camera to use a smaller aperture and get more depth of field.

- If you don't want to mess around with shutter speeds, some cameras have a "portrait" mode.

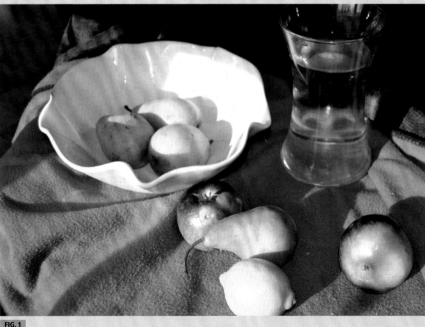

FIG. 1

STEP 2: SKETCHING THE COMPOSITION

First, I sketched the rough contour of my fruit and then scanned in my sketch (Fig. 2). I have defined my fruit fairly realistically, but the wonderful thing about still life painting is you really don't have to worry about whether your apple even looks like an apple. Have the confidence to distort your shapes if it feels rights for your painting. Think of Cézanne's work, and how he completely ignored the rules of linear perspective.

STEP 3: DEFINING THE LIGHT SOURCE

I chose to use blue as my base color to help the blanket recede. Remember that this base color will set the mood for your still life, so choose this color wisely. I am going for a somber look, so this slate blue color will work perfectly (Fig. 3). For more on defining a light source, follow the steps on p. 46–47 for "Prepping your Underpainting."

IMPORTANT!

When working with Impasto brushes, you must save and work in the .riff format to keep impasto effects. I do all my brushwork in Painter and then flatten the file to be opened in Photoshop for color correction and preparation for press.

STEP 4: SETTING BASE COLORS

Next, I laid down my base colors. I chose the *Variable Flat Opaque* brush found in the *Impasto* brush category.

1. At this step, I stripped the depth out of my brush becasue I only wanted a thin wash of color. To use an *Impasto* brush without depth, I selected *Window > Brush Control Panels > Impasto*. Under the *Draw To* menu I changed the drop-down menu to *Color* (Fig. 4). Now the brush paints only with color.

2. In the *Color Variability* menu (*Window > Brush Control Panels > Color Variability*) I set the hue to 4% and the saturation and value to 10%. Changing these settings will make each brushstroke apply varying degrees of hue, saturation, and value (Fig. 5).

 Variable Flat Opaque

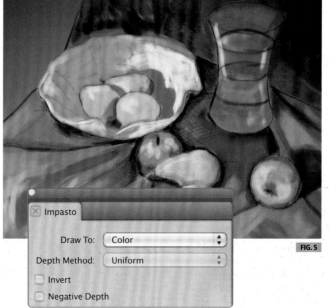

FIG. 4

FIG. 2

FIG. 3

FIG. 2
A rough sketch marks out the placement of my still life. I have stolen another trick from Cézanne and distorted the size of my foreground objects to make them appear closer.

FIG. 3
This blue shade will become the base for my shadows and help tone down the brightess of my fruit colors (red, green, and yellow).

FIG. 4
Impasto brushes can be turned into regular brushes and most brushes can have impasto effects added to them by changing the *Draw To* method.

FIG. 5
As you lay down color, remember to keep foreground and background colors related to each other.

STEP 4: PAINTING WITH IMPASTO BRUSHES

Now, it is time to add more dimension to my painting. In this step, I modified the settings of my *Variable Flat Opaque* brush to paint with heavier paint.

1. Under the Impasto settings (*Window > Brush Control Panels > Impasto*) change the *Draw To* drop-down menu back to *Color and Depth*. Then lower the depth slider to 5% (Fig. 6).

2. In the *Property Bar* (Fig. 7), change the feature to 5. This will spread the hairs of the brushes out creating stiffer bristles. Change the opacity to 24%,

the resaturation to 55%, and the bleed to around 35%. These settings will give a slightly thicker layer of paint that blends with neighboring colors as you paint.

3. After I laid down more color, I went back to the depth slider in the *Impasto* menu and increased it to 20%. The trick to creating the right amount of depth in your impasto strokes is to vary the amount as you paint. You can also at any time strip out the impasto effects by painting just to Color (Fig. 8).

UNDERSTANDING IMPASTO COMPOSITE METHODS

How an impasto layer combines with the layer beneath is controlled by a layer's *Impasto Depth Composite Method* of *Ignore, Add, Subtract,* or *Replace*. When you use an Impasto brush, the layer is set to Add by default. Here is what each does:

Add: Builds up the height of overlapping Impasto layers. I use this method in areas where I want really thick paint.

Ignore: Strips away the impasto effects, flattening the brushstrokes. I use this when I want the paint to run smoother.

Subtract: Reverses the Impasto height. I use this method to get the look of scraped paint.

Replace: Replaces impasto effects from lower layers with information from top layers.

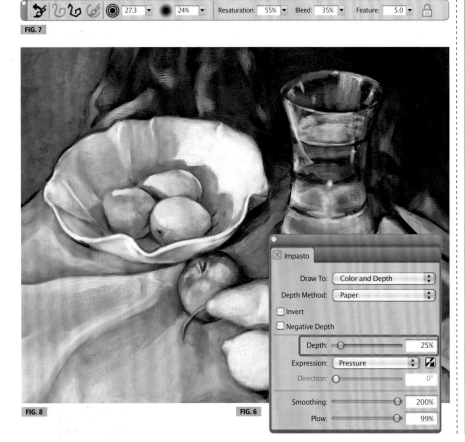

FIG. 7

FIG. 8

FIG. 6

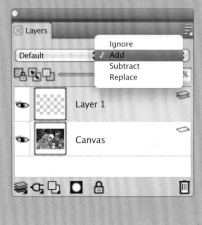

STEP 5: BLENDING AND REFINING

In this last step, I blend the colors to model the fruit in greater detail. At this stage, I am still using pure color to define my shapes (bright red, orange, yellow, and green). You might be tempted to use a blender brush at this stage, but a blender will blur the brushstrokes—exactly what I don't want. The brush used here will blend paint while keeping the depth of each stroke.

1. I used the *Wet* brush found in the *Acrylics* brush category, but set its Impasto (*Window > Brush Control Panels > Impasto*) to *Color and Depth*. This brush blended the paint while keeping the paint's depth.

2. Once I had blended my colors, I looked for areas that were too bright and changed my brush into a super blender. To do this, I changed the *Wet* brush to a *Dirty* brush (Fig. 9A). Dirty brush mode

does just what it says: it mixes paint like a dirty brush. I used this sparingly to keep my colors from getting too muddy. I also increased the blend, viscosity, and wetness to 100%.

3. Next, I used this brush to define the black outlines in my shapes. The black outlines were my guide for where to lead the eye, but it is still color that defined my shapes. I made thicker strokes where the shadows were deeper and thinner strokes where the light hit the fruit (Fig. 10).

4. Next, I went back to the *Variable Flat Opaque* brush used in Step 4, but I used smaller paint dabs. I still layered paint on very thick, but used smaller dabs to capture the way the light disperses. On areas that I wanted more in focus, I used smaller dabs. On areas that are more distant, like the blanket, I used bigger strokes.

5. Lastly, I used the *Depth Equalizer* found in the *Impasto* brush category with its default settings. The Depth Equalizer takes away the impasto, flattening out my brushstrokes. I used this brush very lightly to flatten out areas that I wanted to recede, like the bowl and the red blanket. I didn't want to strip out all the impasto effects.

● Wet Brush

A

20.0 ▾ ● 53% ▾ Grain: 0% ▾ Viscosity: 100% ▾ Blend: 100% ▾ Wetness: 100% ▾

FIG. 9

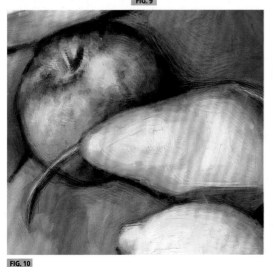

FIG. 10

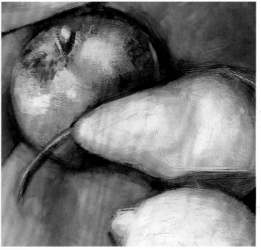

FIG. 11

FIG. 10 & 11
Try to resist sampling from neighboring colors when you paint. Two highly saturated colors painted on top of each other will cancel each other out, thereby reducing their chroma. So don't be afraid to use the brightest red and greenest green. For the deepest shadows, I used blue. For the lightest lights, I used yellow. I used white sparingly. Remember that every piece of fruit reflects that color on the blanket. For example, the blanket is redder around the apple and more yellowish around the lemon.

09
CRACK ADDICT

Little Boney
from The Raucous Royals,
Houghton Harcourt

Application
PAINTER/PHOTOSHOP

This tutorial pays homage to the great Neoclassical painter, Jacques Louis David. In David's painting, Napoleon's faithful mount (believed to be Marengo) rears up as Napoleon points his hand toward the heavens like a God of Antiquity. Unfortunately, the truth was not as pretty. In reality, Napoleon crossed the Alps on a mule, and although he was victorious in the battle with Austria, he lost far more men than the enemy.

I pictured Napoleon's horse laughing at his rider rewriting history. In this tutorial, there are tips on how to make more expressive, caricatured animals. You will also learn the easiest way to make a customized, stiff bristle brush that will fool anyone into thinking you chewed on your brushes for lunch. To finish, I will show you how to add a few centuries' worth of deterioration by using Painter's crackle paper and hard pastels. I spent far too many hours inhaling crackling medium back in my college days. This tutorial promises to save your brain cells.

Napoleon
Crossing the Alps
Jacques Louis David
(1748–1825)

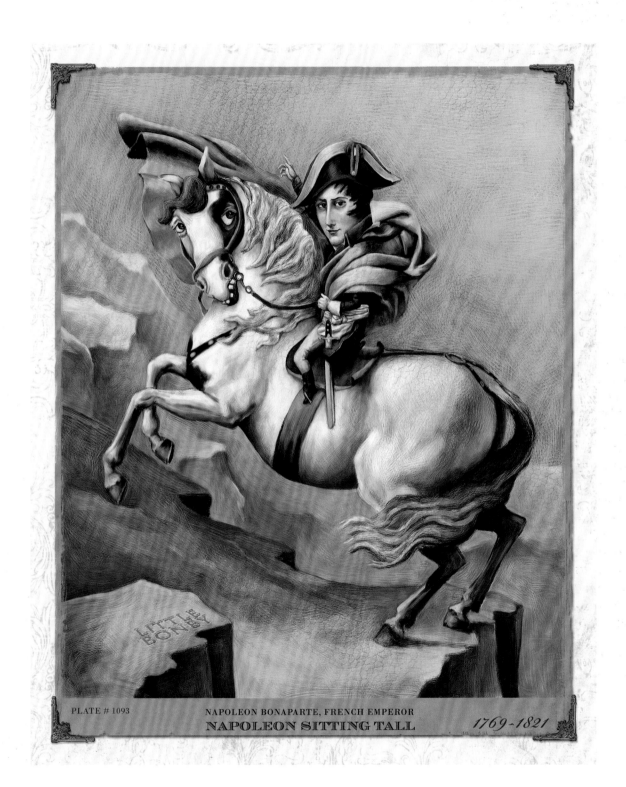

PLATE # 1093
NAPOLEON BONAPARTE, FRENCH EMPEROR
NAPOLEON SITTING TALL
1769-1821

STEP 1:
DRAWING A CARICATURE

Whenever I draw a caricatured face, I always start with the most dominant feature. When drawing animals, that dominant feature is usually the nose. Think about what a dog does when he first greets you. He doesn't size you up with his eyes. He goes right for the nose in the . . . well, you get the picture. Most animals feel out their world through their noses, so it is important to get that feature right.

Next, I worked on the eyes. If the nose gives your character a sense of purpose, the eyes make that purpose believable. When we look at human faces, we always look to the eyes first for signs of life. Scientists have even proven that the eyes hold the key to facial recognition. (This might be why we can get fat and old and our friends still recognize us.)

On some faces, I start with the mouth, mainly because the mouth's movement will change the shape of the other muscles in the face. For example, when we smile, it changes the shape of our cheeks, eyes, and nose.

Lastly, to give your animals more character, base them on a human with that same expression. I keep a mirror at my desk when drawing caricatured animals so I can quickly

FIG. 1

FIG. 1
Using David's painting for inspiration, I drew a similar pose except I decided to put the focus on Napoleon's horse, Marengo. In the final sketch I illustrated a gap-toothed Marengo glaring incredulously at his rider.

reference how my features change when making a particular expression. You would be surprised how closely your face can resemble a disgruntled horse.

QUICK TIP

ANIMALS DON'T NEED BOTOX

When drawing eyes, I first illustrate their shape and then I think about how that shape changes the eyebrows. Most animals obviously don't have eyebrows, but if you omit them then your animal may lack emotion. Think about how hard it would be to show anger on a human face without your eyebrows moving.

FIG. 2

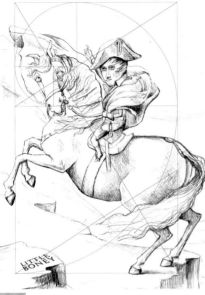

FIG. 3

STEP 2: A BALANCED SKETCH

Next, I scanned in the sketch and put it on its own layer so I could easily move it around. To follow the rules of Classicism, I turned on the *Divine Proportion* tool to make sure the horse's eye was the mathematical center of the piece. To use the Divine Proportion tool:

1. I selected *Window > Composition Panels > Divine Proportion* and then within the menu checked the first box for *Enable Divine Proportion* (Fig. 4).

2. With the *Divine Proportion* tool selected from the *Toolbox*, I moved the tool so that the bottom of the spiral matched the bottom of the figure (Fig. 3).

FIG. 4

STEP 3: MIXING THE NEOCLASSICAL PALETTE

To mimic David's classical balance of warm and cool colors, I used a similar color palette. To make a color palette from this image:

1. I opened Painter's *Color Sets* menu (*Window > Color Panels > Color Sets*).

2. I opened David's painting and selected *New Color Set from Image*, creating a color palette from the painting (Fig. 5).

FIG. 5

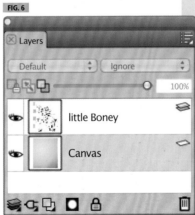

FIG. 6
At this point, I had two layers. The canvas layer contains the blue/green base with my light source and the sketch layer above set to *Multiply*.

STEP 4: PREPPING YOUR UNDERPAINTING

For this painting, I chose a blue-green base, as I wanted to create a contrast between his red/orange cape and hat.

1. I used the *Paint Bucket* tool to fill the canvas layer with a blue-green color.

2. I selected *Effects > Surface Control > Apply Lighting* and added a light source at the top left of the page.

3. Next, I increased the distance of my light source to get a more subtle effect. (For more on creating light sources, see p. 47.)

4. In the *Layers* palette, set the sketch layer's composite method to *Multiply* (Fig. 6 & 7).

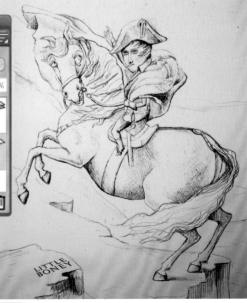

FIG. 7

STEP 5:
CREATE A BASE PAINTING

For this painting, I wanted a really bristly brush with lots of movement and texture. To create a bristly oil brush:

1. I selected the *Real Round* brush variant found in the *Oils* brush category.

2. In my *Property Bar*, I set the opacity to 35%, the restauration to 100%, the bleed to 35%, and the feature to 2.2. I began by painting a few spirals to warm up my hand (Fig. 9).

3. Next, I created a new layer by selecting the *New Layer* icon and moved it below my sketch layer. I blocked in a rough range of warm and cool colors. For larger patches of color, I increased the feature. This will increase the distance between the bristles and give my art more textured strokes (Fig. 8).

STEP 6: BUILD UP COLOR

In the next step, I decreased the feature of my brush to apply less bristly brushstrokes and changed a few more settings to thin out the paint:

1. In the *Property Bar*, I increased the bleed to 100% and lowered the opacity to 15%. This created a thinner glaze of paint that mixed together as I painted. For the rest of the painting, I went back and forth between this brush and the one used in Step 5 by laying down paint and then blending it.

2. Next, I built up texture by selecting the *Thick Clear Varnish* under the *Impasto* brush category. This brush adds texture without changing your colors. I used this brush on areas with thick paint such as the rocks in the background (Fig. 10).

QUICK TIP
BETTER WITH AGE

Here are some techniques to help you achieve aged textures and thicker paint:

Real Bristle Brush

You can get a lot of varied effects just by using one brush and changing the settings. In this example, lowering the feature and opacity allows you to work in glazes.

Using the same brush, increasing the Feature to 8 and the opacity to 100% will add more bristly brushstrokes. I used this for the horse's mane and tail.

Impasto Brush

The Thick Clear Varnish brush adds thick reflective paint on areas that need more texture.

Pastels

The *Hard Square Pastel* is the perfect brush to give your painting a light aged look. Pastels set to a low grain will pick up more texture. Remember to vary the size of the paper as you paint for a more natural look. (This brush is covered in more detail on p. 38)

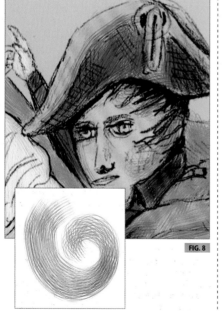

FIG. 8

FIG. 9

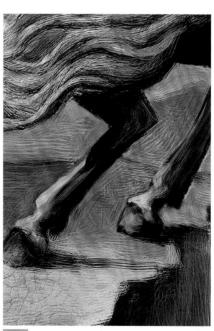

FIG. 10

STEP 7:
CREATE BRUSH TEXTURE

The secret to creating a textured brush is not always in impasto effects but in loading your paintbrush with more than one color. By loading a brush with two contrasting colors, each stroke is more defined and creates more interesting, textured brushstrokes. In this next step, I load my brush with brown and blue created from a gradient. I use this brush technique on backgrounds where texture will not distract from the modeling of the figures.

1. First, I needed to create a gradient to load onto my brush. Painter does come with a library of different gradients, but for this painting's background I needed a specific gradient of blues to browns.

2. I opened the *Color Panel* (*Window > Color Panels > Color*) and clicked the main color (Fig. 11A) and set it to a high chroma aquamarine. Then I selected the background swatch (Fig. 11B) and set it to a deep brown.

3. Next, I opened the *Gradient* menu (*Window > Media Control Panels > Gradients*) and chose the Two-Point button from the drop-down menu (Fig. 12A). I then clicked the *Linear Gradient* button (Fig. 12B).

4. Now, I needed to edit the gradient slightly to make the brown fill less of the gradient. In the *Gradient* menu, I clicked on the small right arrow and selected *Edit Gradient* from the drop-down menu.

5. In the edit gradient dialog box, I clicked on the left-hand side of the bar to add a control point (the upward arrow) and dragged this control point to the left. Now my color transition uses more blue than brown. Next, I added another hue to the gradient by clicking on the right-

hand side of the color bar. In the *Color* panel, I selected a lighter aqua. Now my gradient goes from light aqua to brown (Fig. 13).

6. I then clicked the small right arrow in the *Gradient* menu and selected *Save Gradient* from the drop-down options. I named this gradient "blue to brown" (Fig. 12). This gradient will now be a part of my *Gradient Library* (*Window > Media Control Panels > Gradient Libraries*).

7. In the *Color Variability* menu (*Window > Brush Control Panels > Color Variability*), I set the drop-down menu to paint *From Gradient* (Fig. 14). Now when I lay down paint, my brush is loaded with blue and some slight brown (Fig. 15).

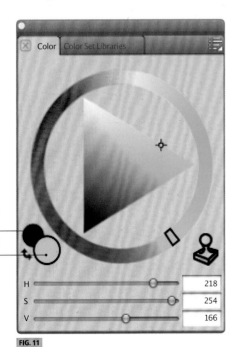

FIG. 11

FIG. 12

FIG. 14

FIG. 13

FIG. 12
Remember that you can change your gradient from the Gradient Library to paint with different textures.

FIG. 13
If you need to delete a color in the gradient transition, click on the small bottom arrow and hit the *Delete/ Backspace* key.

FIG. 15
With my brush set to paint from gradient, each stroke is a mixture of blue and brown. As I paint, I occasionally switch the Color Variability controls back to HSV to apply strokes of pure color. I use this method to paint backgrounds.

STEP 8: GET CRACKLING

Now for the fun part. Time to start aging the painting a couple of centuries. As discussed earlier, many hard media brushes reacted differently with textured papers. In this example, I used the *Hard Pastel* brush and the *Crack Texture* papers to create an aged surface. You can download these papers from the Corel Painter product page, within the extra content found under Resources.

1. First, I needed to load the *Crack Textures* papers. I opened the *Paper Libraries* (*Window > Paper Panels > Paper Libraries*) and then clicked the small right arrow to reveal the drop-down menu (Fig. 16). From the menu, I selected *Import Legacy Paper Library*.

2. Then, I navigated to the crack textures folder (*Extra Content > Papers > Crack Textures.papers*) and clicked *Open*. My new crack paper library is now loaded in a separated tab beneath my default paper library.

3. From the paper library (*Window > Paper Panels > Paper Libraries > Crack Textures*), I selected the *Dry and Cracked* paper (Fig. 17A).

4. I then lowered the scale (Fig. 17C) to 30%, to get smaller cracks, and set the brightness to 70% (Fig. 17D), to make the cracks more defined. I also checked the invert button (Fig. 17B) to get the paint to fall only in the crevices.

5. I added a new layer to the top of my layer stack by selecting the *New Layer* icon and named this layer "crackle." I always paint on a separate layer in case I want to remove some crackle later.

6. Next, I selected the *Hard Pastel* brush variant from the *Pastel* category and set the opacity to 25% and the grain to 5%.

7. I painted on the crackle layer where I wanted to age the canvas. While I painted, I made sure to occasionally vary the size of my paper so that I got small and large cracks. I also switched my paper to the *Faded Cracks* paper to vary the shape of the cracks (Fig. 18).

8. Finally, I flattened the image and saved it as Napoleon_final.psd and opened it in Photoshop. I increased the sharpness of the brushstrokes by selecting *Filter > Sharpen > Smart Sharpen*. I set the amount to 100%, the radius to 0.3.

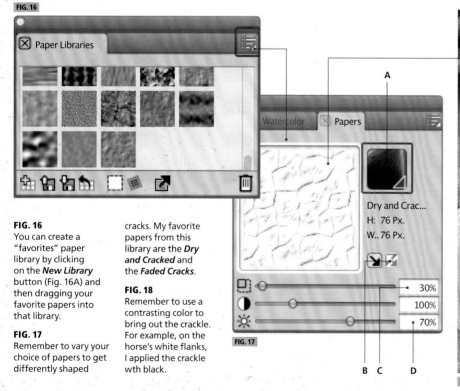

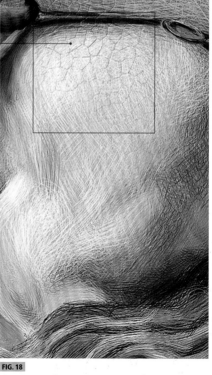

FIG. 16
You can create a "favorites" paper library by clicking on the **New Library** button (Fig. 16A) and then dragging your favorite papers into that library.

FIG. 17
Remember to vary your choice of papers to get differently shaped cracks. My favorite papers from this library are the *Dry and Cracked* and the *Faded Cracks*.

FIG. 18
Remember to use a contrasting color to bring out the crackle. For example, on the horse's white flanks, I applied the crackle wth black.

FIG. 18

FEATURED ARTIST CHRIS BEATRICE: DIGITAL DREAMSCAPES

Chris' whimsical characters, magical landscapes, and vivid imagery bring the magic of the fairy tale to young and old alike, recalling the Golden Age of children's book illustration. His art focuses on people and character, both figurative and portrait, with animals and creatures that are bursting with life. Myths, legends, folklore, fairy tales, and history are the stuff of which his work is made. Chris' work has graced the covers of classic books such as Jonathan Swift's *Gulliver's Travels*, Daniel DeFoe's *Robinson Crusoe*, and Oscar Wilde's *The Selfish Giant*, in addition to games, packaging, magazines, posters, private commissions, and a variety of other books. His work has also appeared on display in the Lyceum Theater Gallery in San Diego, California, and The Danforth Museum of Art in Framingham, Massachusetts.

www.chrisbeatrice.com
artist@chrisbeatrice.com

Chris uses Corel Painter for all his digital painting, employing a small stable of simple custom brushes to create a more hand-crafted look, letting his marks show through in the final work. Chris also uses Photoshop for making value and color adjustments, as well as scaling and moving picture components.

FIG. 1
The Giant Returns

FIG. 2
Hel

FIG. 3
Grave Robber

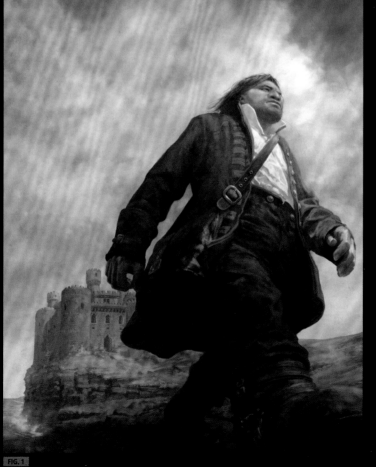

FIG. 1

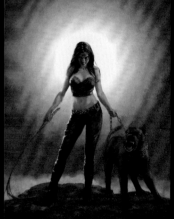

FIG. 2

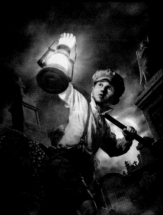

FIG. 3

10
CHARLOTTE'S CHOICE

Ps Application
PHOTOSHOP

One of the most enjoyable ways to play with the digital medium is through collage. As kids, most artists fall in love with cutting and pasting images while eating glue. I have many fond recollections of slicing off the heads of family members in photos and Frankensteining them on to various bodies. My sister immediately became the circus fat lady. My dog's head fit perfectly on Nancy Reagan's body. The possibilities were endless.

I created the surreal world of *Charlotte's Choice* for my daughter, Charlotte, who is always picking up found objects and inventing elaborate stories around them. (She is either going to be a talented writer or artist, or just a very good liar.) This painting reminded me of the myriad keys we are given in life, not knowing which ones will open the right doors.

Charlotte's Choice
In this tutorial you will learn how to paint a photomontage by combining different photos and painting techniques.

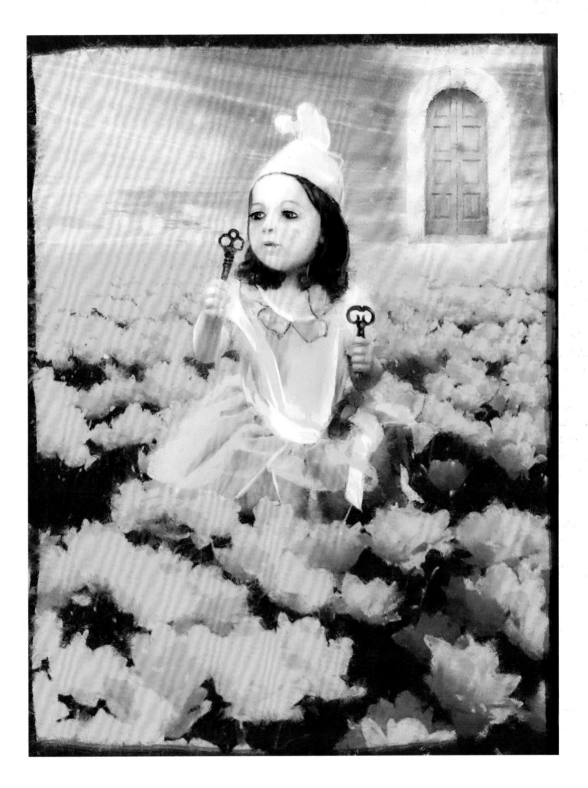

STEP 1: GATHER YOUR COLLAGE PIECES

With every photo montage, I always start by establishing a focal image. Next, I search my photo library to find images that will support the theme I have chosen. This theme was "choices" so a door, a key, and a vast field seemed appropriate. I also looked for photo elements that would frame my composition. I used an old door to give my montage an asymmetrical feel.

1. Next, I find images that will make interesting textures. In this example, I used the end pages of an old book (Fig. 2) to create a swirly pattern in the background. Other texture ideas include flaking paint, sidewalk cracks, weathered leaves, or splattered paint.

2. At this point, I don't worry about the photos' colors matching. In the next step, I am gong to strip the color out of the photos and then recolor everything using my own color palette.

FIG. 1
Getting kids to pose usually takes some bribing. It also helps if you can distract them with something to hold. In this picture, I asked my daughter to blow on this weed.

FIG. 2–6
If you don't have a big library of your own photography, you can purchase pictures from libraries like fotolia.com or istockphoto.com. Just make sure to check the licensing agreement before using any photos.

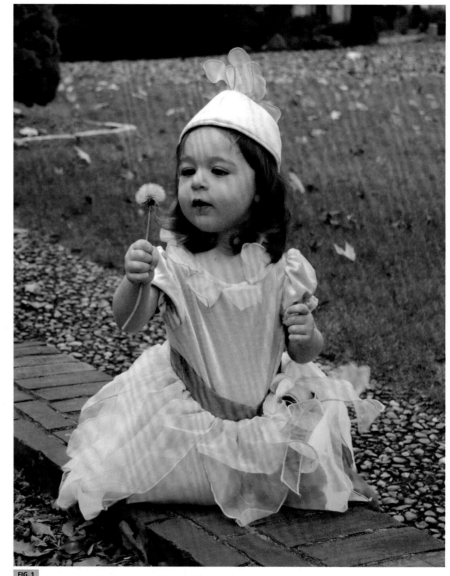

FIG. 1

FIG. 2

FIG. 3

FIG. 4

FIG. 5

FIG. 6

STEP 2: WORK IN GRAYSCALE

In this step, I converted all of my images to black and white so that I didn't have to worry about matching the different colors. Starting with a grayscale also gives your montage a cohesive base from which to build.

1. Open each of your photo pieces and select *Image > Adjustments > Black & White* (Fig. 8). Using the color sliders, adjust each of the colors until you see a strong contrast of values from dark to light. I adjusted the color sliders to make Charlotte's fairy dress turn to white so I could color it in Step 4. Hit *OK*.

2. Repeat Steps 1–2 for each of your images.

There are several ways to turn an image into a grayscale image, but this method is simplest and gives me the most contrast between black and white values.

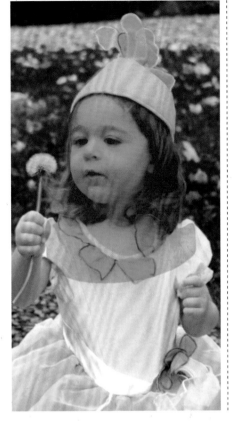

FIG. 7

STEP 3: SELECTING THE IMAGES

Here comes the tedious part. I now have to cut Charlotte from her background. If you are new to digital painting, you might want to re-read Part 1, Chapter 5 on selection and masks. Entire books have been written on the subject of making selections, but as this is a fairly straightforward image without a lot of tricky fly-away hair, I am just going to use a good old *Quick Mask*. To make a Quick Mask of your subject:

1. Press the *Q* key. This will put Photoshop in *Quick Mask Mode* and your foreground color will automatically turn to black.

2. From the *Brush* control panel, I chose a hard, round brush at 100% opacity and painted only on Charlotte. Although my *Toolbar* shows black as the foreground color, the paint comes out red. That is your mask and that bright red color will help you distinguish the edges of your selection (Fig. 7).

3. When you are done painting in your object to be cut, press the *Q* key again. Now you will see the "marching ants" around your selection.

4. At this point, you have to reverse the selection because you actually have the background selected. Choose *Select > Inverse*.

5. Now select *CTRL/Command + C*. This will make a copy of your selection.

Black and White

Preset:	Custom		OK
			Cancel
Reds:	■	60 %	Auto
Yellows:		125 %	☑ Preview
Greens:	■	−20 %	
Cyans:	■	131 %	
Blues:	■	−38 %	
Magentas:	■	151 %	
☐ Tint			
Hue		°	
Saturation		%	

FIG. 8

STEP 4: ASSEMBLE THE COLLAGE PIECES

Now for the fun part. In this next step, I assemble all the pieces to make my black and white montage.

1. First I created a new file by selecting *File > New*. I set the dimensions to letter size at 300 dpi.

2. Then I selected *Ctrl/Command + V* to paste my selection from the previous step into the new file. I named this layer "Charlotte."

3. I opened the field of flowers and, using the *Move* tool, dragged it into my working file. In the *Layers* palette, I dragged the image's layer beneath the Charlotte layer.

4. Next I resized the flowers to the paper size. To resize an image select *Edit > Transform > Scale*. Now grab the small handles of your object and pull until you get the desired width and height. If you need to constrain the width to height size ratio, hold down the *Shift* key as you drag.

5. I then selected the Charlotte layer and added a layer mask by selecting the *Layer Mask* icon in the *Layers* palette.

Using black as my foreground color, I masked out the areas where the flowers were overlapping her knees (Fig. 9).

6. I made a rough selection around the door and the key and dragged them into my composition. I also masked out the areas on the key covered by her hand (Fig. 10).

7. Next, I dragged in the background clouds image. The clouds were feeling a little flat so I increased the contrast by selecting *Image > Adjust > Levels*

and moving both the left and right sliders toward the middle (Fig. 11).

8. Lastly, I increased the shadow around the door by selecting the *Layer Effects* button in the *Layers* menu and then *Drop Shadow* from the drop-down menu. In the layer effects dialog box (Fig. 13), I set the opacity to 51%, distance to 0, spread to 25, size to 237, and noise to 10, then I hit *OK* (Fig. 12).

FIG. 12
Any time an object is not popping out from its background, try applying a Drop Shadow to increase the contrast.

FIG. 13
I often use a lot of noise in my shadows because it reminds me of more textured brush work. Also, try experimenting with the Outer and Inner Glow effects to get more dramatic results.

FIG. 11

FIG. 12

FIG. 9

FIG. 10

FIG. 13

STEP 5: APPLYING VALUES AND LIGHT

Now that I have all my main pieces in place, I set a value for my painting and a light source. This step is very important because one consistent light source makes all the photos look like they belong together.

1. In the *Layers* palette, I selected the top most layer in my layer stack.

2. I then clicked on the *Layer Adjustment* button in the *Layers* palette and chose *Gradient Map*. This created a new layer titled "Gradient Map."

3. In the *Adjustments* dialog box (*Window > Adjustments*) I clicked on the arrow next to the gradient strip (Fig. 14A) and choose a black to white gradient (Fig. 14B) from the drop-down menu. This gradient map adjustment layer will set the overall values for every layer beneath it. But I still need to set a stronger direction to the light source.

4. I created a new layer at the top of my layer stack by selecting the *New Layer* icon in the *Layers* palette. I named this layer "light source."

5. I selected the *Gradient Tool* from the *Toolbar* and hit the *D* key to make my gradient begin with black.

6. In the *Gradient* control panel, I selected a black-and-white gradient from the gradient drop-down menu (Fig. 15A) and the diamond gradient (Fig. 15B).

7. Next, I placed the cursor at the bottom right of the page and dragged upwards towards the top left. This created a gradient with the whitest whites at the top left, fanning out to black towards the bottom right.

8. Next I set the light source layer's blend mode to *Overlay* and lowered the opacity to 60% (Fig. 16).

STEP 6: APPLY BACKGROUND TEXTURE

At this point, I felt that the clouds were looking a little bland and certainly not worthy of such a dramatic subject matter. So I pulled in some texture by using some endpapers that I found in an old book. They had a swirly pattern that reminded me of wind blowing.

1. Using the *Move* tool, I dragged in my background texture and dragged its layer to the top of the layer stack.

2. Next I resized it to my composition as outlined in Step 4.4.

3. In the *Layers* palette, I changed its blend mode to *Soft Light* (Fig. 17).

FIG. 14

You can also click on the Gradient Strip to adjust the color, opacity and fade off points in your gradient.

B

A

B

A

FIG. 15

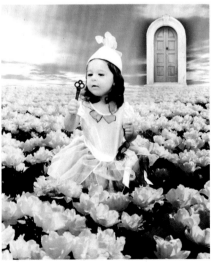

FIG. 16

FIG. 17

STEP 7: TINTING THE PHOTO

Now it is time to tint the photo with some color. I could use blend modes to let the color show through over the black and white, but instead I am going to treat my black-and-white montage as an underpainting and apply paint on top almost covering most of the black and white photo.

1. I selected all the layers in the montage by *Shift + clicking* on the layers. I merged these layers by selecting the small right arrow in the *Layers* palette and choosing *Merge Layers* from the drop-down menu. I named this new layer "black and white."

2. I created a new layer by selecting the *New Layers* icon in the *Layers* palette. I named this layer "flower colors" and moved it above the black-and-white layer (Fig. 18).

3. I then selected the *Brush* tool from the *Toolbar*.

4. In the *Brush Presets* menu (*Window > Brush Presets*), I chose one of the *Dry Media Brushes* from the drop-down options. (Fig. 19). With the "flower colors" layer selected, I began painting in the flowers with yellow.

5. I repeated the same step for the sky, door, and Charlotte, using different colors (Fig. 20).

6. Charlotte still looked too "Photoshopped," so I applied more color but this time exaggerated her features by painting black around her eyes and adding white highlights in her pupils (Fig. 21).

7. Finally, I applied a border using the *Hard Media Brushes*.

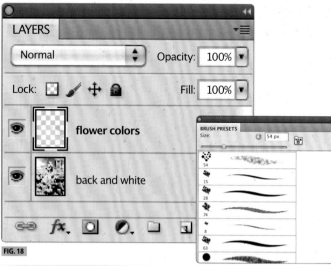

FIG. 18

FIG. 19

FIG. 20

FIG. 21
In this step, keep each color you use on its own layer so that you can easily change the colors later if needed. For the door area, I increased the noise of my brush to create a grainy glow around it. A brush's noise can be adjusted in the *Brush* menu (*Window > Brush*) by checking the noise box.

FIG. 21

FEATURED ARTIST JASON JUTA: ALTERNATIVE MYTHOLOGY

"I'm a full-time freelance fantasy illustrator based in London, UK, and before that I was a concept and in-game artist in the computer game industry. I've also worked as an album-cover illustrator for the metal music scene. I produce digitally painted art for publishing, usually in the RPG industry, and also photo-based art for licensing, which is typically more personal. I try to produce an end result where the viewer has difficulty distinguishing which elements of the image were studio photography, 3D, matte painting, and so on, but with an overall stylized, painterly feel. I attempt to maintain a mythological and dark mystical aspect and atmosphere to my own work, and I usually incorporate elements of underground or alternative culture."

www.jasonjuta.com
jason@jasonjuta.com

FIG. 1
Morrigan

FIG. 2
Limbo

FIG. 3
Belphoebe

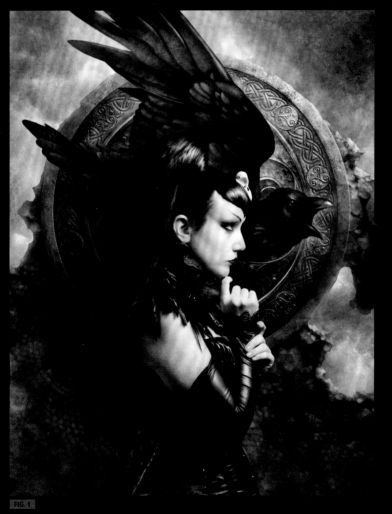

FIG. 1

FIG. 3

11

DOWN THE RABBIT HOLE

WITH JENNIFER MORRIS

Jennifer Morris
www.jemorris.com

Ps Application
PHOTOSHOP

"I began my illustration career in the stationery industry winning two GCA Louis Awards. I now work in licensing and children's book publishing and wrote and illustrated the best-selling picture book *May I Please Have a Cookie* (Scholastic).

In this tutorial, I colored a drawing to give it the feel of an Arthur Rackham illustration. Now, before you say it, I know, I'm no Arthur Rackham. But you can use these techniques to create a vintage sepia tone painting reminiscent of an Arthur Rackham illustration."

STEP 1:
CREATING A SKETCH

First, I scanned a drawing into Photoshop. You could start with a pen and ink drawing, or charcoal, whatever you want. Mine was a pencil sketch that I did at the beach last summer. My sketch had a pinkish cast and lots of pencil smudges. I decided to leave the smudges because they gave the sketch an antique feel, but I removed the paper's pinkish tint. To remove color casts: click *Image > Adjustments > Desaturate* (Fig. 1).

FIG. 1

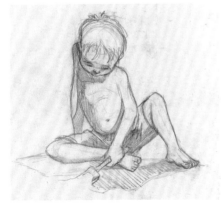

FIG. 3

Arthur Rackham
Alice in Wonderland (frontispiece)
Arthur Rackham's signature bold pen and ink lines colored with a minimalist palette distinguished him as one of the leading illustrators during the Golden Age of illustration. Rackham started his illustrations with a light pencil sketch and then blocked in the lines with pen and India ink. Next, he colored his art with light transparent washes of watercolor—a very lengthy process, but one perfect for photographic reproduction.

FIG. 1
The original sketch had a pink cast. I removed it using *Image > Adjustments > Desaturate*.

STEP 2: SETTING YOUR BASE COLOR

First I put my line drawing on a layer above the background layer.

1. I right-clicked on the background layer and selected *Duplicate Layer*. I named this layer "line drawing."

2. From the color palette (*Window > Color*), I selected a tan color.

3. I selected the background layer and then clicked *Alt + Backspace/Delete* to fill the background layer with the tan color (Fig. 2).

FIG. 2

FIG. 2
You will only see your layer window change at this stage.

STEP 3:
TINTING YOUR SKETCH

Now that I have my base color, I added value to my sketch with a gradient map. A gradient map applies a "map" of different tonal values to an image. I chose a gradient that goes from dark brown to white with an orange/brown color in the middle. This gives a warm, sepia tone to the drawing.

1. I selected the line drawing layer and created a new adjustment layer by selecting the black and white cookie icon at the bottom of the *Layers* palette. From the drop-down menu I chose *Gradient Map*.

2. When first opening the *Gradient Editor* (Fig. 4), it will contain your last settings used. If this is your first time opening it, you will see a simple black and white gradient strip with small box/arrow shapes below and above the gradient. The left hand side is the start of your gradient (in this example black) and the right hand side is your ending gradient color (in this example white). The bottom boxes (Fig. 4B) control the color in your gradient while the top boxes (Fig. 4A) control the color's opacity. I left the opacity alone, but changed the color of my gradient.

3. Click on the left-hand side bottom box (Fig. 4B).

4. Next, click inside the color box (Fig. 4C). This will pop up the *Color Picker*. Choose a dark brown color.

5. Repeat this process for the right hand side box (Fig. 4D). I chose a white color.

6. Next, I added another midtone to my gradient. To add another color point to my gradient, I clicked anywhere below the gradient strip and my cursor turned into a finger pointing. I put my midtone

FIG. 4

FIG. 5
Experiment a little with the gradients. You'll find that you can tinker with it in all sorts of ways to get lots of great effects.

values three quarters down the gradient (Fig. 5). At any point, you can change its position by dragging the box left or right. You can also change the *Fade Off* value between each color by grabbing the tiny circle in between each color (Fig. 5B).

7. When I was happy with my gradient, I clicked *OK*. A new layer is now created titled "Gradient Map 1." Now, I can go back and adjust this gradient by clicking on it in the *Adjustments* menu (*Window > Adjustments*).

8. Next, I needed to see the tan background color through the line drawing, so I changed the blend mode of the line drawing layer to *Multiply*.

9. Unfortunately, the gradient map was now altering the pencil drawing and the tan color in the background. To make the gradient map influence only the line drawing: I selected the Gradient Map 1 layer, then clicked on the small right arrow in the *Layers* palette and selected *Create Clipping Mask*. The layer now has a downward pointing arrow next to its name (Fig. 6) and the gradient map changes only the values in my sketch.

FIG. 6

FIG. 8

STEP 4: WASHING IN COLOR

Now I am ready to add color. I chose to use subdued hues, keeping with the Arthur Rackham feel. To color my sketch:

1. I created a new layer between the line drawing layer and the background layer by selecting the *New Layer* icon in the layers palette. I named this layer "color."

2. Next, I set the opacity of the layer to 70% so that some of the tan background color showed through.

3. With the color layer selected, I washed in color using the *Airbrush* tool set to 100% opacity (Fig. 7).

STEP 5: ADDING TEXTURE

Lastly, I dabbed in some texture at the edges of the image with some large texture brushes (Fig. 8). (For more on creating textured brushes see pp.48–56)

1. I created a new layer above the line drawing Layer and named it "texture." I set the blend mode to *Multiply*.

2. I then painted in the edges of my painting with a dark brown color.

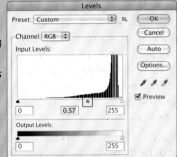

FIG. 9

FIG. 10

FIG. 9 & 10
I made these brushes from a photo of a parking lot (Fig. 9) and crackle paint on an old dumpster (Fig. 10). You can download these brushes from www.carlynpaints.com.

QUICK TIP

DARKEN YOUR LINES

You may need to darken your lines once you begin to wash in color. To darken your line work:

1. Select the line drawing layer and then select *Image > Adjustments > Levels*.

2. Drag the center input levels slider to the right. This boosts the contrast and makes the drawing and smudges more pronounced.

FIG. 7

12
ON A DARK, DARK NIGHT

WITH JENNIFER MORRIS

Ps Application
PHOTOSHOP

Some artists believe that good, digital art should mimic traditional mediums. I don't always follow that suggestion. Sometimes I prefer to take inspiration from the old and create something slightly new and different.

The piece that I am going to deconstruct in this tutorial is from a children's book I illustrated, titled, *On a Dark, Dark Night* and written by Jean M. Cochran, published by Pleasant St. Press. Wood or linoleum block printing has many irregularities in the art that gives it a handmade feel and lots of personality. I tried to incorporate that feel into the illustrations for this book.

STEP 1: THE LINE DRAWING

The technique I used to create the outlines in this image is similar in many ways to creating a traditional wood block print. Only instead of cutting the image into a block of wood with sharp gouges, I used Photoshop and the *Eraser* tool. One benefit of this is that I've never cut myself on my Wacom tablet; I can't say the same of carving tools.

1. First, I scanned a pencil drawing into Photoshop to use as a guide. I positioned it on a layer above the background and named this new layer "pencil" (Fig. 1).

2. I set the blend mode of the pencil layer to *Multiply* and set the opacity to 50%.

3. Next, I created a layer below the pencil layer named "outlines." Using a *Hard Round* brush and a medium-blue color, I laid down a large swath of blue on the outlines layer. I prefer to use blue to make it easier to see the pencil lines, but you may use any color you want at this stage. Later it will all be converted to black (Fig. 2).

4. I selected the *Eraser* tool and a *Hard Round* brush. Using my pencil drawing as a guide, I started erasing the blue to leave the outlines of my design. I purposely like to leave little bits here and there to keep the lines scratchy and interesting. If you erase too much, no problem—just go back in with the Brush tool and fix any mistakes (Fig. 3).

5. Once I've gone over the whole drawing this way, I make sure I still have the outlines layer selected and then lock the transparency by checking the transparency box in the *Layers* palette (Fig. 4A).

FIG. 1

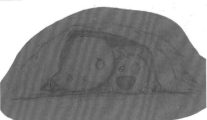
FIG. 2

FIG. 3

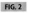

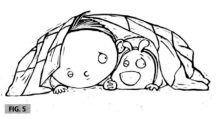

FIG. 5

6. I filled the outlines layer with black by hitting the *D* key and then selecting *Alt + Backspace/Delete*. The pencil layer can be deleted at this point, as it is no longer needed (Fig. 5).

LAYERS	PATHS	CHANNELS		
Normal		Opacity:	100%	►
Lock: ☐ 🖌 ✛ 🔒		Fill:	100%	►
👁		**Outlines**		🔒

FIG. 4 ——— A

As you can imagine there are a lot of options with this technique. Try crosshatching, using different brush shapes, or using colors besides black. Experiment and find what works for you.

STEP 2: ADDING COLOR

In this next step, I added color to my sketch.

1. Now I created a new layer below the outlines layer by selecting the *New Layer* icon. I named this layer "color."

2. I selected one of the *Hard* brush tools from the control panel (Fig. 6).

3. I then filled in the outlines like coloring in a coloring book. Now everything should be filled in with a base color (Fig. 7).

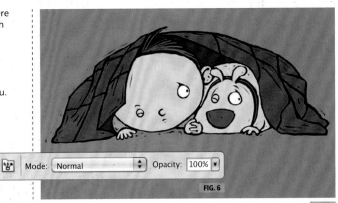

Mode: Normal ▲▼ Opacity: 100% ▼
81
FIG. 6

FIG. 7

STEP 3: ADDING TEXTURE

Creating your own custom brushes is a fun project and it makes your artwork very personal and unique. Here is how I made one of my favorite brushes. It's one that I used extensively to texture this image. First get some white paper and some black paint (yep, I said paper and paint). I used some copy paper and cheap black acrylic craft paint. Then use sponges, old brushes, leaves, and anything else you can find to make irregular shaped blobs on the paper. You can even get your kids to help with this part. Once the paint dried, I scanned in my blobs. I created this blob (Fig. 8) with a wadded up piece of plastic wrap dipped in paint.

1. I selected the blob using the *Lasso* tool.

2. I then clicked *Edit > Define Brush Preset* and hit *OK*. I named this brush "blob 1."

3. Next, I selected the blob 1 brush from the control panel.

4. If I then use the brush tool using my newly created brush, I get something like Fig. 9. It's interesting, but too mechanical and repetitive. Next, I opened the *Brushes* palette (*Window > Brushes*) and made some changes.

5. I clicked on the *Shape Dynamics* on the left-hand side of the dialog to open the options. The first thing I changed was the size jitter and set the control to *Pen Pressure*. To stop the brush size from varying too much, I set the minimum diameter to 70% (Fig. 10).

6. Next, I set the angle jitter to 100% and also checked *Flip X Jitter* and *Flip Y Jitter*. This gave it a more random look, as if you were dipping a sponge in paint over and over again, twisting the sponge as you went. As you can see from the preview window in the bottom of the brush dialog box, this is looking a lot more random now (Fig. 10).

7. Now, armed with my new texture brushes, I added some texture to the image. Using the *Magic Wand* tool and the color copy layer, I selected areas of the design and started adding textures. Nearly all the texturing in this image was done with the plastic wrap brush I described above and another brush that was created using a black and white photo of crackled paint (Fig. 11).

FIG. 8

FIG. 9

FIG. 10
Play around with the brush settings and see what sorts of effects you can come up with. Creating your own brushes will give your art a personal touch.

FIG. 10

FIG. 11

IMPORTANT!

It's very important to remember that once you change the brush settings you need to save it as a new brush, or the next time you go to use the brush it will revert back to the old settings.

STEP 2: ADDING PATTERNS

In this next step, I created a file containing a robot pattern to use on the boy's bed sheets (Fig. 13).

1. I cut and pasted the sheet design into my file, but it didn't look as though it was lying under the boy. I needed to add some perspective. To do that, select *Edit > Free Transform*. Once in transform mode, drag the top center anchor point downward to squish the pasted image.

2. Next, I selected one of the lower corner anchors. While dragging it outward, click *Ctrl + Shift + Alt* to distort the image in perspective. This makes the pattern look more like it's sitting on the bed's surface (Fig. 12).

3. All that's needed now is to crop the robot pattern to fit the bed. I used the *Eraser* tool set to a hard brush to erase around the boy and the dog, and then chose a soft jagged *Eraser* brush to soften the transition along the bottom edge. I also added a little more texture to the sheets to further blend it.

4. Add one more layer named "shadows" and set the blend mode to *Multiply* and the opacity to 80%. Then I created shadows using a *Hard Round* brush and a medium-warm gray color (Fig. 13).

FIG. 12

FIG. 13

FIG. 12
I used a pattern with a lot of neutral colors so that the eye would still be drawn to the red blanket around my figures.

FIG. 13
I used a lot of textured brushes to give the painting a grainy feel.

QUICK TIP

Make sure to use a pattern that is not too busy. You don't want your pattern to give a touch of drama but not steal the show.

FEATURED ARTIST CHET PHILIPPS: DIGITAL SCRATCH BOARD

Chet Phillips
chet@chetart.com
http://www.chetart.com
http://www.chetart.
etsy.com
http://www.chetart.
com/blog

Chet Phillips creates "digital scratchboard" illustrations using the natural media software Painter. A few of the clients he's worked with for the last thirty years include The ASPCA, Pepsico, Workman Publishing, Klutz, *The New York Times*, and Warner Brothers. In addition to his commercial work and gallery shows, he creates personal projects that include uniquely humorous trading card sets and hand-bound limited edition books.

FIG. 1
Fox in a Henhouse

FIG. 2
Time Machine

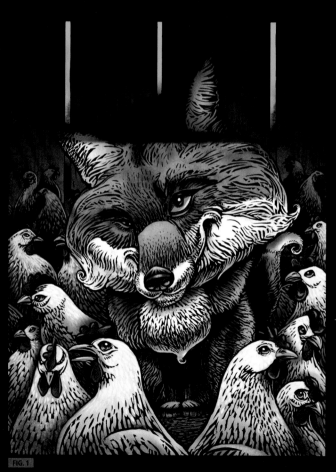

FIG. 1

FIG. 2

GLOSSARY

Adjustment Layer
A layer allowing nondestructive color changes to any layer beneath it.

Atmospheric Perspective
(also called Aerial Perspective)
The effect the atmosphere has on the appearance of an object as it is viewed from a distance.

Bitmap
An image composed of a rectangular grid of pixels where the pixel is either on (black) or off (white).

Brush Variant
The term used in Painter to describe a type of brush in a chosen medium.

Chroma (sometimes referred to as saturation)
The purity of a color or the strength or weakness of a color.

CMYK
Subtractive color model in which cyan, magenta, yellow, and black are combined to reproduce the colors used in offset printing.

Color Management System
A system to ensure that colors remain the same regardless of device or medium.

Color Variability
The Painter menu that allows your brush to pick up varying degrees of hue, saturation and value.

Dab Profile
The Painter menu that controls the shape of the brush.

Divine Proportion
(also called the Golden Ratio)
A mathematical constant in which the sum of the quantities to the larger quantity is equal to the ratio of the larger quantity to the smaller one (approximately 1.6180339887)

Dry Brush
(also called dry-on-dry)
A painting technique in which a dry paint brush is loaded with paint and applied to a dry surface.

File Resolution
The number of pixels in an image measured in pixels per inch for offset printing and dots per inch for inkjet printing.

Grayscale
Is used for black and white images in a gray tonal range without any color information. Grayscale images are also measured as percentages of black ink coverage (0% is equal to white, 100% to black).

Grisaille
Method of painting in gray monochrome, typically used as an underpainting.

Histogram
A graph that plots the tonal range of an image.

Horizon Line
The eye level of the viewer.

Hue
A color or shade.

ICC Color Profile
A set of data that characterizes a color input or output device, or a color space, according to standards promulgated by the International Color Consortium (ICC).

Inkjet printing
A printing process in which a printer creates images by spraying tiny dots of ink.

Jpg
A standard file format for compressing images more commonly used in web graphics.

Layer Blending Mode
Changes how Photoshop layers interact with each other.

Layer Composite Method
Changes how Painter layers interact with each other.

Layer Mask
Controls the what part of your layer is visible and in what percentage.

Layer Opacity
Controls the transparency of the entire layer.

Linear Perspective
A type of perspective in which the relative size, shape, and position of objects are determined by drawn or imagined lines converging at the horizon line.

Monitor Calibration
The process of modifying the color behavior of a monitor by it to a standard state, usually a color temperature of 6500k and a gamma of 2.2.

Monitor Characterization
The process of creating a profile to describe how the monitor is currently reproducing color.

Noise
Tiny specks of random color that create a grainy appearance.

Offset Printing
A printing process in which an inked image is transferred from a plate to a rubber blanket, then to the printing surface.

One-Point Perspective
Linear perspective in which all lines converge at one vanishing point on one horizon line.

Pixel
The smallest representative component of a raster image.

Proof
A trial sheet of printed material that is made to be checked and corrected.

Ram (or Random Access Memory)
A form of computer data storage in which stored data can be accessed in any order.

RGB
Additive color model in which red, green, and blue light are combined to reproduce the colors used by monitors, TV screens and Digital Cameras.

Screen Resolution
The number of distinct pixels that can be displayed by your screen.

Three-Point Perspective
Linear perspective in which lines converge at two vanishing points on the horizon line but also at a third vanishing point above or below the horizon line.

Tif
Bitmap graphics format more commonly used for high resolution printing to PostScript printers and imagesetters.

Two-Point Perspective
Linear perspective in which lines converge at two vanishing points on one horizon line.

Underpainting
A layer of paint that is intended to be seen through a subsequent paint layer.

Value
The scale of light to dark.

Vanishing Point
The point at which receding parallel lines viewed in perspective appear to converge.

Vectors
Lines, curves, objects, and fills that are calculated mathematically.

Verdaccio
An Italian name for the mixture of black, white, and yellow pigments resulting in a grayish or soft greenish brown commonly used in an underpainting.

Wash
A layer of paint spread thinly on a surface.

Wet-on-Wet
A painting technique in which layers of wet paint are applied to previous layers of wet paint.

INDEX

ACKNOWLEDGMENTS

PICTURE CREDITS

Many thanks to the featured artists, Chris Beatrice, Jason Juta, Jennifer Morris, Dennis Orlando, Chet Philipps, Don Seegmiller, and Jeremy Sutton, who contributed their knowledge, inspiration, and talent.

p8: Brian Sullivan/iStockphoto; p82: Giraudon/Bridgeman Art Library; p94: Swim Ink 2 LLC/Bridgeman Art Library; p100 TR: Biodiversity Heritage Library/Missouri Botanical Garden's Rare Books Collection; 101 BL: Green Paper; p104: Lorenzo Lees/Bridgeman Art Library; p118 BL: Museum of Fine Arts, Boston/Bridgeman Art Library; p118 BR, p132: Giraudon/Bridgeman Art Library; p140, p142 BR: Sergey Lavrentev/Fotolia; p142 BL: Mcswin/iStockphoto; p142 BC: Massimo Basso/Fotolia; p142 B: Cappi Thompson/Fotolia; p149: Blue Lantern Studio/Corbis.

Carlyn Beccia's following artworks can be found in her previously published books from Houghton Miffin: p38: Henry the VIII from *The Raucous Royals* (2008); p42: The Alchemist from *I Feel Better with a Frog in my Throat* (2010); p133: Little Boney from *The Raucous Royals* (2008); and (left) The Bearded Lady from *Who Put the B in the Ballyhoo?* (2007).

ABOUT **CARLYN BECCIA**

I guess if you bought this book you might want to know a little bit about the author. First, that's me on the left lounging in my Victorian finery (I take the gloves off when I paint). When I am not brushing my long beard, you can find me creating children's books. My books have won several awards, including a Golden Kite Honor, National Reading Association's Nonfiction Award, Oppenheim Toy Award, and a Parents' Choice Silver Award.

You can find more digital painting tips and tutorials on my blog:
http://blog.CarlynBeccia.com

My more recent work can be found at:
www.CarlynBeccia.com.

I answer emails (eventually) at:
info@carlynbeccia.com